Landscape in pen and wash

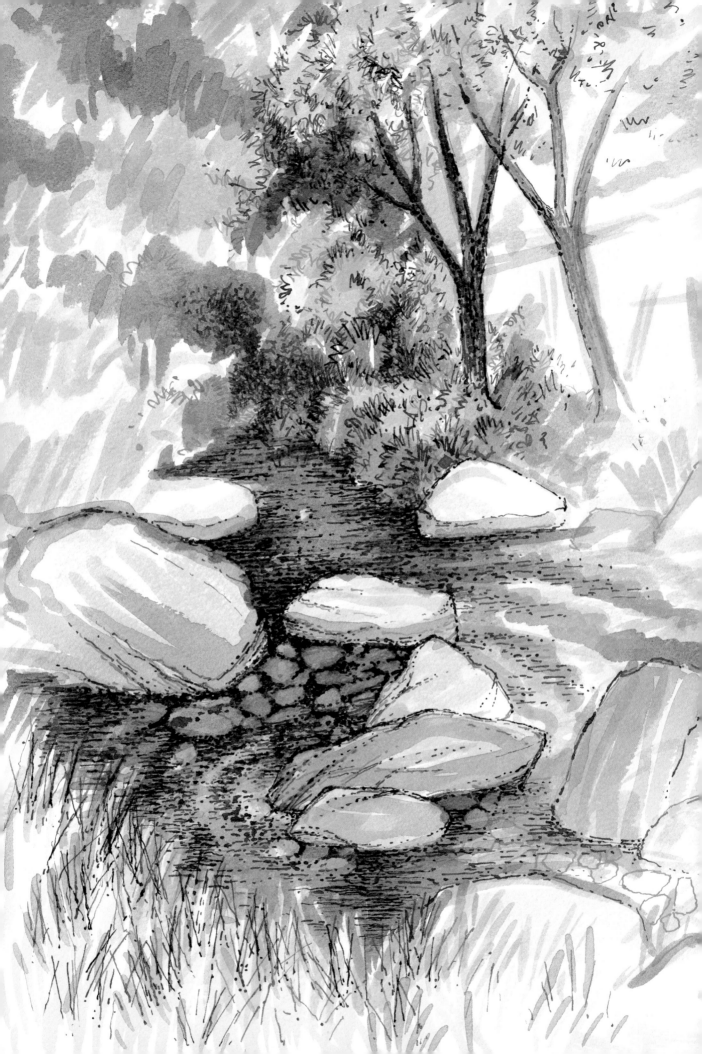

LANDSCAPE
in pen and wash

PAULETTE FEDARB

David & Charles

ACKNOWLEDGEMENTS

I would like to express particular thanks and gratitude to Mike Kelly, my husband, for the excellent photography, in addition to his invaluable help and support throughout the making of this book.

I am also indebted to the following: my editors Alison Elks and Freya Dangerfield for their guidance and advice; Jeff Court of Infotec Limited for photocopying facilities; Michael Edwards for kind permission to use his painting; my family and friends for their forbearance; and finally my dog, Poppy, for her companionship through many hours of writing, drawing and sketching forays.

A DAVID & CHARLES BOOK

First published in the UK in 1996

A catalogue record for this book is available from the British Library.

ISBN 0 7153 0284 1

Book design by Hammond Hammond
Printed in Singapore by C.S. Graphics Ptd Ltd
for David & Charles
Brunel House Newton Abbot Devon

CONTENTS

INTRODUCTION

LOOKING across the countryside with its pattern of fields and hedgerows, or walking through woodland, it is hard to imagine that this attractive planet was once a spinning vortex of toxic gases. Through numerous geological phases, over millions of years, the plates moved and bucked, the magma boiled and erupted, pushing up mountains and hollowing valleys, to form the incredible structure of our beautiful planet.

And so the landscape was shaped in its infinite variety, altered by climate and tempered by the seasons, embracing everything from Tennyson's 'crag ... close to the sun in lonely lands' to the pastoral minutiae of Edward Thomas's 'chip of flint, and mite of chalk'. Whether we seek the expansive panorama that so excited Turner, or the half-hidden world in a tuft of grass that inspired Dürer, there is something for everyone who loves to draw and paint the landscape, responding to its colour and form.

Most artists at some time will have set down on paper or canvas an image related to the land, either as a subject in its own right or as a background. For some, the response is a direct one: to capture and record what is seen; a held moment of a particular place and time. For others, an introspective interpretation takes precedence: painters such as Van Gogh, Samuel Palmer and Paul Nash all possessed exceptional imagination, reflected in the visionary quality of their work, transforming landscape into an intense personal experience.

Our own talents may be considerably less, but the land is there for all to enjoy. Don't be put off by the great artists, but rather see them as an inspiration, a stimulus to discovery. Painting is not a competition, it is about expressing ideas on things that move us; it is a personal foray into the visual world.

LANDSCAPE PAINTING THROUGH THE CENTURIES

Landscape painting has not always been regarded with the importance that attaches to it today. Until the end of the eighteenth century it was considered a minor art and there was little demand for it, apart from the landed gentry who liked to have 'views' of their country houses and estates. With one or two notable exceptions, including Ruisdael and Hobbema in Holland, landscape painters were not generally thought of as serious artists, unlike those who painted portraits or epic scenes from history and mythology. Most artists who did paint the landscape did so to satisfy their own private interest.

Gainsborough was one such artist. He longed to paint the countryside he was so fond of, but the necessity to earn a living obliged him to do portraits instead. A painting that seems to reflect this dilemma is *Robert Andrews and his Wife* (National Gallery, London) where, charmingly as he depicts the couple, I suspect that his real interest lay in painting the landscape that surrounds them; the couple are tucked away so much to one side, that a little further and they would be out of the picture altogether! The lopsided placing of the figures makes it an unusual composition for portraiture at that time, and the canvas is a landscape format; a prophetic hint of things to come.

In Britain, the Romantic Movement was influential in the rise in popularity of landscape painting towards the end of the eighteenth century. This movement, which affected all the arts, found the poet William Wordsworth among its most committed exponents and his poetry did much to awaken people's awareness to the beauty of the natural world. Mountains and lakes, forests and

LOW TIDE AT ETRETAT
Etretat, with its spectacular cliffs, has inspired many paintings and drawings. Seen from the shore the striated rocks rise up sheer for hundreds of metres; from above, their heights give a vertiginous bird's eye view. This is dramatic scenery with much to attract the artist.

I chose a high viewpoint, perching on the edge of the cliff to look straight down onto the small bay below. I was intrigued by the dark textures left on the shore by the receding tide and it is these, rather than the cliffs, that dominate the painting. I made a number of pen sketches from which the picture was later composed, when layers of watercolour and ink were intermingled until they reached the desired effect.

TREE FORM

A painting in which an objective subject – a tree – has been treated in an imaginative way. It is expressionistic, a picture about mood and feeling: it resembles a tree superficially, but is more to do with the painter's reaction to the subject than with realistic representation. Rhythm is important, the movement of the brush depicted in linear sweeps through and around the forms. This is accentuated by the dark, thick lines which also give weight. The thrust of the composition is an arc that runs from the lower left-hand corner up to the top, from which radiating limbs spread out as a counter-balance. Lighter echoes of this are found in the background.

Cartridge paper and a round No.12 brush were used, the smoothness of the surface enabling the brush to move easily across it on its point, producing the linear effect. Watercolour, acrylic inks and black indian ink provided the media and were applied with a bamboo pen and a worn, flexible Waverley nib in addition to brush. This is, therefore, a good example of a picture which is both drawing and painting, and it could be referred to as either. The brush has been used like a pen in that the colour has been 'drawn' on, while the splodginess of the bamboo leans towards the painterly.

wild flowers became places and things to admire and enjoy, in contrast to the artificiality of the contrived landscape, which had been so fashionable earlier in the century. Before this, wild and dramatic scenery had been viewed with positive hostility and dislike; mountainous and hilly places, many of which today are considered beauty spots, were avoided.

The first two landscape painters of real stature were Turner and Constable. Born within a year of each other, in 1775 and 1776 respectively, their approaches were very different. Turner was a traditionalist, in spite of the innovatory nature of his mature work, with a great reverence for Claude Lorrain, the seventeenth-century French painter, whose influence is seen in some of his early pictures. He also had a fondness for the 'grand gesture' and liked to make an impact. Later, with a deepening awareness of light and atmosphere, his painting soared away in a burst of colour and rich surface texture, becoming, at times, almost abstract in concept. Monet, who knew Turner's paintings, was to continue these explorations of light and colour with the Impressionists.

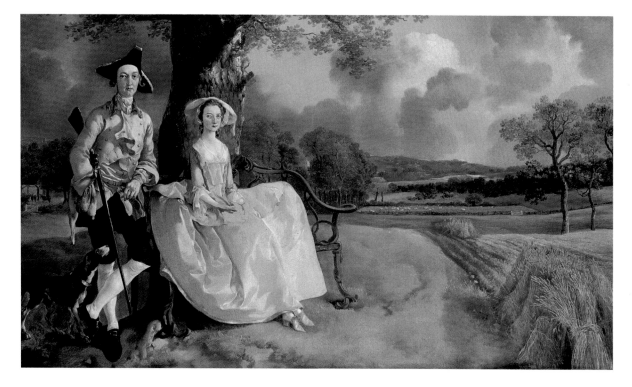

ROBERT ANDREWS AND HIS WIFE *by Thomas Gainsborough. (Reproduced by courtesy of the Trustees, The National Gallery, London.)*

Although this is an oil painting and not pen and wash, it is such an interesting picture and relevant to the subject that I decided to include it. If the composition is divided in half there are two pictures, a portrait on the left

and a landscape on the right, and this handling of the subject seems to reflect the struggle within Gainsborough between portraiture and landscape.

It is a beautiful picture, painted when the artist had returned to Suffolk after his apprenticeship in London, and showing, perhaps, his relief and delight at being in the countryside once more.

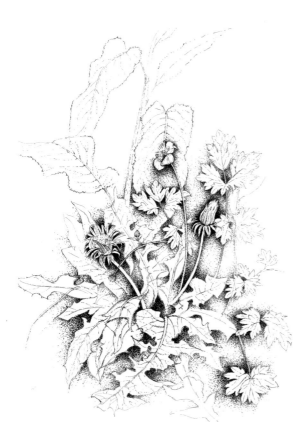

WILD FLOWERS

Dandelions and buttercups are common flowers of field and hedgerow; apart from noticing their bright splashes of yellow in spring, we usually pass them by with little attention. But a closer look reveals an intricate structure of leaf and flower, a perfect example of natural design and an interesting subject to draw. It is always worth looking at the ground to see what lies around our feet: landscape includes small details as well as the spacious view. Drawn in pen and black indian ink, the intention was to bring out both the decorative element and the characteristic shape of the plants.

SADDLE TOR – DARTMOOR

A pen and watercolour drawing made in situ. *As so often happens when sketching out of doors in Britain, rain threatened, so I had to get on rapidly. Washes of watercolour were brushed on with a round No.12 brush and the pen drawing added on top; the ink lines 'discipline' the sketch and provide a contrast to the free areas of colour. Quite apart from the enjoyment of working in the open for its own sake, sketches like this are valuable for gathering information and can be referred to again at a later date, perhaps when planning a larger, more ambitious picture.*

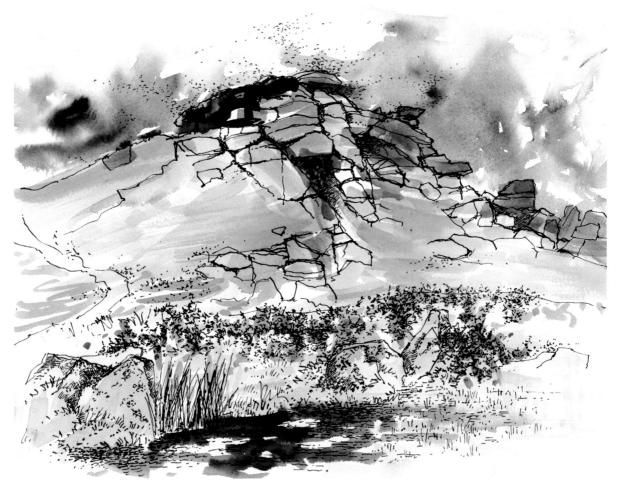

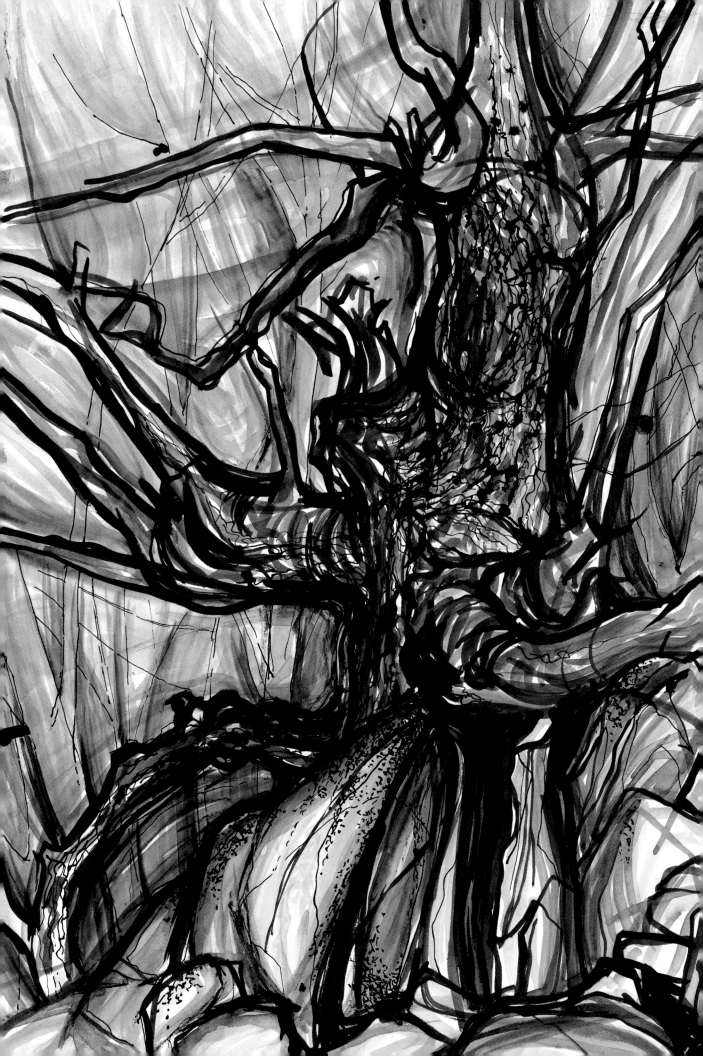

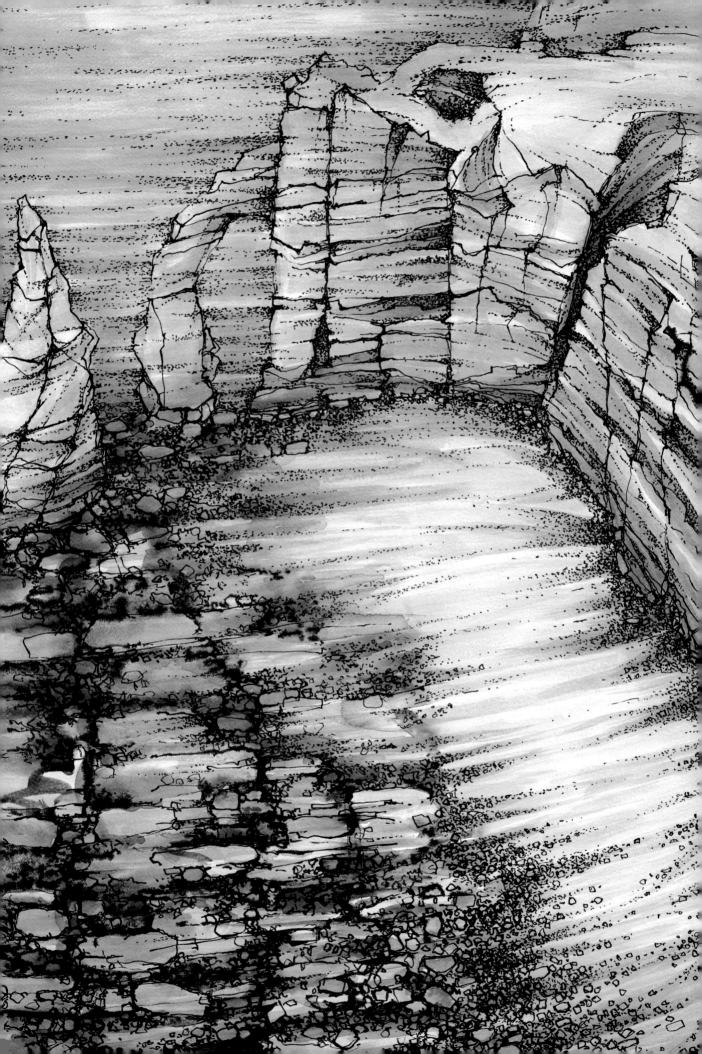

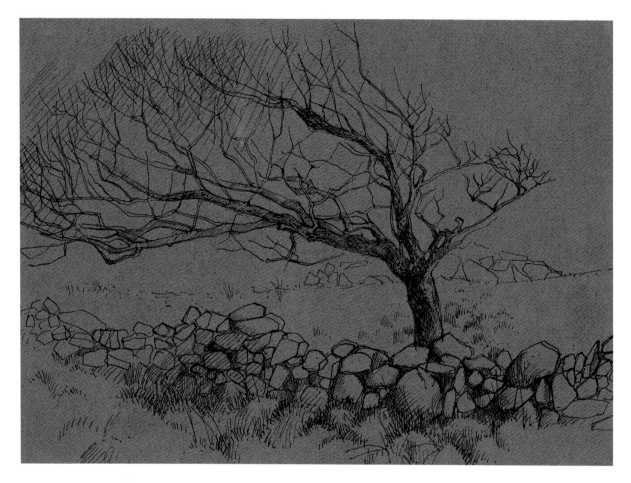

CUMBRIAN TREE

Trees that grow on fells and open moorland take on a typically windswept shape; sometimes finding a roothold in no more than a narrow rock fissure, they cling to existence, torn by the elements while they struggle to maturity. Stunted and bent, they are fascinating to draw, survivors of the wild terrain in which they live. This study in black indian ink on brown Ingres paper shows how the branches are weighted to one side as a result of the prevailing wind, echoing the horizontal line of the stone wall. The width of the tree is consequently greater than its height, an unusual feature that prompted the drawing.

Constable's creed was truth to nature. Influenced by Ruisdael and the Dutch landscapists of a century earlier, he believed in working directly, sketching in the countryside and then painting his studio pictures from these observations. Often it is the sketches, with their spontaneity and freshness, that have a greater appeal today than the more carefully worked finished pictures. His approach was to have a far-reaching effect upon the development of landscape painting, especially in France among the Impressionists and the Barbizon School, a group of painters working in a village on the outskirts of Paris.

At the same time that Constable was working in neighbouring Suffolk, a society of painters known as the Norwich School established itself in Norfolk. The most important of these were John Crome and John Sell Cotman. They worked largely in watercolour from the surrounding landscape, and began the tradition so long associated with a peculiarly British form of art. The wide, open skies and flat fenlands of East Anglia, with their damp and silvery sea-mist colours, were eminently suited to the limpid washes of watercolour. Since then watercolour has become firmly entrenched as a very popular medium, appealing to professional and amateur alike.

THE LANDSCAPE IN PEN AND WASH

My purpose in writing this book is to add to the enjoyment of landscape in watercolour, by showing how it can be combined with pen and ink. Pen and wash, as it is commonly known, is a lovely medium and encompasses watercolour, ink, brush, pen and one or two less usual items, such as bistre, sepia and reed and bamboo pens, dealt with more fully in chapter 2 on Basic Techniques.

Accomplished as you may be in working in watercolour, you may not have considered using it with pen and ink before. Too many people are

frightened away by its indelibility and the fear of messing up a picture irretrievably; they prefer the safer element of pencil, which can be rubbed out. I hope to show that these fears are groundless, and that with a little practice, pen and wash can be one of the most liberating of all media, with scope for many different applications. Much depends upon building up confidence, which will only come once you have taken the plunge and decided to have a go. Then you may well wonder why you didn't try it long ago!

Drawing with a pen is not nearly so irretrievable as you may think. There are ways in which it can be used as delicately as pencil, disguised if you do make a few 'mistakes' or, if you are really desperate, removed altogether by scraping with a knife. But never be afraid of altering lines, even if the original ones still show – you must learn to draw without timidity, regardless of any readjustments, because 'thinking' on paper is an essential part of the creative process. Look through any artist's sketchbook and you will find evidence of this. Leonardo's notebooks are full of drawings in which several alternative positions are shown for arms and legs, or the hang of draperies, and there are some wonderfully vigorous drawings of horses with six legs! It is fascinating to see his mind at work, manifesting itself on paper.

When you *write* with a pen, I feel sure you aren't too bothered about errors; you probably cross them out and carry on. This is because it is such a commonplace activity that you hardly think about it, and the pen is like an extension of your hand. Try to develop a similar approach in drawing; aim to be as relaxed with it as you are when writing. Familiarity is the key here, so first you need to get acquainted with the pen and find out what it can do. I suspect that readers who have tried pen and ink and given it up, may have done so because they attempted too much too soon and became discouraged. They didn't give either themselves or the medium a proper chance. One of the purposes of the chapter on Basic Techniques is

HOLLOW TREE 1

In this pen and watercolour drawing of an old decayed tree trunk, the washes have been flooded on freely, with some colours running together. I rarely mix colours beforehand, as I prefer to put them on pure and let the mixtures arise from overlaying, or the wet-in-wet method. As with most of my direct sketching, I began with brush and finished with pen; this always helps me to loosen up and get quickly into the mood of what I am doing.

The pen strokes range from broad lines to fine cross-hatching, used to build up tone in the hollows of the tree. Some of the lines have thickened and spread where they were drawn over wet colour.

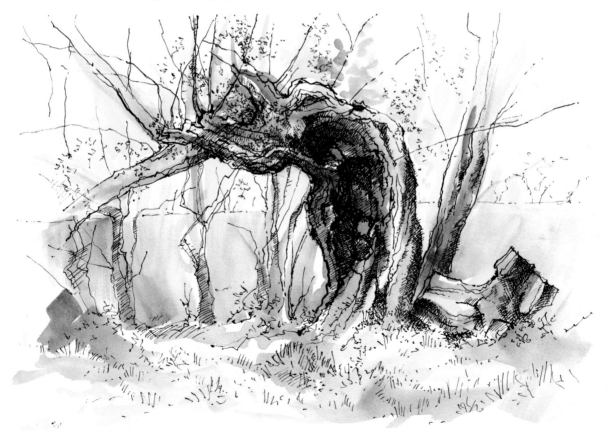

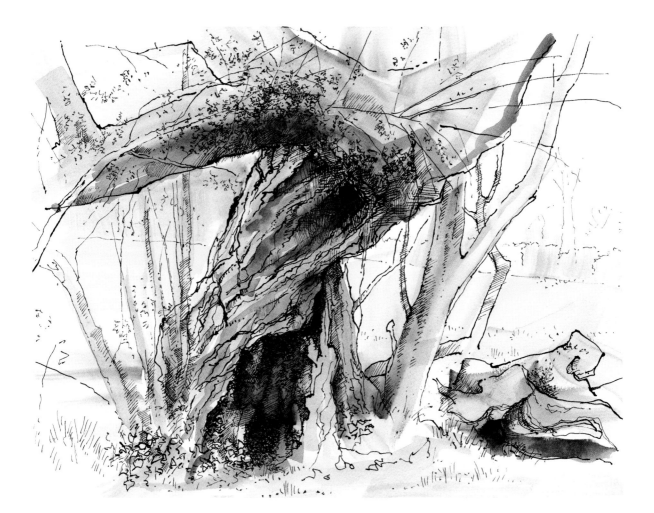

to help you get to know and familiarize yourselves with the materials before any attempt is made at producing a picture.

As you work your way through the book I hope you will come to realize that using pencil first, depending on it like a crutch, is not a good idea: it will lure you into a false sense of security and hinder the development of fluency. Start with pen from the very beginning, however diffident you feel – be positive and persevere. Once you become accustomed to its flow and movement, confidence will blossom and lead to truly expressive drawing. Inking over pencilled lines will only result in rigid, insensitive work because you will be following a line already put down, instead of thinking and working freely. Pencil has not been used in these illustrations at any stage. It is a beautiful medium that should be used in its own right, and not as a prop for other media.

Drawing and painting are so closely related that I have always found it difficult to think of them as separate activities. I draw and paint with brush and likewise with pen; the two become indivisible. Most of the larger, more intensively

HOLLOW TREE 2

Another view of the subject seen in the previous drawing: I have moved in closer to make a more detailed sketch of the textured bark. The method is the same used in the first drawing, with pen added to colour, but the tonal areas are more finely worked than before, incorporating scribbled as well as hatched techniques. The hatching consists of short, fine lines in various directions which gives greater 'mobility' than if the lines had all been made in one direction. Both these drawings are typical of my watercolour sketching method when I am working in situ. I like to keep sketches fluid.

worked pictures in the book were evolved in this way and I am never sure whether I should refer to them as paintings or drawings! I find this continual dialogue between pen and brush less inhibiting than completing the drawing first, then filling in with colour; in other words, segregating them into compartments. I like to switch from one to the other without restraint, building up layers of colour and ink. If you have always started a picture by drawing, then adding the colour afterwards, try mixing them together for a change, or working in a reverse order – the results could be intriguing.

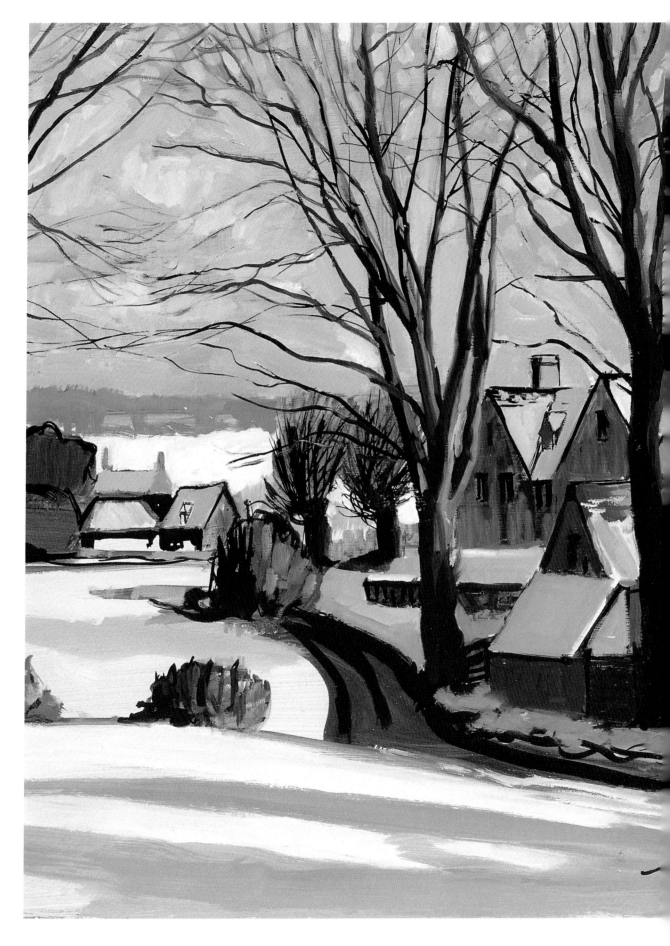

Most important though, is that you should enjoy and have fun with pen and wash; it is exciting, interesting, sometimes unpredictable (which gives it a little 'edge') and immensely rewarding – and it doesn't require a lot of expensive equipment.

THE PERSONAL INTERPRETATION OF LANDSCAPE

One difficulty of writing a book about a creative pursuit is that some readers may simply be looking for easy instruction to unlock the mysteries and provide instant technical skills. Many exhibitions are full of technically accomplished pictures, conscientiously and lovingly executed, but having no spark, no sense of vitality, nothing that really grabs us and compels a closer look.

The 'nub' of painting is individuality and it is this that I shall constantly emphasize. I do not intend to provide set formulas for producing effects, but instead shall point you in various directions and encourage you to make your own discoveries: it is what you have to say personally about what is seen that matters, not how cleverly you can imitate a cloud, or copy the leaves on a tree. Technical skill for its own sake is a rather limited aim, but used as a vehicle for communication then it has a much wider purpose and properly becomes the means to an end. It is not that technique is unimportant but that it can be given too much prominence at the cost of expressive ideas.

The basic techniques and exercises in the early part of the book, therefore, are intended only as a guide. Once you have got going then I hope you will develop them in your own way and go on to discover others. The same advice applies to the

NEAR PAINSWICK, GLOUCESTERSHIRE
by Michael Edwards
In this painting of a snow scene, Michael Edwards shows us how tone values are reversed, with the land appearing lighter than the sky. Trees and other features of the landscape look darker than usual, reduced almost to monochrome. However, we can also see that the snow is not just white, it picks up and reflects the colour of the sky so that a link is established between the two which gives a unity to the picture. Note, too, the way in which he breaks up the foreground by introducing shadows across the snow; these echo the long shapes of the vertical tree trunks, forming interesting patterns and relieving what would otherwise have been an empty space. The technique involved thin acrylic washes, ink drawing and oil paint applied on top.

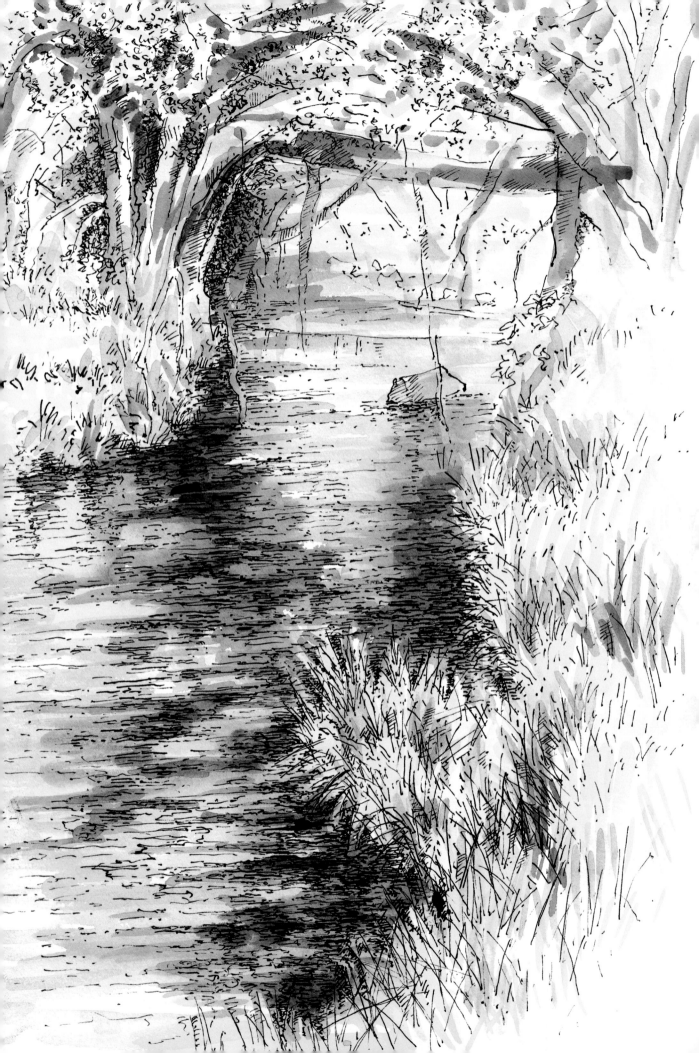

STREAM

Water always attracts artists. This stream has many moods: after rain it becomes opaquely brown and swirls along with considerable ferocity, but on this occasion – an early spring morning – it was tranquil and clear. It was a scene of contrasts, the bright green of young grass in sunlight and dark shadows under the banks.

I brushed colour on first, increasing the intensity in the foreground and letting it lighten towards the background to give a sense of depth. This intention was repeated in the pen drawing, with the strokes more concentrated in the lower half of the sketch. The darkest parts of the water bear the greatest accumulation of strokes, to push up the contrast. The pen lines of the stream are horizontal to emulate the surface, while those of the grass are vertical and diagonal, indicative of the plant growth.

demonstrations. Don't copy them exactly, but heed the principle of what is shown; in this way your own creativity will evolve and a natural style will arise that reflects individuality. Then your painting will have something interesting to say.

The major part of the book deals with different aspects of and approaches to landscape. Although for convenience and accessibility it is divided into sections, each topic covered interrelates with others and should not be regarded in isolation; the points raised in one chapter may apply equally to another. Topographic and imaginative subjects, panoramic views, intimate garden scenes, landscape at night, the effects of climate and the changing seasons are some of the themes considered; there is also a section on working abroad and advice about painting holidays.

Before dealing with the specific topics, the book begins by offering general guidance on selecting and buying materials, getting launched with the medium, and one or two points about working in the landscape for those who may not have tried it before.

The illustrations demonstrate a variety of styles, and supplement the ideas expressed in the text. They range from quick 'thumbnail' sketches, to closely observed studies, to finished paintings and incorporate a broad use of the medium in colour and monochrome. In some cases, part of a picture has been enlarged to give a closer, more detailed view of pen and brush techniques, the intention being to show how pen, brush, watercolour and ink complement and enhance each other.

Landscape is unique in that it offers the choice of a direct experience 'in the field', of being part of what we paint, or the alternative of working within the confines of a house. It involves the enjoyment of environment allied to the pleasure of drawing and painting. The aim is to explore the possibilities this stimulating subject offers, and to see how they can be interpreted in pen and wash. If this is an introduction to the medium for you, then I hope it will encourage you to want to continue and extend the acquaintance. For those already familiar with it, perhaps some new slants will have been initiated that can be developed further. Whichever applies, may you find it an interesting venture and feel spurred on to be inventive, adventurous and original, realizing that above all it is your own ideas that matter and not the imitation of someone else's, however skilfully done.

The book is written not as a didactic manual, but as a personal setting down of thoughts and experiences, with some practical signposts along the way. I hope you will be able to share in the excitements and occasional disasters and compare them with your own. Ultimately we are all involved in a common end, namely the portrayal of the fascinating world of landscape through colour and line, whether we are part-time artists painting purely for pleasure, or full-time artists painting to earn a living.

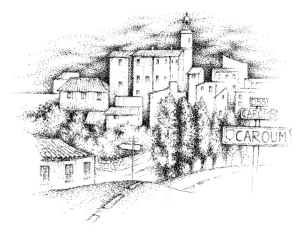

MATERIALS AND EQUIPMENT

BEFORE you begin to draw you will need to give some thought to your materials. Choosing carefully and suitably will go a long way towards the successful outcome of a picture – it is essential to feel in tune with the tools you are using. The paper that buckles each time it sees a wash, the brush that leaves a trail of hairs, or the pen that hiccups and splatters, is not going to provide much enjoyment but will lead instead to frustration and wasted effort. Paper, pen and brush, ink and paint should work in harmony with each other, so that handling them is a pleasure. The tactile sense is important: the crisp feel of the pen incising its way across a smooth surface, the silky fullness of a brush charged with colour – these sensations are all part of the enjoyment. Experienced artists will already know this, but beginners too will find themselves aware of this dimension after a little practice.

It follows, therefore, that in order to get the most out of your work you should aim to get the best equipment that you can afford. Go for quality, not quantity. Art shops are full of gadgety paintboxes, filled with umpteen colours, bottles of this and tubes of that, and one, or possibly two indifferent brushes! Seductively packaged, they are a trap for the unwary; they are also expensive, even more so when, having succumbed to their trappings, you realize that some of their contents will never be used. A few well chosen items of top quality are of far greater value to the development of your art than a quantity of second-rate materials.

PAPER

To begin with papers: these come in a bewildering display of types, grades and colours, some hand-made, some machine-made. Selection can be difficult when you are unfamiliar with the terminology, and the following information should give you guidance on what is available, and what to

Papers (from left to right): Arches mould-made 100 per cent rag – rough 300gsm (140lb); Arches mould-made 100 per cent rag – Not 300gsm (140lb); Bockingford Eggshell mould-made – Not 300gsm (140lb); Canson Mi-Teintes pastel paper – 160gsm (72lb); CS10 – smooth Designer paper; Ingres paper – tinted.

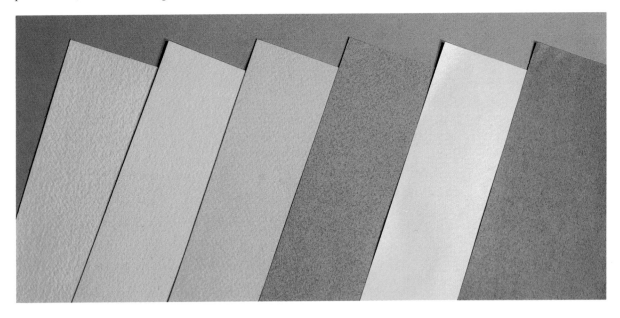

look for. The finest papers of all are those made by hand, and not surprisingly, these are expensive. Originally made from linen rags, today they are mostly made from cotton, with the characteristic uneven edge, or 'deckle', on all four sides, produced naturally during the making process. The term 'rag' is still used for all cotton-made papers of quality, including all those made by machine.

There are two types of machine-made papers: those known as *mould-made*, which use cotton, or a mixture of cotton and woodpulp; and *economy* papers, produced from woodpulp or extracted cellulose. In mould-made papers, the higher the level of cotton, the better the quality and like the hand-made ones, these papers also have deckle edges, although only two are produced naturally; the other two are simulated by tearing. Economy papers have straight edges on all four sides. In spite of their name, they are still of acceptable quality. Most top quality papers are produced for watercolour painting, but they are also suitable for ink washes and pen and ink work generally, with the exception of the roughest surfaces which may snag the pen.

The most popular drawing papers are cartridge and Ingres, both of which are smooth and good for pen and ink. Ingres is usually tinted and sometimes contains a fleck. Cartridge, so called because of its original connections with the gun trade, is an inexpensive, general purpose paper, often used in sketchbooks. The quality can vary considerably, so examine it carefully before making a choice. Price is usually the best indication of what you are getting. Designer art boards and papers are smooth and glossy, and are excellent for fine pen drawing, although they may be rather slippery for washes.

Papers are identified by weight and surface texture. Weight is marked in grams per square metre (gsm), or pounds, and the higher the number, the thicker and heavier the paper. Thick papers will be less inclined to wrinkle under washes than thinner papers. There are three types of surface texture: (1) hot-pressed (HP) which is smooth; (2) Not, abbreviated from 'not hot-pressed', which is medium; and (3) rough, which is coarse. Not papers are the most popular and suited to a wide range of techniques.

Most papers that you work on are likely to be white, which can vary from a bright cold white to a softer creamy white, depending upon the manufacturer. Tinted and coloured papers are worth trying for a change, particularly for the way in which they affect colour washes.

Examples of the deckle edges on better quality papers, such as the T.H. Saunders Waterford mould-made papers shown here: (left) Not – 300gsm (140lb); (right) hot-pressed (HP) – 300gsm (140lb).

Different papers will, of course, suit different people and different needs, so the best way to find out what appeals to you is to buy an assortment. Experiment with them, trying out brushes and pens, paints and inks in a variety of techniques.

BRUSHES

The main implements for drawing will be brushes and pens. Good brushes are expensive, but fortunately pens are relatively cheap, with the exception of the more sophisticated technical pens.

As with papers, there is an enormous range of brushes made from many kinds of hair or bristle, both animal and synthetic. Sable, ox, squirrel, goat and hog are among the natural fibres used, each having a particular quality of softness, springiness or stiffness. The aristocrat of brushes is the sable,

with the Kolinsky sable top of the list. It has a lovely bouncy feel, holds colour well, points up beautifully and readily springs back into shape after use; in short, the perfect brush! Its only disadvantage is its price, but try to afford at least one if possible. Properly looked after it will last a long time.

During the last decade or so, synthetics have become increasingly popular, and also greatly improved. Some are mixed with sable hair to give a brush of good quality, without the high cost of pure sable: a compromise brush, which performs well and is reasonably hard wearing, it makes an acceptable alternative to sable.

The other brushes commonly used for watercolour and washes are those made from squirrel and ox hair. Squirrel hair is very soft and because of its lack of resilience is best for applying large areas of wash. It does not spring back into shape after use, which makes it limp and awkward to handle in detailed and linear work. The cheaper type of watercolour boxes, especially those for children, usually contain squirrel brushes. Ox hair

is stronger and more resilient than squirrel, but it is coarser than sable, and therefore less capable of producing a fine point; it is a useful, general purpose brush, without the Rolls-Royce feel of sable. There are also hog-bristle brushes; these are stiff, tough and most suitable for oil and acrylic painting, but you might find them appropriate for producing textures, particularly in mixed media.

Shape is another important feature of brushes. Round, flat, square, filbert, pointed, long- or short-haired, fat or thin, each will make a distinctive stroke and add to the richness of brushwork. Choice depends upon purpose, but in general, go

Brushes (from left to right): sketcher's pocket-box synthetic brush – the detachable handle fits over the brush end when not in use, to protect it and fit into the box; flat 2cm (¾in) – sable mixed with synthetic fibres; flat 1cm (½in) – sable mixed with synthetic fibres; round No.8 – sable mixed with synthetic fibres; rigger No.2 – sable mixed with synthetic fibres; long round (lettering brush) No.6 – ox mixed with sable; round No.2 – Kolinsky sable (the best quality available).

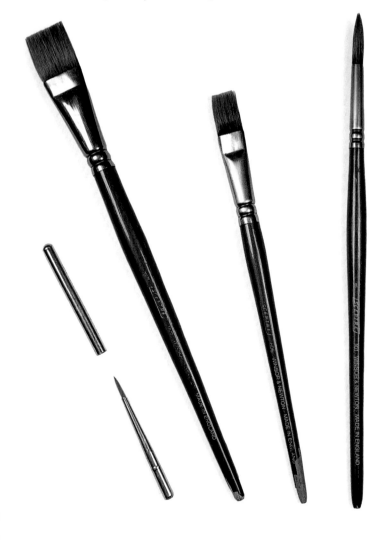

for bigger sizes rather than smaller; this encourages boldness of approach, especially for those who tend to use too small a brush. This is an understandable ploy in the belief that mistakes will be less noticeable, but too often the result will be a cramped, niggly style and tired, anxious pictures. Learn to open out and make full use of arm movement. It takes courage at first, but you will soon get the hang of it. An economic reason for choosing larger sizes is that it is easier to paint details with a big brush than to block in broad areas with a tiny brush!

PENS

Pens are considerably cheaper, but the main drawback here is their limited availability, at least with regard to traditional drawing nibs. The average art retailer will have only a very limited selection, and not necessarily the most suitable. In order to get the widest choice you will need to contact specialist suppliers, addresses for whom can be found in art magazines.

The dip pen still holds its own among all others with regard to flexibility, nuance and diversity of line and mark: there is simply nothing to beat it – it is the equivalent of the sable in pen terms. The steel pen is the one commonly used and the most versatile due to the enormous range of nibs available, once a reliable source has been tracked down. And as you build up a collection of these, don't automatically discard the older ones as wear produces a thickened, malleable point which can often be used to good effect; I have been using one nib for more than twenty-five years!

Although they are not so durable, it is also worth trying the less usual reed and bamboo pens. Reed pens are extremely flexible and bouncy, and the tip soon softens to give a broader line, especially if you draw vigorously; they need to be handled with a light touch if you want to retain their original sensitivity. Bamboo pens are similar, but give a stronger, firmer line and lack the pliability of the reed. The quill can also be used for drawing, although it is more often considered a calligraphic instrument.

Technical pens, ballpoints and fibre-tips are all useful additions to the drawing scene, their chief advantage being their capability to draw continuously without a refill of ink. This makes them ideal for sketching and rough jottings, although what is gained in convenience is lost in quality of line, which is monotonously regular when compared to that of the dip pen.

Sketching pens are a different case. Containing

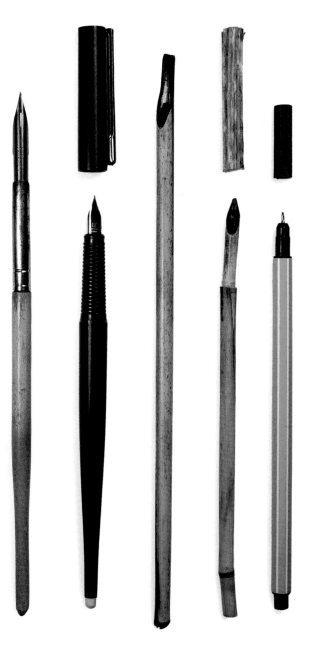

Pens (from left to right): dip pen with shoulder pen nib F; sketching pen – cartridge-filled; bamboo pen; reed pen with cover; ballpoint pen.

a cartridge of ink, they combine convenience with reasonable drawing flexibility, although I would not put them in the same class as the dips. Cartridges are available in several colours, as well as black and sepia. I find them more sympathetic to use than the technical and ballpoint group.

It is not absolutely necessary to use a conventional pen at all. Sticks, slivers of card, string, even fingers – anything, in fact, which can be dipped into ink or paint will make some form of

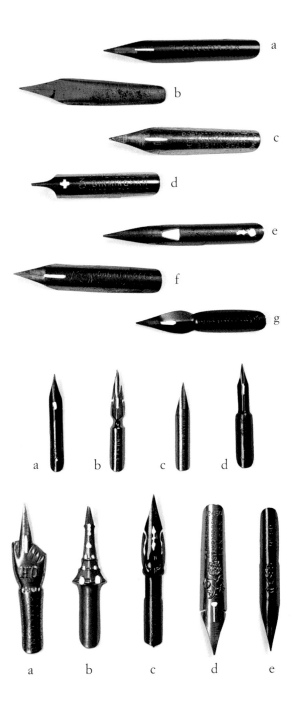

Nibs. Horizontal group (top to bottom): (a) shoulder pen F (A. Brown & Sons Ltd); (b) Ajusto pen painting pen 776F (Geo W. Hughes); (c) ballpointed 521F (D. Leonardt & Co.); (d) 3 (M. Myers & Son Ltd); (e) Figaro pen No.208 (C. Brandauer & Co.); (f) Bank pen, 5 slits (John Heywood); (g) Waverley (Macniven & Cameron).

Middle group – fine pens (left to right): (a) No.513 (Brause & Co.); (b) No.66 EI (Brause & Co.); (c) Dial No.17 (Wm Mitchell); (d) artist's pen (Joseph Gillott).

Bottom group – novelty (left to right): (a) pointing finger (O.H. Macniven & Cameron); (b) Eiffel tower (maker not known); (c) 475 (John Mitchell); (d) rose – standard pen No.450 (T. Bower & Son); (e) plume ballon No.50 (F. Soennecken).

I have given the fullest details possible for identification purposes, but you will need to find a specialist supplier in many cases. Anyone interested in the history of pen nibs would have a fascinating time finding out about them, particularly the novelty group. 'Image' nibs were popular in Victorian and Edwardian times; if you look closely at (e) you might just be able to make out a hot air balloon, with the basket towards the nib point!

mark or line. Moreover the mixing of traditional and off-beat methods often produces lively pictures, so don't be afraid to experiment.

INKS

Inks fall into two simple categories: soluble and non-soluble. Both groups contain coloured, black and sepia inks and can be diluted with distilled water to give paler versions; coloured inks can usually be intermixed as well. Each group has unique characteristics suited to specific techniques: thus soluble inks, after they have dried, can be brushed over with water to soften and blur lines; tones can be blended with a damp brush to give a range of subtleties, and the effects produced are sensitive and delicate. Non-soluble inks cannot be altered by water once they have dried, but owing to their transparency, they can be modulated by building up successive layers of colour. While they are still wet both categories can be worked in similar ways; it is only after they have dried that the intrinsic differences can be exploited.

There are many good quality brands on the market. On the whole I find the acrylic coloured inks more subtle in use than the shellac-based ones, with better lightfast properties, too. When purchasing inks be sure to find out whether they are water-soluble or not, or you could be in for some unwelcome surprises. And one final point concerning black inks: black indian ink (non-soluble) tends to be more intensely black than liquid indian ink (soluble).

WATERCOLOUR PAINTS

Watercolour paints – by which I mean transparent colours, and not opaque gouache colours – are available in tubes and pans. 'Artists'' watercolours are the best quality, but well known manufacturers usually run a cheaper line; these are good value for money and I would recommend them for beginners and those with less experience. Some artists use them all the time and find them perfectly adequate to paint with, although they do lack

the zip and potency of the finest colours.

Watercolours can be bought individually, or in boxed sets containing either tubes or pans. If you are inclined towards a box, heed my earlier warning and make sure it is a reputable make, and bought from a reliable retailer, preferably a specialist in artists' materials. Should you choose tubes or pans, and if pans, whole or half? As with so many things to do with art, you must be guided ultimately by instinct and what feels right – and if you are still not sure, buy one or two to try, and find out that way. I use a mixture of tubes and pans, with a particular liking for whole pans; I enjoy sweeping a brush across the surface and collecting a succulent swathe of colour, ready to flow onto the paper. Tubes give a lovely squidge, but this must be carefully mixed with water or dollops of colour may occur in the wrong place. Tubes are extremely useful for making large amounts of wash, while pans are perhaps more convenient for sketching.

Since the merits of each are more or less equal, what about any disadvantages? The main problem with tubes is that of drying out and hardening, rendering them useless; this is usually because they have been stored for too long without use, or because the tops have not been screwed on properly, or even left off altogether! Pans will also harden if left for long periods, although it is possible to retrieve these by adding a drop of water and leaving them for a day or two. A tip for keeping pans in good, moist condition is to keep them covered with a strip of plastic, particularly if you won't be using them for a while; but remember to check them occasionally.

MISCELLANEOUS EQUIPMENT

I have dealt at length with essential materials and equipment, to help avoid costly or uninformed mistakes; other items, less indispensable, I will mention only briefly.

Easels come in many sorts and sizes, in wood and metal. Sketching easels are lightweight and collapsible for ease of transportation; table easels, in wood or aluminium, are small and convenient for restricted space; radial easels, more substantial, are suitable for larger areas and studio use. Likewise sketching stools come in various forms, some with a back support; make sure they are comfortable as some have minimal seat allowance.

A selection of inks used in the illustrations for this book. On the left: coloured inks; on the right: black, sepia and iron gall (in the small corked bottle). The triangular-shaped bottles and acrylics should all be available at good general art retailers, but the others may be obtainable only through specialist firms.

The white plastic dishes are useful and convenient for mixing washes. They stack inside each other and are secured with a lid (not shown).

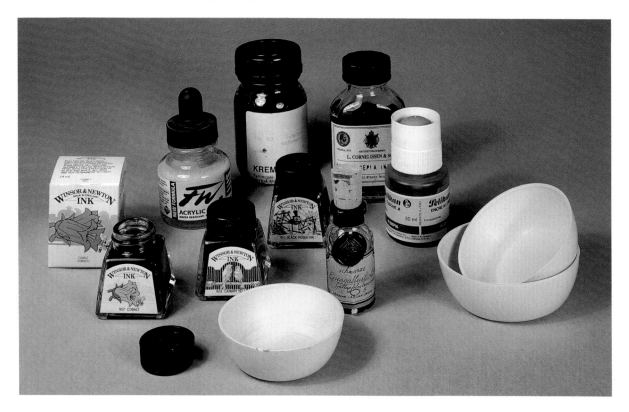

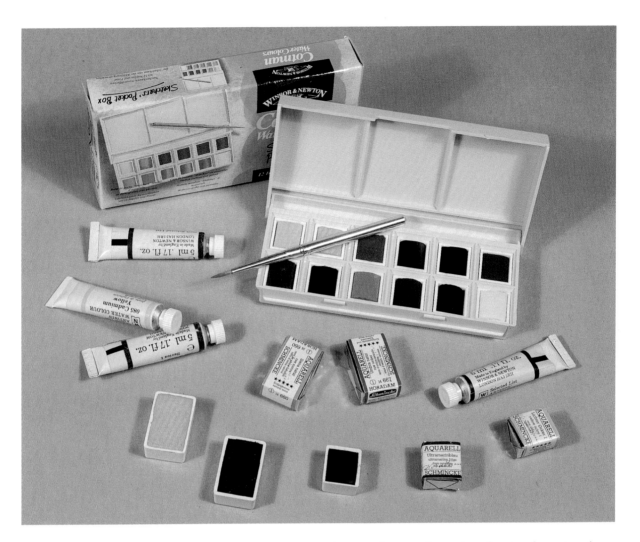

Further articles, such as knapsacks and containers for various purposes, can be improvised if not already possessed; thus a jamjar for storing paintbrushes is just as efficient as the ceramic holder bought at an art shop.

Finally, don't forget my earlier exhortation to go for quality rather than quantity where essentials are concerned, especially in the case of brushes.

CARE OF EQUIPMENT

Once you have set yourself up, take the trouble to look after and treat equipment with respect. Always clean brushes and pens after use, and never leave brushes standing in water as the hairs will become distorted. Make sure paints and inks are kept in good condition with the tops properly fixed. A little attention to their welfare means your materials will always be ready and enjoyable to use, and they will also last much longer.

The following list gives the nibs used for the illustrations in this book:
Shoulder pen F

A group of watercolour paints showing the various forms in which they can be bought. The box is the sketcher's pocket-box referred to in the text on page 94; it is very small, but there are many other sizes ranging from the moderate to the sumptuous.

If you are investing in tubes for the first time, make sure they are Artists' watercolours, or their economical equivalents, and not Designers' gouache colours. Both are 'watercolours', meaning that they require water as their mixing medium, but Artists' are transparent and Designers' are opaque, and for the type of work discussed in this book you will need transparent colours.

You can, of course, mix inks with gouache, or indeed any media that you choose, as Michael Edwards does in his picture on pages 14–15, but this should be a deliberate decision and not dependent upon chance.

Bank pen – 5 slits
Ajusto pen painting pen 776F
Brause Nos. 513 and 511
Waverley (very old and thick, due to wear)

Full details, with the names of the manufacturers, are given in the caption on page 22.

THE 'PETRA' HAT

A hat is a sensible precaution if you want to paint in the sun: it will protect against sunstroke and shade the eyes. Sitting in the heat for any length of time – which is likely when you are sketching – can have dire consequences if your head is unprotected, and the canvas hat in the photograph was invaluable to me in Jordan where it can be very hot indeed. In addition to its more usual function, it also fulfilled another, more unorthodox use at Petra: clambering among the rocks, I was incredulous at the richness of the colours they displayed and wanted a method of registering them. The rock was soft and rubbed off easily, so I thought of paper, but that wasn't absorbent enough – and then I thought of my hat. It was the perfect answer, which is how it came to be adorned with smudges of colour all round the brim! However, I nearly lost my precious collection when a kindly Arab tried to remove the 'dust' by beating at it vigorously. Fortunately I was able to stop him in time, and now have a unique memento of my trip as well as a record of the colours.

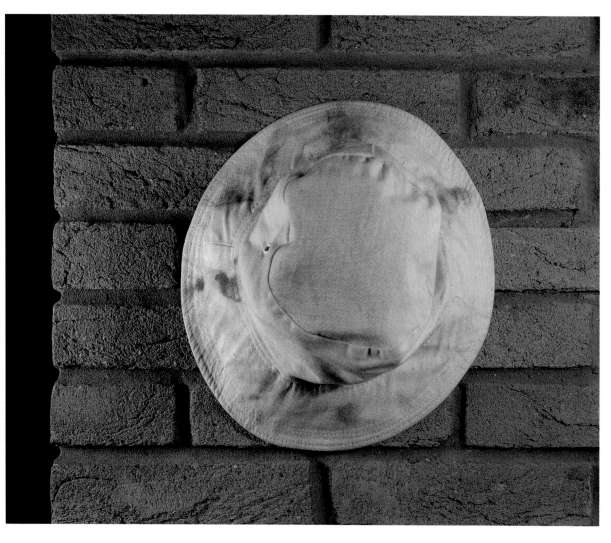

BASIC TECHNIQUES

THE first time a jumble of marks resembles a recognizable object is a moment of achievement: you have managed to create an illusion of reality on a flat piece of paper, the result of skilful co-ordination between eye, hand and tools. The temptation then is to immerse yourself so thoroughly in the development of this newly acquired skill that everything else is ignored, and technical prowess becomes the dominant partner in the relationship between technique and expression. However, it is, above all, individuality of expression that makes drawing and painting so interesting, and it is important to get the right balance between what you want to say, and how it is said. Learning to handle and manage tools and materials so that they respond to your needs is the basis of sound technique.

The aims of this chapter are twofold: to provide basic knowledge in the use of pen and wash; and to give an opportunity for experimentation, free from the demands of picture-making. The various examples show how pen, brush, inks and washes can produce particular effects, although they are not intended to be followed slavishly. They are possibilities, a stimulation of the artistic juices, to be mixed and matched in any combination – and the more

inventive they are, the better.

Some of the techniques are traditional and go back several centuries. Hatching and cross-hatching show how tones can be built up with pen strokes, and beautiful examples of these are found in the drawings of Leonardo and Michelangelo. Rembrandt and Van Gogh were great exponents of the reed pen, and many of their drawings reflect the vigour of this malleable instrument. Most twentieth-century artists use an eclectic mixture of traditional methods with modern – scribbles, lines, dots, smudges, blots, lifting, scratching, even spit can be used to blur or modify a line. Anyone venturing into this area for the first time has a wonderful field of opportunities ahead, and those who already have some experience will be able to explore further.

PEN MARKS

The samples on these pages are intended primarily to give guidance to readers with little experience of the medium, so consider them as exercises to be tried out; it is one of the few occasions when I advocate direct copying from the page. Such an exercise is equivalent to practising scales on a musical instrument, which develops adroit finger work but won't teach musical interpretation; there is all the difference between learning to articulate

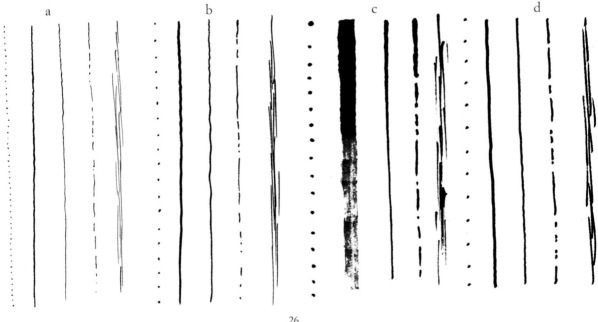

a b c d

specific methods and imitating creative ideas.

The illustration on page 26 shows an assortment of lines and dots made with different pens. Arranged in groups, they show a fine nib (a), a medium nib (b), a bamboo pen (c) and a fibre-tip (d). Each group begins with a line of dots. These are the smallest marks to be made with a pen and can be very precisely controlled. In the bamboo example the dot sometimes has a 'tail', due to the specialized shape of the implement. The succeeding lines show firm hand pressure; light hand pressure; a tentative 'lose and find' line, and broken lines. The last two are good for exploring and 'feeling' round a shape where a more positive line might be inappropriate. All these demonstrate how flexible pen lines can be, besides which, as in handwriting, the individual pressure and hold on the pen will also affect the marks made.

The second sample (right) shows how tones can be produced with pen strokes. Hatching (a) with diagonal lines drawn in quick succession; cross-hatching (b) where a second series of lines is superimposed upon the first; stippling (c) built up with dots; scribbling (d) created by random strokes in all directions.

In the first two groups (a and b), the top rows were made with fine and medium nibs, and the bottom rows with a reed pen (left) and a fibre-tip (right). The darker tones were produced by repeating the procedure, in other words by double hatching and double cross-hatching. The stippled effects (c) were made with fine and medium nibs, and a fibre-tip. The scribbled tones were done with fine and medium nibs, reed pen and, lastly, fibre-tip. Notice how the reed gives a soft grey line as it runs out of ink. This is most apparent in the scribbled sample (d) and is similar to the effect given when drawing with a stick (see *Thorn Bush* on page 119).

Each type of pen has its own characteristic feel and mark. Factors of paper and different kinds of wash, whether watercolour or ink, will also govern what you do.

BRUSH STROKES

While the pen represents the more controlled side of pen and wash, the brush represents freedom and spontaneity. It is this particular combination that I have always found so attractive: the brush can be given its head, while the pen exerts the discipline of structure, like the curb that checks the spirited horse without destroying its natural exuberance. The brush must be one of the most delightful instruments ever devised. Its fluid movements

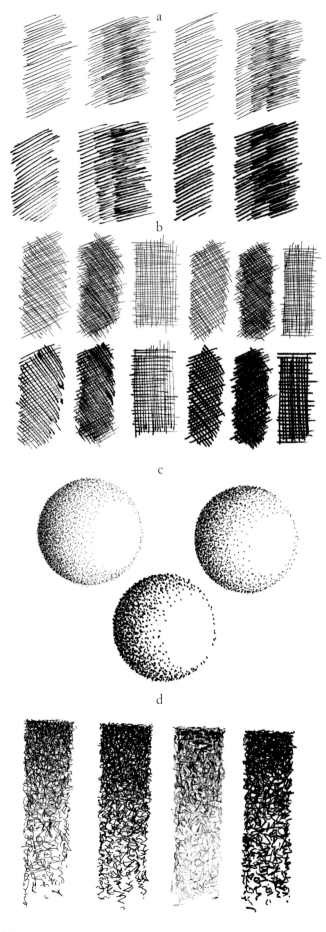

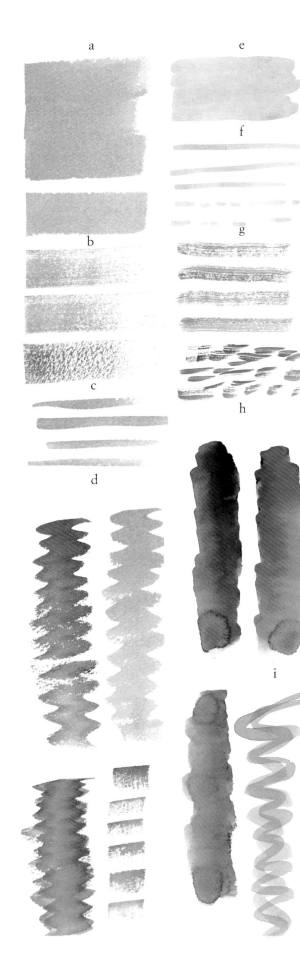

FINE NIBS

Fine nibs are interesting to use, as they give a delicate tracery of lines that can be most effective in a drawing. However, they are not always easy to manage and I would not recommend them for beginners, advising instead a more robust type of nib until you are accustomed to using pen. The main difficulty is a tendency for the nib to get clogged with ink, which is annoying and frustrating when it stops the work flow. There are two ways to overcome this problem.

First, add a little water, preferably distilled, to the ink. This will thin it and make it more acceptable to the nib. The disadvantage of doing this is a slight reduction in colour intensity. Second, when the ink becomes reluctant to flow, dip the tip of the nib in water and this will release the flow again. Because such a tiny amount of water is involved, there is usually a negligible effect on the intensity of ink.

In addition to these two remedies, it is advisable to clean the nib at regular intervals during the course of drawing. This applies to all nibs, not just fine ones, and although it sounds a nuisance, it is no more trouble than washing a brush between changes of colour. Fine nibs will need more care than those that are thicker, as they can easily be damaged. Rinse the nib in clean water, then dry it thoroughly with a rag or tissue. Make sure that no pieces of fluff get trapped in the nib, or you will find that you are drawing with a 'blob' instead of a precision instrument. I always work with a jar of water beside me, expressly for this purpose.

The other difficulty with fine nibs is snagging them on the paper, which may cross or even break off the tip. They require a light touch, a mere skimming across the surface, and don't attempt to push them, as you can with some of the thicker nibs. Once you have learnt how to handle them, they are very rewarding to use.

Brush Marks: Flat brush on Bockingford 300gsm (140lb) paper: (a) joined strokes, single stroke; (b) dry brush; (c) line made with the corner of the brush; (d) strokes produced by wiggling the brush from side to side. Round brush on cartridge paper: (e) joined strokes; (f) single strokes; (g) dry brush; (h) two-coloured effect, produced by pressing the brush down onto the paper and rippling from side to side; (i) wiggled stroke, produced with the tip of the brush.

possess a wide repertoire of strokes, influenced by shape, type and thickness. It is the perfect complement to the spiky pen.

The illustration (opposite) shows a variety of brush marks: those on the left were made with a flat brush on watercolour paper of 300gsm (140lb), and those on the right with a round brush on smooth cartridge paper. They demonstrate the distinctive character of each type of brush. Flat brushes give a broad band of colour and are good for blocking in large areas (a), while round brushes are more suitable for linear work (f). By using the corner of a flat brush it is also possible to achieve fine lines (c).

Diversity of stroke comes not only through the inherent shape of the brush itself but also through the way in which it is manipulated. Brushes can be pulled, pushed, dabbed, bounced, feathered or wiggled. They can be used fully charged with paint or squeezed almost dry; they can be used end-on or sideways and each method will have a distinctive appearance. Compare examples (d) and (i). These were both made by wiggling the brush rapidly from side to side, but the end results are different.

Even more variety can be produced by loading the brush with two colours, one on each side, and rippling the brush down the paper. This will give the two-coloured effect seen in (d) and (h). A two-toned alternative to this is to charge the brush with colour on one side and water on the other.

PEN AND WET WASH

The illustration on the right shows examples of pen, using sepia and black indian ink, in conjunction with wet washes. The inks spread to give interesting effects and textures, and the wetter the wash, the further the ink will run, so managing this method depends on controlling the wash. Another factor governing results is the type of paper that is used; again, the two papers demonstrated are watercolour (300gsm) on the left and cartridge on the right.

In general when using washes, the 'feel' of watercolour paper is preferable to that of cartridge, since it is less inclined to cockle and the wash is

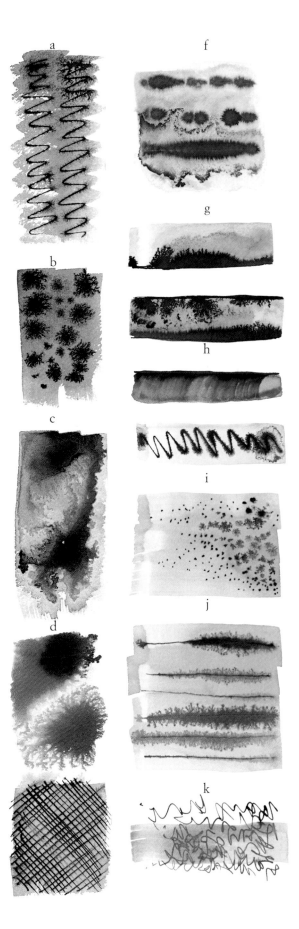

Ink on wet wash: (a) black ink on two-coloured wash; (b) 'spiders' created by touching the wash with the tip of the pen; (c) sepia, black ink and water on blue wash; (d) black ink and sepia on clear water wash; (e) cross-hatched lines on wash; (f) broken and continuous lines on wash; (g) black ink applied with pen; (h) black ink applied with brush; (i) sepia stippling on partially dried wash; (j) sepia lines on two-colour wash; (k) wash brushed over water-soluble sepia lines.

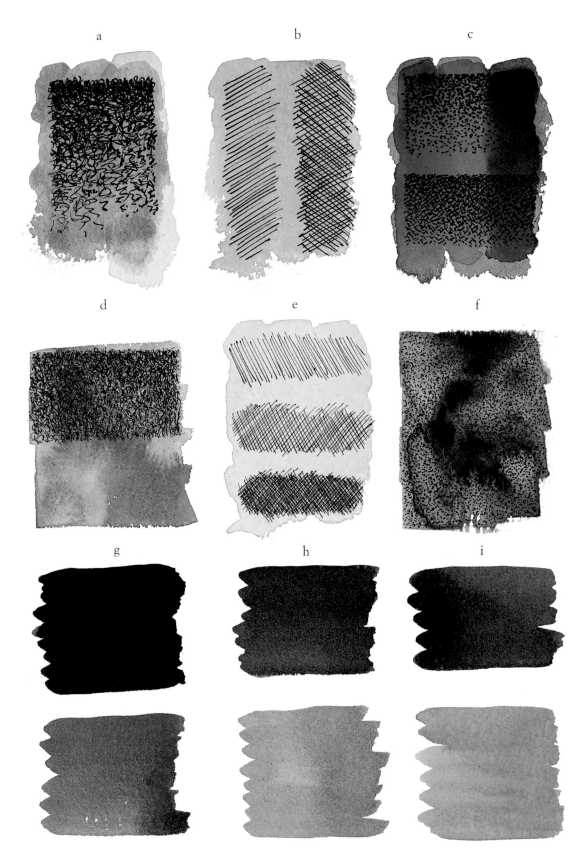

Ink on dry wash: (a) scribble over oxide of chromium (green) and indian yellow; (b) hatching and cross-hatching over olive green; (c) stippling (dots and dashes) over prussian blue and indigo; (d) scribble over olive green and prussian blue, using fine nib; (e) hatching, cross-hatching and double cross-hatching over indian yellow using fine nib; (f) stippling over ultramarine and blue-black, using fine nib. Other inks: (g) iron gall; (h) french sepia; (i) sepia. Below these are examples diluted with distilled water to give lighter tones.

quickly and evenly absorbed into the surface. Cartridge paper can be stretched to overcome the problem of cockling, but its lack of tooth makes it more slippery and the wash tends to sit on top of the surface for longer before it dries.

The samples illustrated on page 29 demonstrate an assortment of lines, dots and drips of ink. In most cases the drawing was done on top of the wet wash, but in (k) the wash was dragged over the water-soluble lines, causing the smudged effect. In (c) drips of black ink, sepia and clear water were dropped onto the blue wash, and in (d) the drops of ink were applied to a clear water wash. The crisp edges shown in (g) were produced by drawing a pen down the side of the wash in the first two examples, and a brush in the third example (h). Other samples show variations of lines and stippling.

PEN WITH DRY WASH

On the left are more examples of pen used with colour washes, but this time the drawing has been applied after the wash has dried, resulting in a sharpness absent from the wet work. Some of the washes have made use of the 'wet-in-wet' technique, in which one wet colour is added to another, producing spontaneous mixing. The pen drawing demonstrates the tonal techniques of hatching, stippling and scribbling, using both medium and fine nibs. Below these are samples of iron gall and sepia inks, in undiluted and diluted forms. Today these are less popular as drawing media than they once were, having been largely replaced by modern black and coloured inks, and they may be difficult to get, except through specialist firms. However, their warm tones make them attractive to work with, and it is worth taking a little extra trouble to seek them out. They can be used in conjunction with black ink, their rich browns enhancing the colder black. Originally sepia was made from cuttlefish ink, but nowadays it is manufactured synthetically. Different makes

Coloured inks: (a) acrylic inks – brown, yellow, blue and green superimposed in different combinations; (b) shellac-based inks – brown, yellow, blue and green superimposed in different combinations (these are more transparent than the acrylics); (c) different effects (clockwise from top left) – blue dropped on wet yellow, clear water dropped on wet blue, blue scribble over yellow scribble, dash stippling using four colours, dot stippling in brown and green, blue lines drawn on wet green; (d) diluted versions of the shellac-based inks shown in (b).

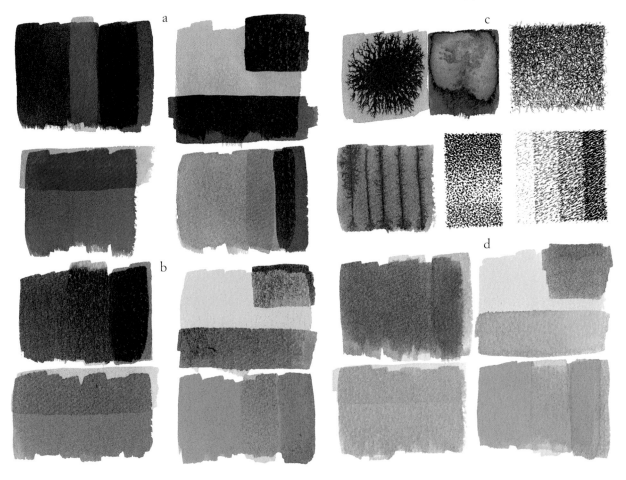

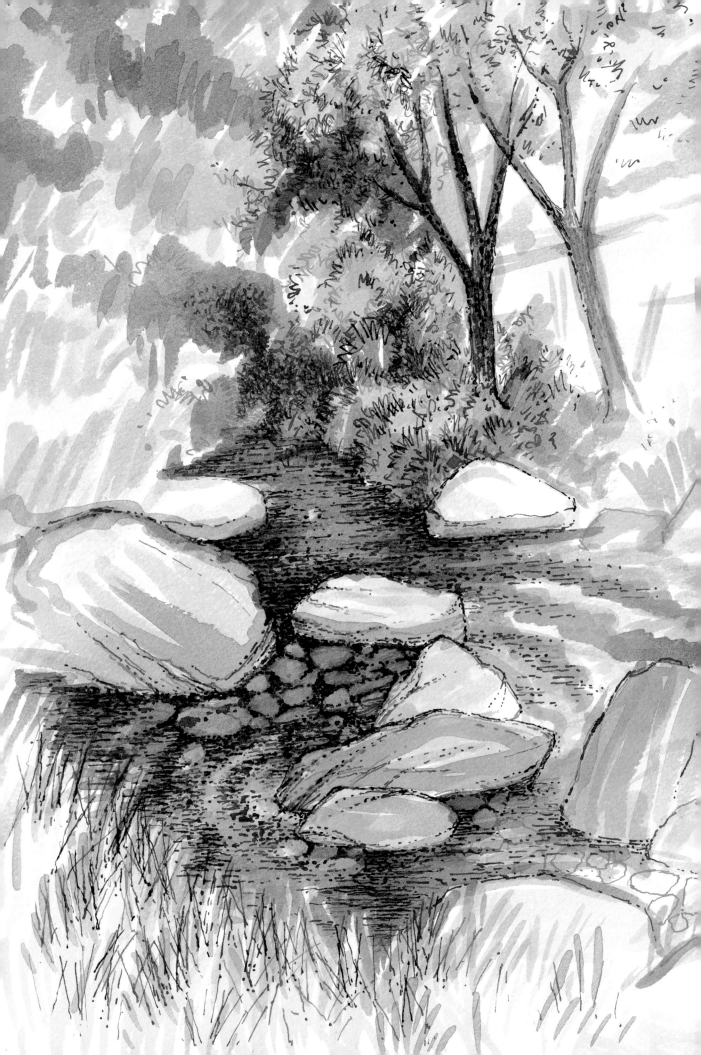

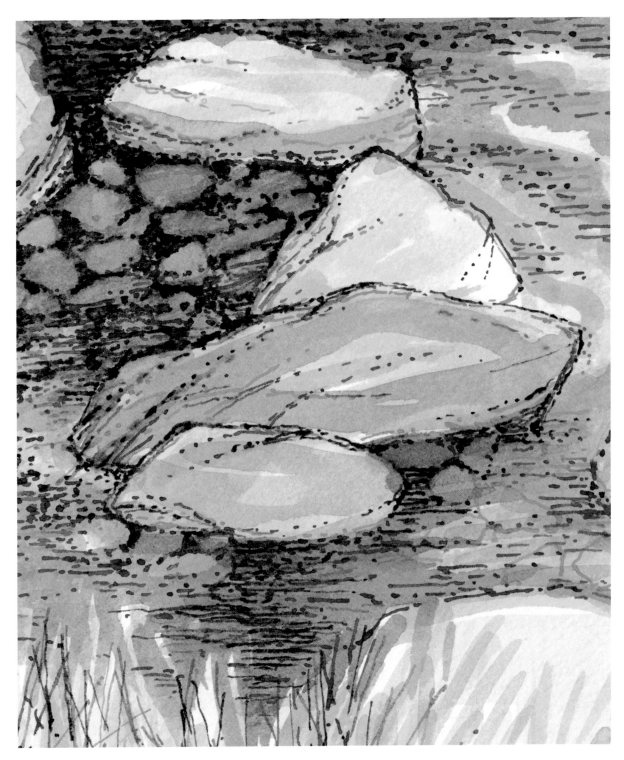

▲ ROCK POOL – CUMBRIA *(DETAIL)*

◄ ROCK POOL – CUMBRIA

A picture in coloured inks, which demonstrates the working process from start to finish. The right-hand side shows how I began by drawing in the image with a round No.12 brush and a pale wash of cobalt blue. I chose this colour because it is unobtrusive and will marry in later with other colours. Next, broader swathes of colour washes were added, and then I introduced pen. This can be seen in the viridian green lines towards the centre. Other colours were brought in: peat brown, sunshine yellow and ultramarine. I continued to build up the colour using pen and brush until I had reached the desired intensity, shown in the group of stones on the left-hand side (see detail above). The washes consisted of diluted inks, but the penwork used ink at full strength. No black has been used in this picture; the dark tones were produced by superimposed layers of colour.

The paper was Bockingford Eggshell 300gsm (140lb).

PLUM TREE – WINTER

This is a study that focuses on the structure of the tree, although I see that the dove that inhabits my garden has managed to slip in surreptitiously.

Pen and black indian ink have been used in a number of techniques: stippling, hatching and an assortment of lines. It is a 'searching' drawing, which means that I look hard and then try to put down what I see as accurately as possible. Before beginning the drawing, I spent some time examining the tree closely, feeling the shapes of the branches and looking at it from different angles. This helped me to understand the form so that I was able to draw from what I knew, and not only from what I could see.

PLUM TREE – SUMMER

The two pictures above right and right show the same tree drawn from the same position at different times of the year. In the version (right) the leaves hide most of the branches, although the overall shape of the massed foliage is dependent on the underlying structure. Compare the drawings and you will see how they fit together.

The brown inks used were two kinds of sepia, bistre and iron gall. I started with a light wash of sepia and brushed in the main shape. On top of this, still using brush, I worked in some iron gall, a very thin, watery ink which produces the purple-brown colour in the drawing. The inks were used freely at this stage.

The leaves were drawn with pen, using bistre and french sepia, warmer in colour than the first sepia. These last inks were used undiluted. I had some trouble with the bistre as its sticky consistency blocked the nib, which required frequent dunking in water to clear it.

This picture is more expressive in spirit than the other one turned out to be.

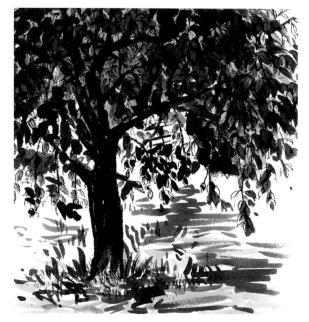

produce variations of the basically brown colour.

Iron gall is a thin ink with a purplish bias, and bistre is a thick, rather glutinous medium made from charred wood; it can be diluted with water to give a better flow for drawing, otherwise it tends to clog the nib.

COLOURED INKS

Coloured inks can be used with brush and pen, either for drawing or as washes. They can be intermixed in a similar way to watercolour or built up in transparent layers (see illustrated examples on page 31). The colours are brilliant, even brash, and lack the subtlety and range of watercolour paints, although diluting them with distilled water does temper them to some extent. *Rock Pool – Cumbria* (pages 32– 3) shows coloured inks used in

a landscape context; compare this with the watercolour drawing of Castelbouc in the following section and note the difference.

In spite of certain reservations I have about coloured inks for landscape, try them if they are new to you, as you could find that the extra brilliance has an appeal and suits your approach. Ultimately, the choice of one medium over another depends upon personal taste, and it is a sensible idea to experiment widely first in order to discover your preferences.

OTHER MATERIALS

The illustration on page 36 shows various effects achieved through the use of additional materials. Wax (a) is a popular resist for graphic work and gives an attractive, broken texture. An ordinary

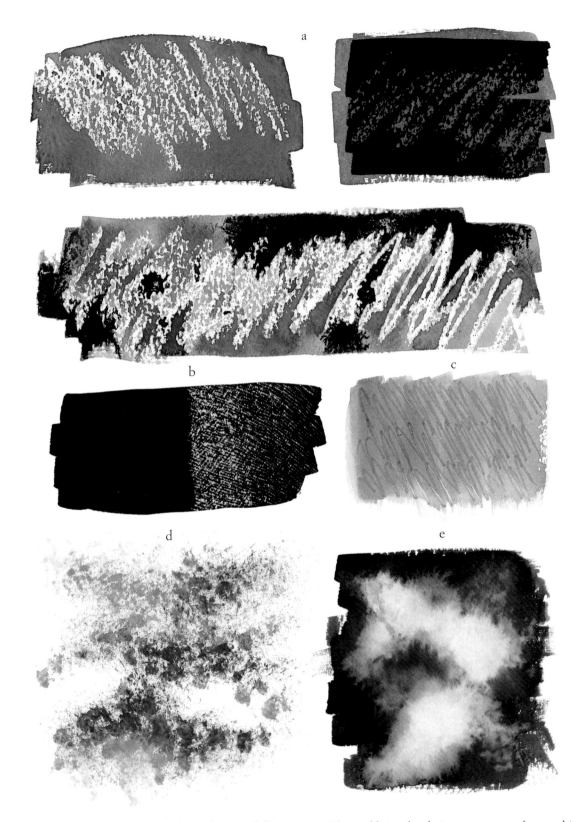

a

b

c

d

e

Additional techniques: (a) wax (clockwise from top left) – blue watercolour brushed over wax, wax over blue with black ink on top, blue and green watercolour with black ink over wax; (b) scratching – black indian ink scratched with a scalpel knife; (c) indenting; (d) mottling produced with a sponge; (e) 'lifting' done with a sponge.

These additional techniques are more often used in experimental and innovatory work, although they can have a liberating effect used in conjunction with traditional methods, provided they are not over done.

white candle can be used to produce a single line, or rubbed on its side to make a broader band. A slight disadvantage is that it is difficult to see until the colour has been added.

Scratching and indenting (b and c) need to be carried out on thick paper to prevent tearing. A scalpel knife is excellent for the scratching method, giving a fine texture closely allied to that of scraperboard, a similar technique executed on a specially prepared surface. Indenting must be carried out while the colour is still wet; it can be done with a paintbrush handle, or comparable implement, pressing it into the paper to produce the darker line.

Anyone familiar with watercolour techniques will probably be acquainted with the sponge already, either for damping large areas of paper or for removing unwanted passages, and it can also be used as a technique in its own right: thus dabbing the paper with colour produces mottling, while 'lifting' leaves a negative image. The last method involves pressing a damp sponge onto the colour, which will then be sucked away from the surface; the best results are obtained before the colour has dried and become absorbed by the paper. Its most obvious use is for skies and foliage, but be careful not to overdo it – it is easy and fun to do, but it soon becomes a cliché!

All these extraneous techniques have considerable 'eye' appeal. However, they are really in the 'tricks' category and should be used with discretion, and not as a regular substitute for more challenging techniques or your work may begin to look slick and superficial.

IN CONCLUSION

I have covered a varied range of techniques and hope you will be encouraged to exploit them more fully in your own work, and to try those not encountered before. They can be developed in infinite ways, the outcome depending upon type of nib, thickness of brush, surface of paper and choice of medium, as well as individual style. The important point to reiterate is that they should be directed towards the fuller expression of your personal and creative ideas, and not used simply for their own sake.

STRETCHING PAPER

It is worth mastering this simple procedure to enjoy the sensation of working on a really flat piece of paper which is unlikely to cockle when a wash is applied. It works on the principle that wet paper expands (stretches), then contracts as it dries.

First, assemble all the required materials: paper; board; four lengths of gumstrip, cut to extend approximately 2.5cm (1in) beyond each side of the paper; a wet sponge. Then proceed as follows:

1 Immerse the paper in water; then, holding it up by one corner, allow any surplus water to drain off.

2 Position the paper on the board. Remove any large wrinkles by gently lifting the paper and repositioning it. Try not to touch the paper surface more than is necessary.

3 Wet one piece of gumstrip with the sponge and attach it to the paper and board, overlapping the paper by 5mm (¼in). Repeat this with the other pieces of gumstrip on the remaining three sides of the paper so that the paper is fixed to the board on all four sides.

4 Keep the board horizontal and leave the paper to dry thoroughly. This usually takes 2–4 hours, depending upon the temperature, but leaving it overnight is preferable, to ensure a drum-tight surface to work on. Occasionally the tension becomes too tight for the gumstrip to hold the paper, causing it to tear or pull away from the board. If this occurs, try making a deeper overlap with the gumstrip. It could also be due to uneven drying – perhaps the board was not flat – or too thin a piece of paper.

There are paper stretching frames available on the market which will do the job for you, but since the traditional method is simple and quickly learnt, I suggest your money would be better spent on more brushes and paints.

MAKING DECISIONS

Painting and drawing are creative processes that involve numerous decisions. Sometimes one knows instinctively what to do, and ideas float into consciousness without any apparent effort; they have been fermenting away in the mind, and all that is required is the trigger of memory or an incident to release them into awareness. It is exhilarating when this happens, and then it is simply a question of getting on with it while the momentum lasts.

At other times it may be necessary to work hard to stimulate the flow. Some people maintain that they can only work when they are inspired, although more often than not I suspect this is an excuse for laziness; most, if not all, major artists will have achieved their reputations through sheer hard work and application. Of course inspiration plays a part, otherwise there would be no compulsion for self-expression in the first place, but it is not the only ingredient.

Professional artists must pursue their occupation constantly – to carry out a commission is not to work only when the mood takes you, but every day as with any employment. The serious amateur, who may be just as committed as the professional, also needs to dedicate as much time as possible to his or her art if it is to expand and develop. The fact that the one is earning a living while the other indulges a pastime seems irrelevant, and frequently it is through the act of working that a head of energy builds up, which in turn sparks off the inspiration, and so generates motivation. This continuous cycle of application and resulting excitement is infinitely more rewarding than waiting for the muse to speak.

SELECTING YOUR LANDSCAPE

The first decision for the landscape painter usually involves the site. I am assuming here that you are working in the field with the countryside spread before you, and not sorting through photographs. This is one of those vexed questions which constantly arises and to which I shall return later. Suffice it to say for the moment that you should try to work from nature whenever you can, even if it is

only to make brief sketching notes for later use.

The choice of aspect can be surprisingly difficult at times. What looks interesting when seen standing up can alter considerably when seen sitting down, and vice versa. Take time to look around and try out the view from the position in which you intend to work, and don't always choose the most obvious angle: an unusual viewpoint can lead to a more original image.

The illustrations on pages 40 and 41 will give an idea of what I mean by alternative viewpoints. The black and white drawings were made on the spot; the first, *Castelbouc*, with a high eye-level, looks down on the roof tops, and the second, *Ispagnac*, with a lower eye-level, looks up at the landscape. The 'eye-level' indicates the height of your eyes in relation to the scene (see sketch diagrams on page 43).

Bracken on Beacon Hill (page 41) shows how

CASTELBOUC

Castelbouc is a fascinating little village in the Gorges du Tarn in France. It is dramatically situated beside the river at the foot of a steep forested cliff, with the nearby castle perched precariously on top of a vertical rock. There is an amusing story about how the village got its name: during the Crusades, all the men had gone off to the wars with the exception of one. This seigneur *so indulged himself in the company of the ladies that he expired from his excesses; as his soul departed from his body an enormous billy goat, or* bouc, *was seen hovering over the castle, and ever since it has been known as Castelbouc.*

The painting was carried out in watercolour and ink. I began with light washes, and worked in deeper colour while they were still wet; this produced the running together of greens and blues seen in the centre and foreground. In other parts of the picture the washes were put on in successive layers, allowing each layer to dry before another was added.

When the watercolour was completely dry I drew on top with pen and black indian ink. Two nibs were used: a Waverley, which is thick and was somewhat unpredictable due to its age and wear; and a shoulder pen F, which was firmer and more controllable. I invariably use a mixture of old and new nibs to provide my drawings with a variety of line and character.

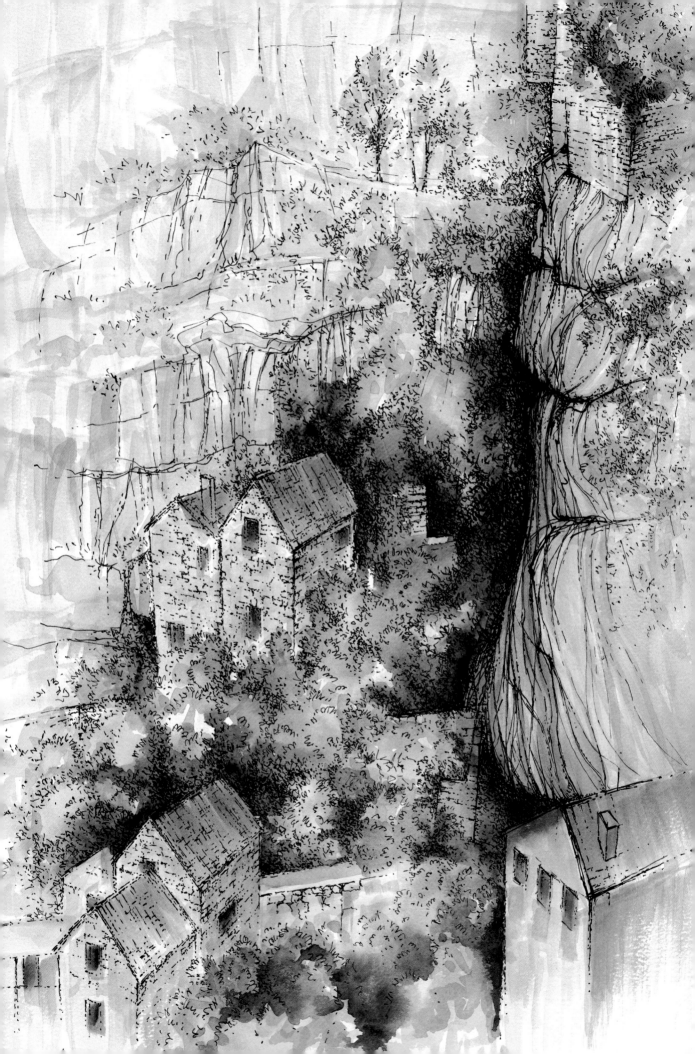

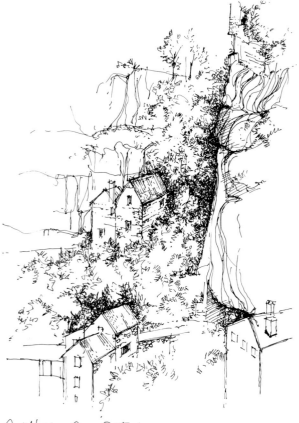

Castelbouc - Gorges du Tarn.

◄ CASTELBOUC (SKETCH)

The sketch on which the painting on page 39 was based. I drew from a position high up on the other side of the River Tarn, which gave this unusual aerial view of the village; the castle was on a level with my eyes and can be seen on the right at the top of the sketch. Views like this are not easy because of the exaggerated height, but they are interesting and give a different perspective on a scene.

The paper was cartridge and I used a sketching pen, which is convenient as well as being reasonably responsive to drawing techniques.

► BRACKEN ON BEACON HILL

A drawing done in watercolour and soluble ink. I began by drawing in the picture with brush and washes of cobalt blue and burnt sienna, keeping the washes very pale at this stage so that they could be adjusted. Washes of Payne's grey and raw umber add more weight to the rock, while a deeper tone of burnt sienna brings out the bracken in the foreground. The warmth of this last colour also brings it forwards.

As soon as the watercolour was dry, I drew over it with pen and soluble ink. When the ink was dry I dragged a damp brush across some of the lines, which caused them to smudge and spread slightly. It also had a softening effect on the painting.

I have made use of the white paper and left it to show through in many places. It adds a sparkle and keeps the drawing fresh.

► ISPAGNAC

This small village is on the edge of the Gorges du Tarn, where the landscape is more pastoral than that of Castelbouc. The Gorges can be seen in the distance forming a spectacular backcloth. The buildings clustered around the twelfth-century church slope gently down to the river, through gardens and cherry orchards full of brightly coloured flowers and fruit. It is a surprising pocket of fertility among the barren rocks.

It was a warm, early summer evening and while I was drawing, a handful of dark, sweet cherries was suddenly thrust into my lap: I hadn't realized they were picking fruit from the tree under which I sat, so engrossed was I with my sketching! It was one of those delightfully unexpected incidents that happen sometimes when you are working in the countryside. I finished my sketch, enjoying both the tranquillity of the scene and the delicious cherries.

The viewpoint here is the reverse of that at Castelbouc. Sitting below the village, I looked up at the scene which forms a sequence of tiers: the foreground with the trees and horse, then the houses and church, and finally the background cliffs.

The drawing materials are similar to those used in the previous sketch.

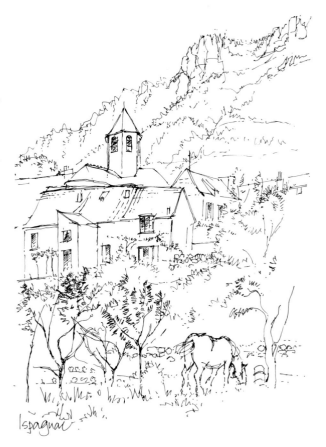

Ispagnac

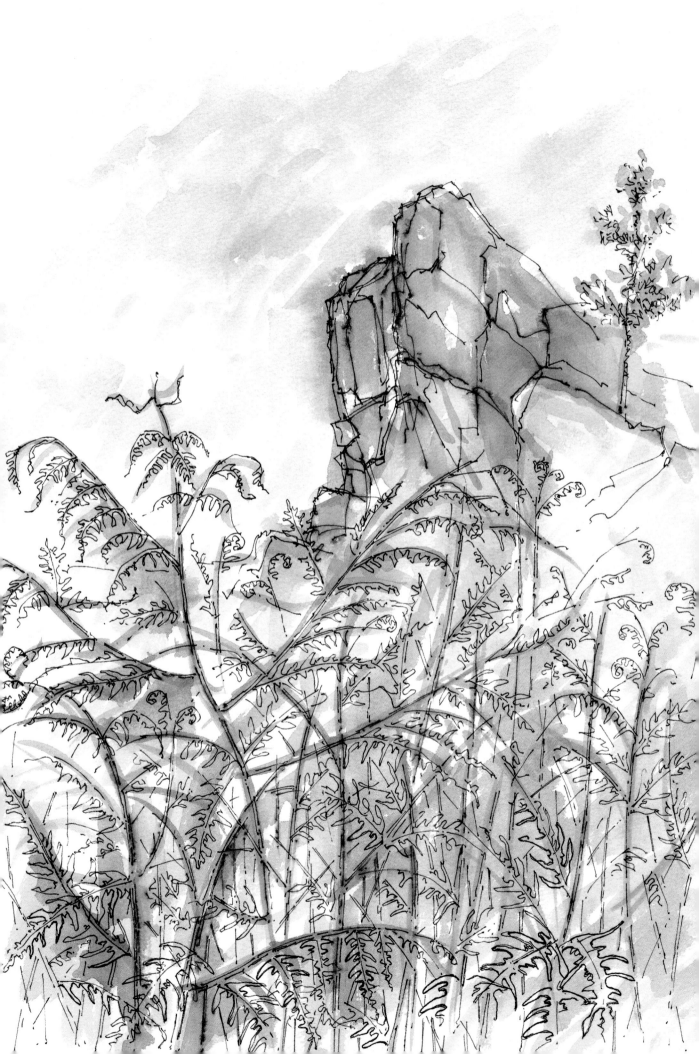

scale can be switched. Here I was sitting on the ground, very close to the foreground bracken which sloped uphill away from me so that my eye-level was below the height of the plants. This exaggerated the size of the fronds in relation to the rocks. A similar effect can be demonstrated in the following way: shut one eye and hold your finger close to the other eye; look beyond it, and everything else will appear much smaller. Try this looking through a window or across a room. It is an optical illusion often used in pictures and you might like to try it yourself.

CHOOSING YOUR SCENE

Other decisions to be resolved early on are those of area, and how much to include. Unlike the portrait or still-life painter for whom everything is relatively close, the landscapist may be dealing with several kilometres of distance in a continuous landscape. There are no convenient walls or table edges to contain the subject, only a piece of paper that begins to look insufficient to accommodate the panorama before him.

One simple method to help you 'see' a picture, is to form a frame with your hands and use this as a viewfinder. By isolating sections of the landscape it will be easier to visualize the scene on the sketch pad. Another less rough-and-ready method is to make a small template out of card; moving this improvised viewfinder around enables you to compose the picture before making any marks at all on the paper.

During these initial stages you may find that the parts of the landscape which appeal don't always coalesce into a satisfactory whole. That interesting foreground, or those fascinating trees, simply won't integrate with the old barn that was intended to be the focal point, no matter how much you change position. Resolving this dilemma will depend on whether you feel you must put down exactly what is seen, or whether it is acceptable to 'move' things around. It also depends on the motivation behind the picture. Do you want a topographical record, or are you more concerned with capturing the spirit of the place?

Faced with this choice I usually compromise and make a number of 'thumbnail' sketches from different angles; these are small drawings that only take a few moments, and I draw what I see (there are examples of these at the end of the chapter). The purpose is to get a broad sense of place and structure – they are the visual equivalent of written notes (which I also use).

At this stage I am not concerned with

composition or what an eventual picture may look like, but with the gathering of information. Armed with these drawings, I may then opt to make a larger and more detailed sketch of a particular aspect. Just how finished this will be, or whether I decide to engineer the scene by rearranging things, will depend upon various factors: time, weather, mood and inclination.

Alternatively, I could let the working notes ferment in my mind for several weeks and return to them later as the basis for a studio painting. This allows for a period of distillation, often used by artists as a sifting process. It crystallizes the response to a subject and releases it from a purely literal approach. There is nothing wrong in painting what you see, but sometimes it can be restrictive if you aspire to something more imaginative. I shall be enlarging further upon this point in chapter 6, Topographic or Imaginative?

COMPOSING YOUR PICTURE

I am wary of writing too much about composition as it is easy to become dictatorial. The problem with a book is that the author has no means of eliciting a direct response from the reader, when matters could be discussed and ideas thrown around in a dual exchange. Instead I must try to be helpful without becoming dogmatic.

Most of us experienced in drawing and painting will have learnt early on about leading the eye into the picture and not letting objects fall off at the edges. We are taught to group things together so that they overlap and give the picture depth. If we portray people we must ensure that we don't chop off their feet or the tops of their heads.

These principles are sound enough, but what happens when we look at the work of a painter like Degas, who turns so many of the edicts of good compositional practice upside down? He flouts the conventions by deliberately cutting off heads and by placing large empty areas centrally, with the 'action' occurring round the edge – and yet he produces superlative pictures. In truth, here we have a brilliant artist with an unorthodox approach, who knew exactly what he wanted and how to achieve it. Some contemporary painters also defy the conventions, their pictures presenting an apparently scattered collection of unconnected objects, with scant regard for formal composition.

These are some of the reasons that make me disinclined to 'lay down the law' too precisely. There are so many contradictions. However, in spite of these reservations, there are one or two points I would like to make, mainly to help those of

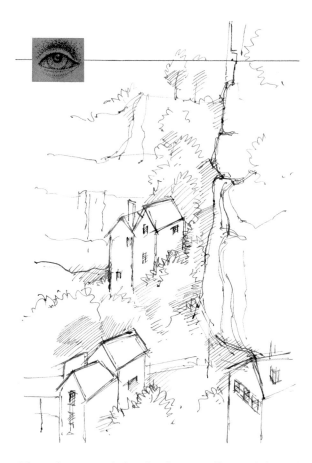

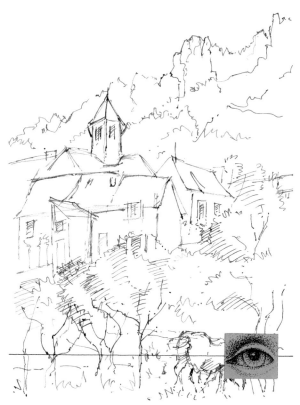

These diagrams of the sketches Castelbouc *(left) and* Ispagnac *(right) show where my eye-level was in relation to the scene I was drawing. Establishing your eye-level with regard to the view will help you get the right perspective for your picture, so that it will not look like a bird's eye view should you want a worm's eye view, and then vice versa.*

It is the lines of depth that are governed by perspective; if you study the diagrams you will notice differences in the direction of these lines. Thus in the Castelbouc *diagram the lines run* down *towards the bottom corners of the paper, because they are* below *the*

eye-level; this is apparent in the rooftops. In the diagram for Ispagnac *the lines of depth run* up *towards the top corners of the paper, because they are* above *the eye-level; this is seen in the church, the house to the right of the church, and the small extension jutting out from the main group of houses. Compare the two drawings carefully and you should be able to see these differences.*

This is perspective in very simple terms, but it should help you to get the correct angles for buildings; just remember that lines of depth above the eye-level go up *and lines below the eye level go* down. *The further they are from the eye-level, the steeper they will appear.*

you with less experience to find your compositional feet. The first concerns focal emphasis. Most conventional pictures need some sort of focal point to direct the eye into the picture and help pull everything together. To illustrate this, on page 45 there are compositional diagrams on which the sketches adjacent to them (page 44) are based; in each case the straight lines show how the eye is led unerringly towards the focal points of house and steeple.

The second involves proportion, balance and the use of space. Verticals can be used to offset horizontals, and diagonals will counter both of these. Large shapes set against small, and textured areas against plain, will provide contrast and

interest. Grouping objects together so that some overlap, gives a sense of depth and the illusion of extending the pictorial area beyond the flat surface of the paper. This is especially relevant in dealing with the wide vistas of landscape.

Composition in its broadest context involves not only shape but also the interplay of colour and tone. Abstract painting sometimes has little clearly defined shape with regard to composition, and relies upon the impact of colour, tone and texture.

My advice is to study both traditional and contemporary approaches. Look carefully at the way in which other artists compose their pictures, then decide whether you think it is successful or not, and why. Discovering how to use these basic

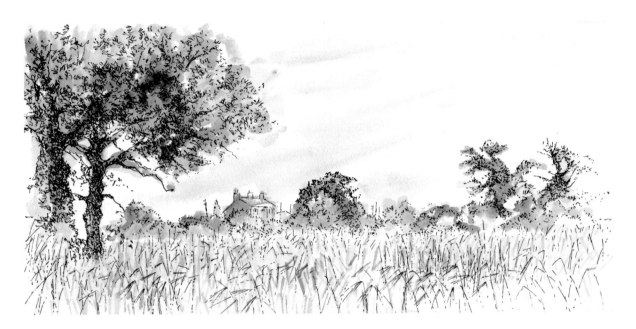

▲ ACROSS THE CORNFIELD

A sketch made in situ *on a very hot day, which accounts for the bleached appearance. Extreme heat seems to leach colour from the landscape.*

The horizontal format of the paper emphasizes the spread of the landscape. This is countered by the strong verticals of the trees on the left, which find an echo in the far trees. Colours also play against each other: the warm ochre of the corn and the cooler blue-green of the foliage. The house was actually a startling red brick but I chose to modulate it here so as to keep it in harmony with the rest of the picture.

▼ VILLAGE CHURCH

A typical summer country scene with fields, foliage, and a church spire in the distance. It is more conventional than the sketch above, but was nonetheless an enjoyable piece to paint for that.

I flooded on the colours freely, letting them mix as they would, before sharpening up the textures with pen. I kept the painting 'open' to preserve the freshness; the white spaces help to liven up the colour and give the effect of sunlight catching the leaves. It is interesting to notice how pale the sky can become on a really hot day in a temperate climate.

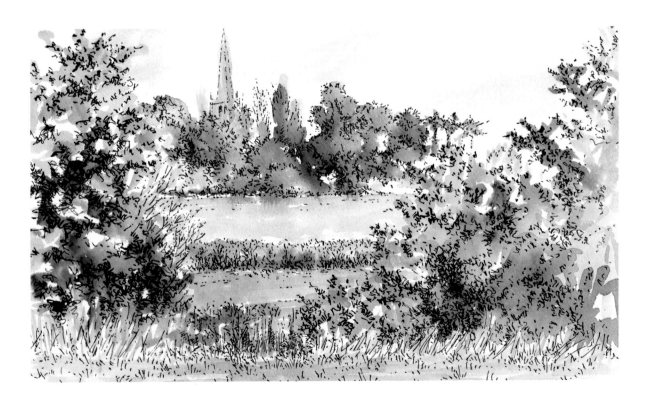

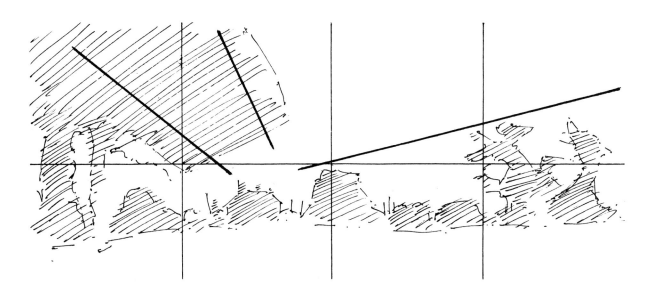

▲ COMPOSITION DIAGRAM 1

The diagrams above and below have been divided into a grid to demonstrate the compositional structures of the adjacent pictures. This diagram shows how most of the picture occupies the lower half of the paper, with only the tallest trees crossing the central line into the upper half. The wide format naturally forces the eye outwards, so it is necessary to counteract this and to lead the eye back into the picture. The required focal point is therefore provided by the house, and the diagonal lines, by indicating the directional thrust of the trees, show how the focus is contained within the composition.

▼ COMPOSITION DIAGRAM 2

With less difference between width and height in the overall proportion, the grid spaces are elongated. In this composition the church and its surroundings occupy the upper half of the picture; the foreground foliage forms a cup-shaped frame, indicated by the V-lines, into which the church and distant trees fit – a picture within a picture. The spire forms the focal point, and the lines show the movement towards this, although with a less pronounced thrust than in the former picture.

This is a popular compositional format, with the 'action' of the picture comfortably contained within the central area; however, it can become rather unadventurous if it is used too frequently.

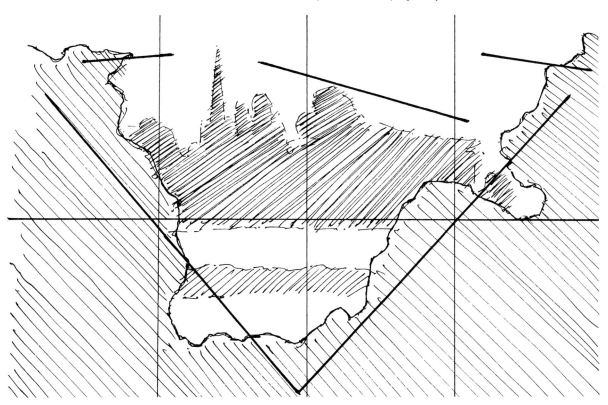

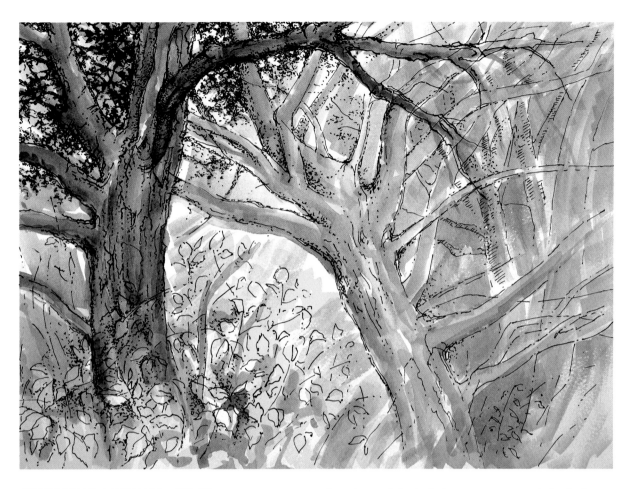

TREES NEAR A STREAM – STAGE 1

These two examples show a painting that was started on the spot and later finished in the studio. It is interesting to compare the final stage with the colour sketches on the previous page which were painted entirely in situ. *I don't usually work like this, unless there has been an interruption, preferring to draw either outside or inside and not mix the two, but on this occasion I did. It is refreshing to vary the method of approach.*

The trees grow along the banks of a local stream, although the plants growing at their feet are so tall with summer growth that they have obscured the water. I was particularly intrigued by the interlacing of branches and the dark abstract patterns made by the leaves against the light sky behind.

The colours used for the watercolour washes were cobalt blue, oxide of chromium (green), olive green, prussian blue, raw umber, yellow ochre and winsor yellow, and the ink was black indian. I established the main shapes of the trees with a round No.12 brush, blocking in the colours broadly. This is noticeable in the foreground plants, where the colours extend beyond the pen-drawn shapes. I like to give colour plenty of breathing space. The ink lines are drawn in loosely with a concentration of intensity on the silhouetted leaves of the foreground tree.

principles of composition will help you initially to make the most of your picture space; later it will give the confidence to be adventurous, and provide a springboard for inventiveness.

WHAT SORT OF PROJECT?

Once you have settled on the subject, you must then decide what kind of drawing to make – is it to be a 'quickie' or a longer project? In colour, or black and white? Sometimes a decision arises out of necessity – a large black cloud looming on the horizon usually means there won't be much time before it rains, so you will have to get on with it!

Choices will also be affected by personal temperament. Some people feel a compulsion to work swiftly: theirs is an immediate response, to be set down in the heat of the moment; for these people, to work a picture further would be to lose the original freshness. Others have a longer-term approach: they become deeply involved and like to whittle away at a picture until they have said all they can before it begins to look laboured, which then raises the question of knowing when to stop – and another decision. It can, however, also be refreshing to work against your natural grain occasionally. Try a few quick drawings if you

normally work slowly, or some careful studies if you usually dash things off.

In this book I have tried to show a range of styles, from rapid notes to finished paintings, some of which took several days to complete. I tend to be a 'whittler' when working in the studio, so I find it beneficial and exhilarating to work more spontaneously out of doors and to finish a picture in one session.

I have found from experience that where it is possible to sustain a studio painting over several days, it is much harder to do the same thing working *in situ*, where the result often looks overworked. This is probably because light and atmosphere are constant indoors, making it easier to pick up the threads again, whereas outside conditions change continually and it is difficult to recapture the ambience of the previous day. This

can be a problem if work is interrupted before you have finished. A compromise is to go home and complete the sketch straightaway, while the memory of the image is still fresh in the mind; this avoids the hiatus of a longer, and possibly more disruptive break.

Sometimes one chooses to work in this way deliberately. The two stages of *Trees near a Stream* are a case in point: the first drawing (Stage 1, at left) shows the trees sketched from life; the second drawing (Stage 2, below) shows how this was developed into the final picture at home.

I have discussed several approaches to working in and from the landscape; others you will discover for yourself. All of them will require continuous decisions and adjustments to be made as you make the most of your opportunities.

STAGE 2
The tones around the foreground plants have been darkened considerably with additional colour and vigorous penwork. This suggests the deep shadows of dense foliage and brings more weight down into the foreground to balance the leaves above. All the trees have been further worked with pen to reinforce the various textures. I have used a broken technique, a cross between

stipple and scribble, to give a dancing effect, a flickering dialogue between branch and leaf. The hatched strokes on the furthest trees distinguish them from the nebulous spaces beyond.

The danger of treating a picture in this way is that it can lose the freshness of its outdoor stage and become tight through overworking. I remedied this by keeping the initial phase understated, allowing for the development.

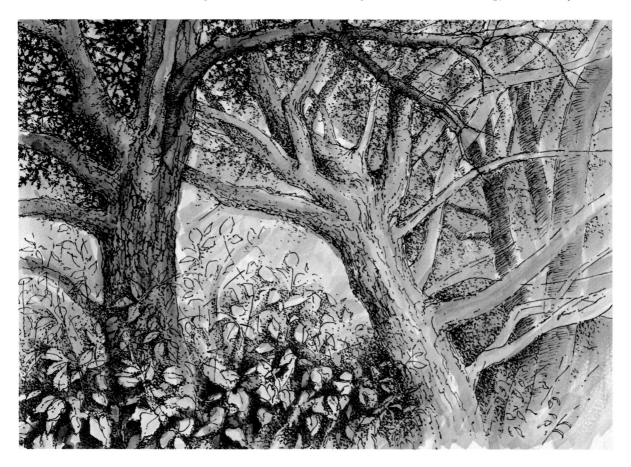

Hound Tor
with rainspots!

◀ HOUND TOR – DARTMOOR (SKETCH)

I constantly refer to the value of making 'thumbnail' sketches, and this little sketch illustrates what I mean. It comes from an A6 sketchbook which fits into my pocket, and which I carry about whenever I explore the landscape, even if I have no particular intention to draw. You can never tell when something interesting may turn up.

When I visit new territory with fresh landscapes to excite me, I try to make as many of these drawings as possible, to stoke up ideas for future reference. I draw anything and everything, whatever the weather – from the shelter of the car if needs be. This is not as indiscriminate as it sounds, for the more you draw, the sooner you will get your 'eye' in, and the easier it becomes to absorb atmosphere and capture the flavour of a place.

Hound Tor was just one of a series of sketches I made on Dartmoor. It was an exceedingly wet weekend, so it was a question of tolerating the rain or having nothing to take back home. Surprisingly, I did manage to get quite a lot of work done, though you can see in the drawing where the rain joined in too! For sketches such as these I use either a ballpoint or sketching pen; these give a smooth flow of ink and can be used swiftly. I start by making a line drawing, and then shade in the main tones with hatching or cross-hatching.

▶ HIGH CADEMAN

Another 'thumbnail' in similar vein to the one above. Incongruities in the landscape make interesting subjects, and the intermingling of tree-shapes with hard angular rocks has always fascinated me. In the woods near where I live there are many outcrops of rock, huge slabs of granite with jagged edges, rising out of the ground like monster teeth. Pushing through cracks, trees have grown, winding their roots and limbs around the stones. I love the contrast of shape and texture, and return time and again to draw them; this is but one of many examples.

I have used the same method as in the previous sketch. There is a flow in drawing like this that is stimulating – there is no time to worry about getting it wrong, you must be bold and confident. It is a good way to encourage fluency, quite apart from its usefulness in collecting information.

HIGH CADEMAN.

USING PHOTOGRAPHY

Earlier I referred to photography, which continues to be a controversial subject among artists. Most of us, nowadays, would probably agree that it can serve a limited use as back-up material, but it should not be regarded as a substitute for going out and finding real subjects. A picture copied from a photograph nearly always betrays its source, particularly if it has been chosen at random from a book. There is no sense of experienced atmosphere or place, but instead a woodenness that looks lifeless, so I hope the sketchbook will always come first and the camera second.

WORKING IN THE FIELD

An important part of decision-making will include choosing appropriate materials. If you plan to stay put in one place then it is feasible to take more elaborate equipment. Some artists provide themselves with what amounts to a portable outdoor studio, with everything from a collapsible easel to a painting umbrella. The painter Stanley Spencer used to trundle his painting gear around in an old pram, a practical, if slightly eccentric solution to the transport problem.

On the other hand, if you are going to wander about making quick studies, then you will want only the minimum of effects. I usually prefer to travel light, using a small knapsack for paints, brushes, pens and inks, and a plastic bag for sketchbook and stool. If I decide not to bother with a stool, I can always sit on the plastic bag.

Delightful as painting out of doors can be, there are a few difficulties that crop up at times. Dealing with the elements is the most obvious: wind, rain and sun can all cause problems. There is not much to be done about persistent rain, other than run for cover, but showers can generally be coped with and even incorporated into interesting effects. Wind is a nuisance, particularly when it flips up loose pages. One solution is to use a sketchblock with glued edges, although these are sometimes difficult to get and are expensive compared to sketchbooks. A loop of elastic or strong clips will control a sketchbook and keep the pages in place. Sketching easels can very readily blow over, too – one reason why I always prefer to work on my knee.

Apart from the dangers of sunstroke, the glare caused by strong sunlight bouncing off white paper can be trying for the eyes. Several remedies will deal with this: a wide-brimmed hat, toned paper or sunglasses. This last may seem a strange suggestion for painting, but provided you are familiar with your palette colours, it shouldn't be a problem.

Other possible disturbances include insects, inquisitive animals and people. Of these the most annoying are flies, which will settle not only on you, but also on the paper. Blowing is an effective way to avoid an unwanted texture of little black marks but you have to be persistent. Insect repellent may also help. People and animals generally drift away after they have had a look, either at you or what you are doing. If the presence of an audience unnerves you, then choose your site carefully, away from the popular spots. Setting up an easel is also more likely to attract attention than working unobtrusively on your knee.

IN CONCLUSION

These are relatively minor diversions, so don't be put off by them; the pleasure of painting in the open far outweighs any such disadvantages. For those who haven't tried it before, I strongly recommend it, and hope the suggestions for overcoming the few problems will make your initial sorties enjoyable ones and encourage you to spend a lot of time painting and drawing outside.

THE EXPANSIVE LANDSCAPE

THERE is nothing more exhilarating to the landscape artist than setting off for a day's painting in the countryside. It isn't just the anticipation of producing a picture that generates the excitement, it is also the sense of partnership with the environment. Working in the landscape is an experience, an involvement with the scene around you. Your picture may show only a fraction of what is there, but you will be conscious of the whole expanse, stretching away on all sides. This awareness infuses the picture, so that features actually portrayed imply the presence of others, beyond the limits of the paper.

I think this is one reason why, looking through sketchbooks a long time afterwards, it is possible to recollect much more than the surface image presents. The lines seem to release a certain undercurrent, so that we remember exactly how it was to be there, at that time, at that place. The act of drawing embodies the whole experience, like a visual diary.

But it is not only to do with sight: landscape is also felt. We can feel the structure of land under our feet, the rise and fall of contour, the hardness and softness of stone and earth. We feel it with our hands, touching different surfaces, and these tactile sensations help in the understanding of what we paint: if you *know* the roughness of tree bark, it is

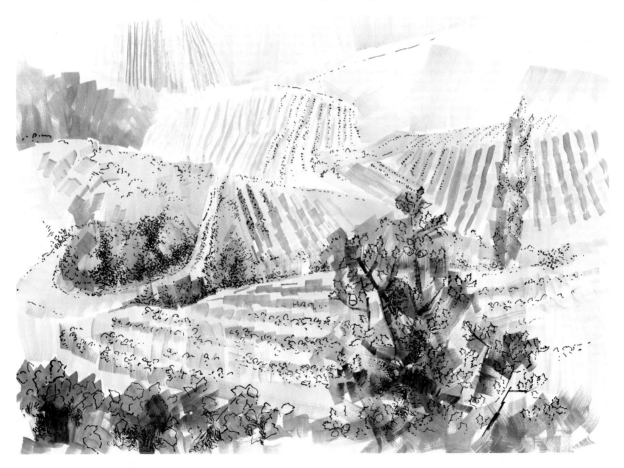

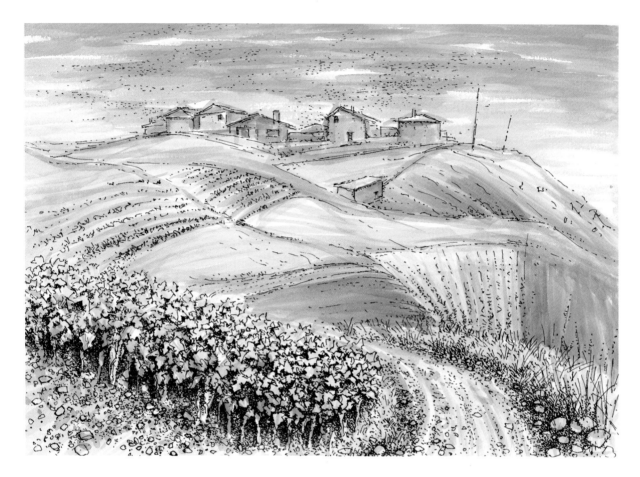

more credibly translated into pictorial terms than if you don't. I know this applies to other subjects too, but I think it is especially relevant to landscape, which embraces so many contrasted sights, textures, sounds and even smells.

These last two may not be part of painting in a tangible sense, but they can have an influence. I remember drawing in the vastness of the Spanish landscape once: I was sitting overlooking a valley when, from a monastery far below, came the sound

VINEYARDS IN VAUCLUSE

The vineyards of Provence pattern the slopes of that sun-drenched region of France, and continue to act as a lure for painters. I made this sketch looking across the landscape from a country road that switchbacked its way among the rolling hills. On either side vineyards stretched away into the distance, the fields of vines interspersed with trees and hedges, their rounded forms in striking contrast with the straight rows.

I restricted my colours to ochres, greens and yellow, to give the impression of sunlight, dried earth and cool foliage. I painted with a flat 2cm (³⁄₄in) brush, using it straight on for the broad strokes, and edge on for the lines. It demonstrates the versatility of this type of brush. The ink drawing adds detail and texture to the watercolour; it was kept understated to retain a feeling of openness.

NEAR ARANDA DE DUERO – SPAIN

Spain's appeal for artists is individual and strongly magnetic for those who come under her spell. Although neighbours, France and Spain offer very different prospects to the landscape painter: where France is lush and pastoral with the occasional barren pocket, Spain is the reverse: raw and big-boned, she is a tawny country. Black, silver and gold are her colours, spiced with touches of green, blue and red; colours much in evidence in the paintings of those great masters, Velazquez and Goya.

I wanted to bring out the essential arid quality of this scene in Old Castile, so I used earth colours: raw umber, yellow ochre, burnt sienna, and a little cadmium yellow for the hills and houses. This predominant warmth was contrasted by the cooler colours presented by the sky and vegetation for which I used cobalt blue, winsor blue, oxide of chromium (green) and winsor yellow. The latter is a sharp acid yellow hinting at green, and a foil to the egg-yolk cadmium.

After brushing in the washes with round and flat brushes, I drew on top with a shoulder pen F and black indian ink. I worked the foreground with considerable detail, forcing up the tones to bring it forwards, but I was careful to keep the rest of the picture sketchy and open in order to suggest space.

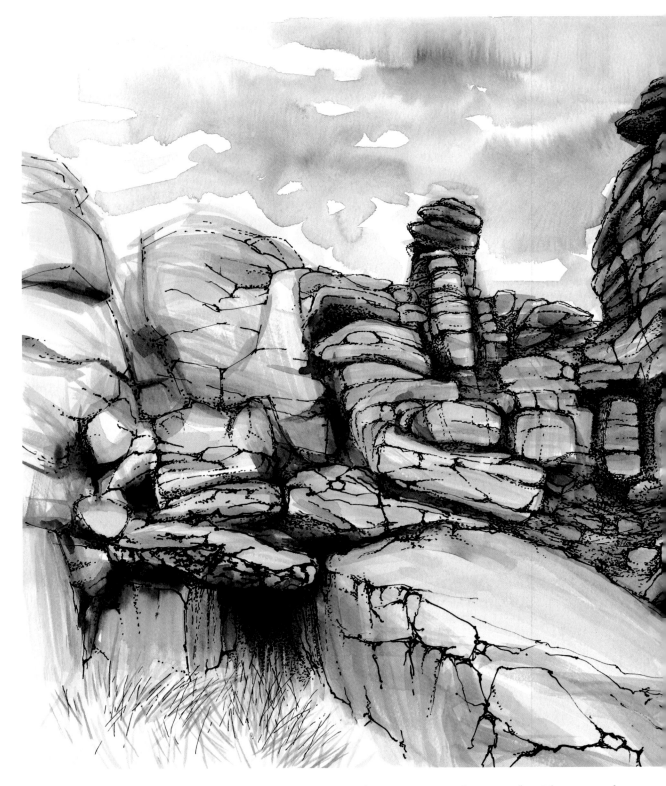

HOUND TOR – DARTMOOR

These rocks rise up on one of Dartmoor's summits like a mythological beast. Heavy boulders, they pile one on top of another, a reminder of primeval origins – they are the 'bone' protruding through the surface of the landscape.

This studio painting was the result of several sketches made at the site, one of which is shown in the previous chapter. The sculptural quality appealed to me and I *wanted to communicate the sense of weight, mass and extreme age that the huge stones presented. There is a watchful, brooding atmosphere here which I have stressed through choice of colour: greys, steely blues and umbers.*

I began the picture by drawing in the composition with brush and pale washes of colour, increasing the intensity, and sharpening up the shapes with pen and black indian ink, until I had achieved the desired effect.

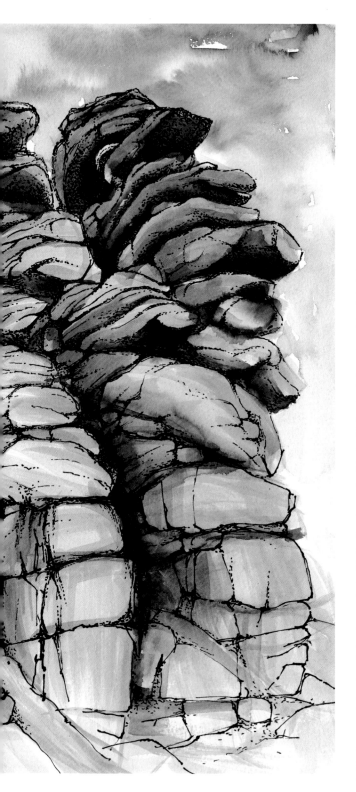

of singing. Very faint at first, it swelled to a crescendo, filling the valley, and then gradually died away. It was a moment of elation that deepened my response to the scene and carried through into the picture, one of those unexpected occurrences that enlarges the scope of painting, and which will be recognized by those of you who may recall similar incidents and experiences.

THE PRACTICAL ASPECTS OF LANDSCAPE PAINTING

So far I have concentrated on the inspirational side of landscape painting; now I want to look at some of its practical aspects. In the previous chapter I gave advice about choosing position and how to see the landscape in relation to your paper. Once you have decided what you want to do, it is most important to give your 'eye' time to settle in – don't be in too much of a hurry, but allow yourself to engage with the subject and absorb the surroundings, enjoying them as you do so. After a little while, senses tune up, perceptions sharpen and you will see particularities instead of generalities. Where at first you merely saw a hill, now you will see the subtleties of contour and colour – a hill has become *the* hill, with a specific identity. These observations help to add interest and individuality to a picture.

Shape, colour and tone will all need careful consideration to make the picture work as a unity. And since you are tackling a panoramic view, scale and distance will come into it as well. Tone is a vital factor here, involving the darkness or lightness of a colour, which in turn will affect how things appear to come forwards or to recede. The demonstration 'La Roque Alric' (page 58) shows how the stronger tones of the trees and houses bring them forwards, while the lighter tones of the mountains push them back. Had I given the mountains the same tone as the foreground, there would have been no sense of distance between the two; everything would have been on the same plane.

All colours have a tonal scale from light to dark. In watercolour this can be governed by the ratio of water to colour, so that the more diluted the colour, the lighter it will appear. A common fault among inexperienced artists is to make light tones too strong, with the result that when you come to put in the darkest tones, they will look very heavy indeed. Working from light to dark is usually more satisfactory than the reverse, but make sure the light tones really *are* light; it is much easier to darken them later, if it is necessary, than to lighten dark tones. This can be a problem, involving

SKY STUDIES

The first study (below) shows a typical summer's sky with small puff-ball clouds; notice how they diminish in size towards the lower edge to give a sense of space. First, a pale wash of cobalt blue was brushed over the paper. Then before it had dried, I took a damp sponge and pressed it down onto the paper. The sponge 'lifted' the colour away to form the clouds.

For the second study I used soluble liquid indian ink. I scribbled lines loosely across the paper, varying the density and thickness, then I brushed water over the ink to make it spread. I added a few more pen strokes when

the paper had dried. The diagonal direction and the energetic penwork of the resulting study suggest the movement of a windy sky.

The last study was a lot of fun to do. I saw a sky similar to this late one evening when darkness was beginning to come but there were still bright pockets of light left. I began with a wash of cobalt blue, covering the whole area. Next, while the wash was still wet, I dropped on raw umber and into this I flooded indigo and prussian blue. I left it to spread and produce the effect seen here. Finally, when everything was completely dry, I added a little stippling in black indian ink.

lifting, scraping and inflicting other tortures on the paper's surface, and probably ruining it in the process. Referring to the demonstration at the end of the chapter again, notice how lightly I have brushed in the sky and mountains in Stage 1; the tonal scale has therefore been established right from the beginning.

PAINTING SKIES

A feature that plays a prominent role in the expansive landscape is the sky. Although not part of the landscape itself, it has tremendous influence on colour and lighting. Skies are lovely to paint. They provide an excuse for unleashing all your expertise and to be as uninhibited as you like. Colours can be flooded on in a maelstrom of effects, or applied with delicate restraint. The brush can be used in numerous ways – dabbing, swirling, feathering or broad sweeps – to simulate the formations of cloud. Weather, season, time of day: all these affect the appearance of that infinite space above us.

One of the delights of depicting clouds is their endless variety of shape. Watch the sky whenever you can, and if you are unable to make colour notes of its changes, learn to make mental notes instead. This can be done even as you go about your daily business – teach yourself to be observant and to memorize what is seen.

A good method for learning how to paint skies – and fun as well – is to have a dozen or so pieces of paper, about A4 size, and paint what you see, changing the paper as the sky changes. If there happens to be a lot of movement, you will be astonished at the variants you manage to collect. My examples of sky studies show the use of different techniques.

Skies can also be drawn, and there is no need always to use a brush; the clouds shown in the monochrome drawing *Spanish Skyline* (page 56)

▼ SIGY LE CHÂTEL

A landscape where the sky plays a prominent role. Here the clouds were gathering on the horizon, and there is the hint of a storm in their grey undersides; this is also implied in the lighter colour of the distant hills against the darker sky.

First I drew in the main shapes of the château with a brush, to establish how much area there was to be for the sky. This was put in with sweeps of cobalt blue wash, and the white clouds were lifted out with a sponge. Then I dribbled a pale wash of Payne's grey on top to make the dark undersides of the clouds. The rest of the picture was accomplished with layers of watercolour and the finishing touches with pen drawing.

▲ SPANISH SKYLINE

I saw this dramatic skyline in Spain. Dusk was falling and the landscape looked very dark against the sky; clouds were gathering in heavy formations, leaving a strip of very light sky immediately above the horizon. It was a subject that lent itself to an interpretation in black and white, the strong contrasts in the landscape matching the tonal contrasts of the medium.

The foreground was put in with brush, and the rest of the drawing was done with pen, building up the shapes with fine stippling. It is a laborious technique but produces an interesting diffused effect. I used black indian ink with two nibs: a medium shoulder pen F, and a fine Brause 513.

were done entirely with a pen. Admittedly it did take time to build up the effect, so this particular method is not so suitable for a large drawing unless you are blessed with a great deal of patience. Other less precise techniques, such as hatching or scribbling, would be quicker.

PAINTING WATER

A companion to skies is water, that bewitching element beloved of painters in the open. Water fascinates us: its movement, its transparency, its reflectiveness, its force. It is not easy to capture its elusive quintessence but it is always worth a try, even if you feel you are a novice.

As with skies, it must be watched and studied. Still water reflects its surroundings, so in effect you have two landscapes to depict, one upside down. Generally, reflections appear darker than the image they mirror, but don't take my word for it – go and have a look.

Swirling, agitated waters are quite different in character, and the continuous rhythm of movement must somehow be caught on paper without appearing static. Curvilinear, flowing strokes in both pen and brush can give the suggestion of motion, as broken lines with the same implements

▶ BEACH

This is a watercolour about openness, and those very calm, still days that you sometimes get on the coast. There is little 'incident' in the picture, which relies instead upon atmosphere for its effect. The distant boat provides the focal point. I decided to paint it in pale washes of cobalt blue, yellow ochre, Payne's grey and a touch of raw umber. The ink drawing serves to liven up the texture and pulls the picture together.

MEMORIZING

It is not always possible to make drawings on the spot, so it is a good idea to learn to use your memory. Once you have acquired the knack you will find you notice far more, which in turn will increase the scope of your pictures. It is also useful for overcoming the problem of sketching from inconvenient places, like the middle of a road!

I had this difficulty once with a subject. It was a derelict cottage surrounded by tangled undergrowth, but the best drawing position was in the road. I decided to memorize it. Each time I saw it I made a point of observing a particular aspect and then went home and drew as much as I could remember. Gradually, over several days, the drawing came together and I had the information I wanted. At first I concentrated on the main shapes, then I narrowed down to the details. Sometimes I *thought* I knew how a shape went, only to discover the next time that it was decidedly inaccurate. This is an excellent way of training the eye to see what is really there.

Another observational exercise is that of 'mental' drawing. Instead of using a pen or pencil to depict an object, draw it in your head, following round the shape in your mind. This is a useful method primarily because it can be done at any time, and in any place – and nobody else will know that you are 'drawing'!

can give an idea of reflections (see *Stream* on page 16). Strongly contrasted tones give an indication of light playing upon the surface, reflecting the sky. There are several illustrations of water in this book, showing different characteristics.

Coastal subjects are in a class of their own, as the large group of marine painters in this country and abroad testifies. Landmass set against the sea makes an exciting arrangement of elements, the combination of salt, wind and sun weathering and bleaching colours to give beautiful silvery tones. Driftwood, pebbles and fishing boats are often part of this scene, harmonizing with the wilder forces of land and water.

The two sea pictures, *Low Tide at Etretat* on page 7 and *Beach* above, illustrate contrasting moods: one of dramatic grandeur, the other of calm and stillness. The first drawing shows a concentrated build-up of ink and colours, while the second is much lighter in execution.

IN CONCLUSION

The expansive landscape contains breadth, depth and height: it incorporates contour of land, openness of sky and flow of water. Its constantly changing appearance offers continuous inspiration to all those artists who love to work among such panoramas.

DEMONSTRATION
LA ROQUE ALRIC

SOUTHERN and central France have many small villages like this, climbing up the side of a cliff, or perched on top of a hill. Colours and stones entwine and blend with the landscape, making it difficult sometimes to distinguish between building and rock. These are picturesque subjects with warm, mellow colours set against the rich greens of foliage.

This particular village, with its little church and inevitable 'Mairie', is tucked away in the Vaucluse. In the summer months it is an area suffused with the scent of thyme and sun-baked earth, alive with the sound of bees and cicadas. Pines, holly oaks and vineyards clothe its lower hills, while to the east rises the long, relentless slope of Mont Ventoux and to the west the jagged edges of the impressive Dentelles.

This demonstration shows my usual approach when working with watercolour and black indian ink. The ink is waterproof, so once it has dried it will not be picked up by the colour washes. I begin most of my pictures with colour, as I do here.

STAGE 1

The preliminary brush drawing in yellow ochre sets the warm key of the picture, appropriate to the subject. I used a flat 1cm (½in) brush, which gives wide sweeps of colour in addition to fine lines; these are versatile brushes and good for blocking in the first stage. I never use pencilled guide lines as they always show, however cleverly disguised, and I dislike the combination of graphite with watercolour; also I think they can be restrictive, inducing a disinclination to 'go over the lines' and thereby curbing the brush's freedom.

With the composition established, the sky is washed in with cobalt blue, using uneven brush strokes to suggest movement and airiness; I want to avoid a static look. The blue acts as a foil to the

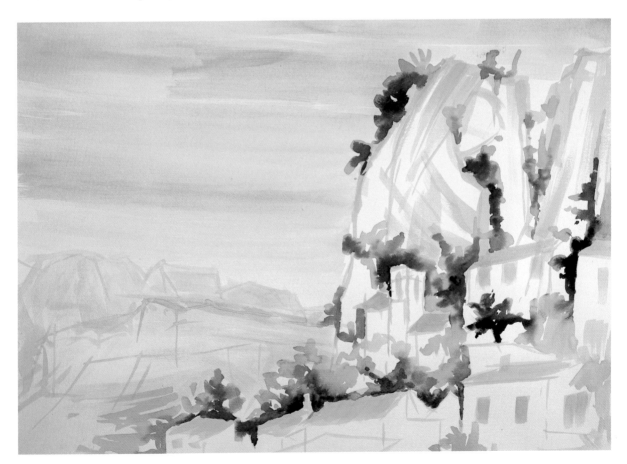

STAGE 1

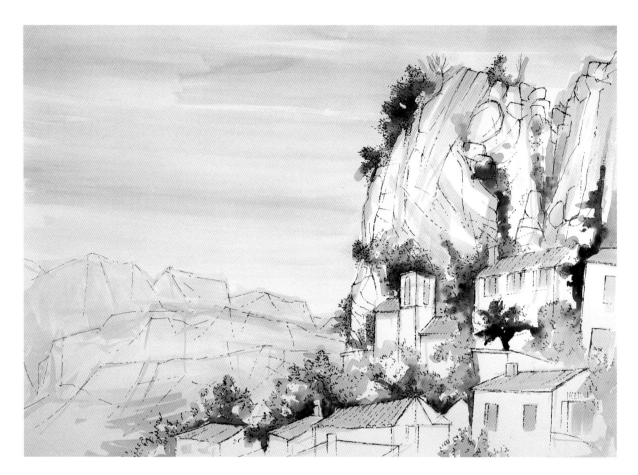

STAGE 2

yellow ochre, and gives the colour scale of the picture from warm to cool. All additional colours will be related to this.

Next, using round brushes Nos.10 and 12 the foliage is put in with olive green, into which dribbles of prussian blue and blue-black are worked while the paint is still wet. These spread and provide the necessary dark tones to liven up the drawing.

By now I am relaxed and working freely, enjoying the sensation of brush and colour on the paper. I always find it takes a little time to settle into a picture and get going. Movements at first are stiff and self-conscious, then, suddenly, the flow comes. This is an exciting stage of painting, with everything open and fluid.

To conclude the first stage, touches of burnt sienna are added to the roof tops, and cobalt blue to the rock, windows and distant mountains. Standing back to assess progress so far, I find the sky is too obviously blue – it needs a hint of warm ochre to tie it in with the rest of the picture.

STAGE 2

The pen drawing defines the shapes and starts to

differentiate between the various textures: roof tiles, foliage and rocks. Because the picture is divided into two main parts – the foreground rock and buildings, and the mountains and sky in the background – I have adjusted the pen strokes accordingly, with stronger lines for the foreground and lighter lines for the mountains beyond. Study the effect of this on the composition.

Although the ink drawing begins to pull the painting together, I still want to keep it 'open'. One of the dangers of penwork is that it can become fiddly and bogged down with detail, resulting in a tight, claustrophobic look. There are several ways to overcome this, however: use a large nib in preference to a fine one; choose an old nib rather than a new one; and try holding the pen high up the holder to give a free action.

For this second stage I choose a well used shoulder pen for its flexibility. After a certain amount of use a nib becomes springy and malleable, giving a soft, expressive line; a new nib feels harder and will be easier to control for more precise marks. Most drawings will need a variety of nibs to produce an interesting range of expression. The picture is now half-way through its

development, with the main components of colour, tone and shape stated. The following two stages will see the build-up of both brush- and penwork.

STAGE 3

This is probably the most crucial part of the procedure. The colour needs filling out to give it more punch, but I must be careful not to overdo this and make it too heavy, with a consequent loss of freshness.

There is still a good deal of white paper showing, so I brush yellow ochre washes over these areas on houses, rock and sky. In the sky this has the effect of breaking down the blueness (commented on at the end of Stage 1) and integrates it with everything else. Other colours are strengthened: burnt sienna on the rooftops; indigo and burnt sienna on the rock; and deeper tones of indigo added to the foliage.

I am not entirely happy with the foliage to the left of centre. In my desire to make these trees and bushes stand out against the mountains, I have used too much brush and not enough water; as a result they appear rather tight and 'blobby' in comparison with the rest of the greenery, where the

colours melt into each other in a more spontaneous way. I shall hope to improve this passage later with pen. The mountains are kept cool in colour with olive green, cobalt blue and a mere hint of blue black, to give a sense of distance. Darker tones on windows and doors add accents to the buildings.

Notice how in all three stages I have worked

DETAIL

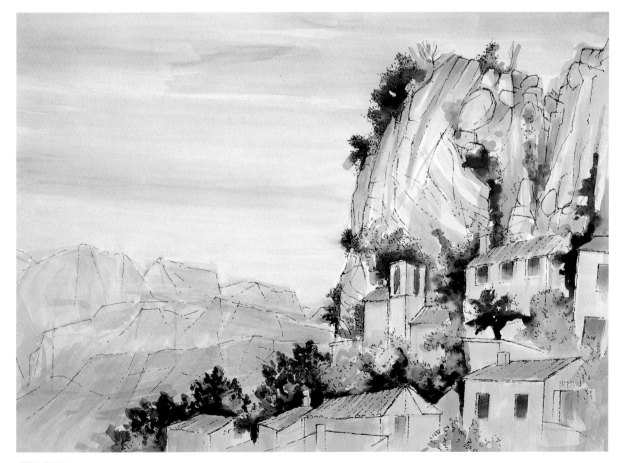

STAGE 3

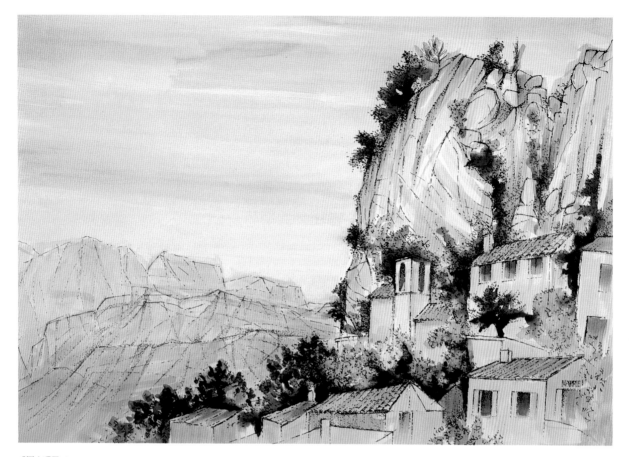

STAGE 4

over the whole picture and not just one part. It is important to keep the unity going so that everything works together; while concentrating on one area you should be aware of the others.

STAGE 4

Now the final pen drawing is put in. This consists of adjusting linear emphasis and bringing out textures, particularly on the foliage. The random strokes here are in strong contrast with the regular lines of the houses.

As there is no 'lead-in' foreground – a road, for example, or open ground – I must make sure the composition does not fall away at the bottom. By concentrating the weight of drawing on the central buildings and rock, and leaving the lower houses less resolved, the eye is led into and focused on the main part of the picture. Changing to a new pen nib to give a finer line, the shapes on the distant mountains are defined more positively, although they still remain understated in comparison to the rest of the drawing.

I must now decide whether anything else should be done. The mountains look too cool in colour and need some warmth, so I slightly deepen the yellow ochre here for a better balance. The aim is to convey space and distance, but the picture must hold together at the same time. After one or two more tonal adjustments, mainly on the lower houses, I conclude that the drawing has been taken as far as I want it to go.

I am often asked how I know when a picture is finished. My answer is that I stop when there is no more I wish to say. This is different to saying that it is finished, which implies a finality. I think pictures need to be open-ended, to retain a 'mobility' in order to keep them fresh and alive. Tying up all the ends can destroy the vigour.

DETAIL

INTIMATE LANDSCAPE

WHERE the expansive landscape takes the wide and deep view, the intimate landscape moves in for a much closer look. For many of us this will be represented by the garden. Gardens are intimate in the sense that they are usually cultivated and planned; they are places of enjoyment, familiar to us, enclosed by hedge or wall. We can encompass them and know the extent of their boundaries. Even the great landscape gardens of stately homes are finite in their dimensions, however much they emulate the expansive vista.

Most gardens are much smaller than these lavish estates and generally consist of a bit in the front and a bit at the back, with enough space to grow a few plants and a patch of lawn. Whatever the size, there is bound to be something to draw and paint. Sometimes it might be the overall view that inspires one; at other times a secluded corner, a tree in a particular light, or a miscellaneous clutter of garden oddments.

One of the most interesting features of the garden landscape is the interaction between artifice and nature, the mixture of ornament and structure with foliage and flower. At their best each will complement the other, although this can go disastrously wrong, with each screaming out their discomfiture. Yet sometimes even this incompatibility has an attraction for the painter!

If you have never thought of your own garden as a 'landscape' worthy of attention as a subject, go and take another look at it – see it with a fresh eye, as though for the first time. Often when things become over-familiar, we stop noticing them and they merge into the background of daily routine, like a comfortable old coat.

Gardens can be approached in many ways and sometimes have the edge here over the wider landscape. They can be drawn from outside or inside the house, from ground level or an upper storey. This is an advantage when the weather is less suitable out of doors, and also more convenient for spreading out materials and equipment, especially if you want a variety of media at your disposal. If work has to be interrupted for any reason, you can go back later and pick up where you left off, a recourse which is not so easy in the open countryside.

The drawings accompanying this chapter illustrate different kinds of garden from the formal to the wild, the latter often being the most appealing from an artistic point of view. They also demonstrate various techniques and an assortment of media.

SELECTING A TECHNIQUE

The selection of a technique is governed by a number of conditions. The subject itself can be the instigator of choice: a softly atmospheric scene may call for limpid washes and brushwork for example, while spiky trees against a winter sky suggest the sharper use of pen. Conversely, the subject may need to fit an already chosen technique – if you have a burning desire to do a line drawing, an appropriate subject must be found to match it.

The technique used in *Stone Urn – Chatsworth* came about in another way altogether, and was the result of a change of pen nib: instead of the longer, pliant nib that I usually prefer, I decided to use a shorter one which gave a firmer, almost scratchy line. As I worked, I found my technique altering to accommodate the different 'feel'. The lines were short, sharp, with an angularity made by flicking

STONE URN – CHATSWORTH

Chatsworth is a perfect example of a large landscaped estate with a splendid house to match. Its lavish grounds contain formal gardens, lawns, tracts of woodland, statuary and fountains, not to mention the numerous varieties of trees. Nature and artifice meet in such a way that each enhances the other. Forbiddingly awesome in some respects where the artist is concerned, nevertheless there are possibilities for painting here, often tucked away in the less frequented areas.

This watercolour and ink picture was inspired by an ornamental garden near the natural woodland which appears in the background. I was interested in the interplay between the architecture and the plants, with the urn a link between the two – its curves reflect the plants, but its substance belongs to architecture. The drawing technique is described in the main text.

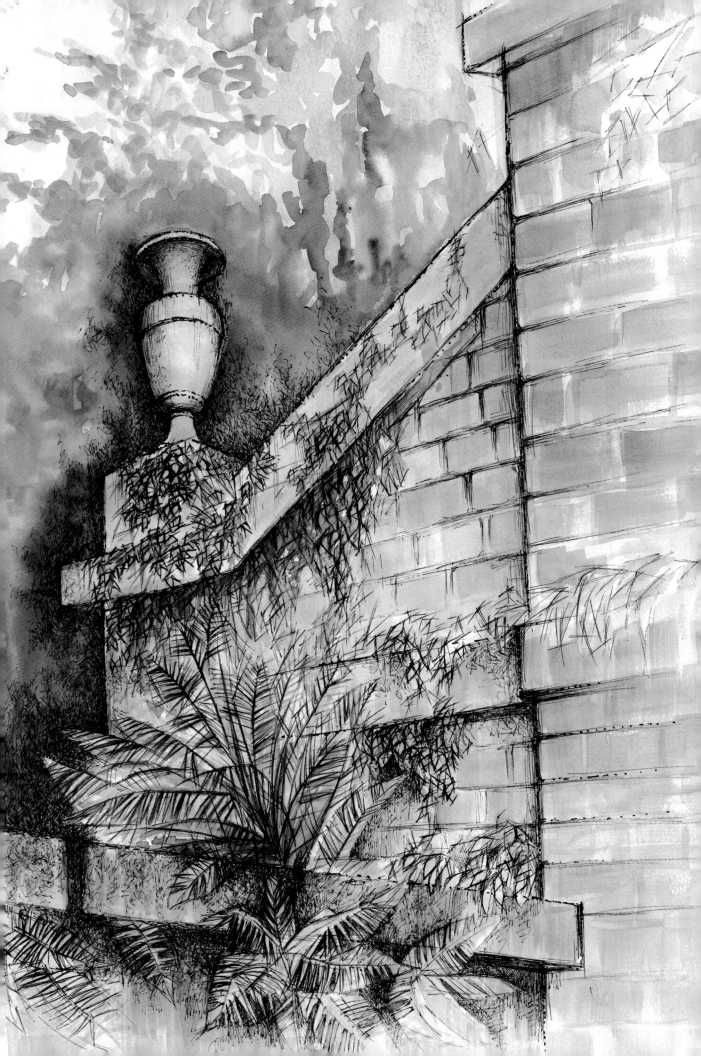

the pen quickly across the paper. This formalized the shapes to some extent, producing a quasi-abstract style, notably in the treatment of the ivy on the wall. The method arose naturally through the process of drawing, and was not consciously intended at the start; it demonstrates how techniques adapt to suit circumstances. A willingness to be flexible will keep you on your mettle and prevent your drawing becoming rigid.

The two illustrations *Clipped Yews* and *Wild Garden* are contrasted both in subject and style. The clipped yews are formal, indeed unnatural in the severe way in which the normal growth has been curtailed and bent to the gardener's will, but it was precisely this incongruity that attracted me. There was a comical strangeness about the way in which the pear-shaped trees huddled together, leaning forwards as though striving to reach something; they were like a group of people caught within a circular cage.

In my drawing I have tried to convey the solid sculptural quality of the forms and also something of the surreal sense of the scene. The decision to restrict the colours to low-key brown and black was a deliberate denial of natural colour, in keeping with the pervading mood. Reaction to a subject is deeply personal. Where I saw something

anthropomorphic in those bizarre shapes, so far removed from their natural form and bearing no resemblance to a yew in its normal state, another artist might interpret it in totally different vein, the formal lines and weighted mass triggering off other responses altogether.

Conversely, *Wild Garden* depicts no restraints to the exuberance of nature. Here the plants grow in wonderful profusion and wander where they will. I love these rambly gardens; there is so much

CLIPPED YEWS

Another drawing motivated by Chatsworth, but one quite different in essence from the first. Almost monochromatic – I have used only french sepia and soluble black ink – I began by mixing a pale wash of the sepia and drew in the composition with a round No.12 brush. Since this particular sepia is non-soluble, once it is dry it will not pick up any subsequent ink laid on top of it. Texture was added with pen.

Changing to the soluble black ink, more pen drawing was worked on the trees and their shadows. When the ink was dry I dabbed on water, which caused the soluble ink to spread and produce a deeper tone. This looked darker than I had intended, so I increased the texture on the grass and path to make a better balance. The background was kept sketchy, to avoid detracting from the main 'action' of the picture, the yew trees.

WILD GARDEN

This view was taken from a window although, sadly, the beautiful shadowy tree seen at the back was blown down in a gale. How transient the landscape can be sometimes. Everything about the drawing emphasizes the profusion and richness of growth; it is crowded with incident: leaves, stems, branches, pebbles, bricks and grained wood, matched by the lively confusion of the pen strokes.

I used a fine ballpoint, which was very good for working up the dark scribbled tones as it never snagged, no matter in which direction it was pushed. Hatching, stippling and short, stabbing lines were also used.

Another aspect worth considering, in connection with the drawings on these two pages, is the variety to be achieved in the use of monochrome – or near monochrome. It is not always necessary to use the full gamut of colour to obtain rich and diverse results. Limiting the means at your disposal can force you to exploit those means to a higher degree.

In this drawing I have tried to be inventive in my use of pen techniques, not only to express the character of the subject but also to make the drawing interesting in its own right. The 'colour' of tonal pattern and texture, which makes extensive use of the monochromatic range, forms a substitute for actual colour.

for the painter to find and be excited by – but their secrets have to be sought out and discovered, one revelation leading to another.

This particular garden is one I know well and have painted and drawn many times. It is quite a large garden, full of individuality: ancient apple trees, distorted and bent, thrust crooked twigs against the sky; the desiccated trunk of a plum tree nurtures plates of fungi and woodpecker holes – a weird, sculptural shape with uplifted arms that gleams whitely at night, like a ghost – a wonderful subject this, and one I have still to do. Tangled webs of ivy and briar form dark caves; mysterious holes that beckon to the imagination. It is a garden that speaks to the romantic and provides a continuous source of inspiration. Perhaps some of you have, or know, similar places, and maybe draw them too, deriving the same intense pleasure as I do from this one.

The technique used in *Wild Garden* echoes the sense of unrestraint. Thus a density of thickly worked scribbled lines builds up the tones and dark spaces around the leaves. I am always fascinated by the counterplay of light against dark and dark against light, and I have made much use of it here. Landscape is full of these little 'conversations'.

Depicting foliage *en masse* can present less experienced artists with a problem. To put in every leaf as it is seen looks stiff and unnatural, unless it is done in the decorative manner of the primitive, or naive, painter where two-dimensional pattern predominates. Wonderful examples of this type of work can be seen in the pictures of the French painter Henri Rousseau from whose brushes flowed jungles and forests in an abundance of exotic images – but they were the product of a fertile imagination rather than the natural world.

How then is it possible to suggest this volume of leafage in a more naturalistic way? One solution is to half-close your eyes to simplify what you see, leaving only the dominant shapes and colours. After blocking these in with a big brush, touches of detail can be added with brush or pen. This accommodates the overall mass without denying a sense of leaf texture, provided in the detail, and experience will teach you just how much detail is needed to produce a convincing effect. Those of you who happen to be short-sighted have a unique advantage as you can eliminate detail simply by removing your spectacles. A handicap that can be put to good use!

Another solution is to imagine the foliage covered by a paper bag; this is a variation on the

simplification theme and makes you consider the big shapes rather than the small ones. It is so easy to become confused by the complexities of trunk, branch, twig and leaf confronting you, and anything which might simplify things could be helpful at the beginning.

STUDYING DETAIL

An integral part of intimate landscape is the close-up view of detail. This is not necessarily confined to the garden, although it is here perhaps that we

LILIES

When you examine flowers, it becomes apparent why many artists choose to concentrate their efforts on this beautiful species. Plants and flowers encompass shape, colour and pattern in infinite combinations, and I personally love to draw them; one of the joys of possessing a garden is being able to draw what grows there. Lilies have a distinctive, bold structure that makes them especially attractive, the whorls of leaves growing in diminishing clusters up the stem and setting off the curving petals at the top.

The study below was an opportunity to look closely at the plant and draw it searchingly: I wanted to understand the structure and see how it all fitted together; I was also conscious of the action of drawing itself, the movement of hand and the flow of line, which heightened the pleasure. I used black indian ink with a Brause 513 nib for the finer details, and a shoulder pen F for the stronger lines. The drawing was made on cartridge paper.

are more aware of it. The panorama usually engages our attention in other ways so we are less likely to notice small things in that context.

Plants and flowers offer one of the richest areas for studying detail. The variation of colour, form and texture is astonishing, and within one detail more detail will manifest itself, unfolding like the layers of an onion. Look at the drawing of the lilies (below). The first picture gives an idea of the general structure, showing the leaves in relation to the flowers. Notice the lovely counterpoint between pointed shapes and graceful hanging curves. The whole plant is full of rhythm – a perfect example of natural design.

The second picture shows a detail of the first and takes a closer look at the delicate structure of spotted petals poised above the stamens, hanging like elongated bells, alongside them the buds waiting to burst open – and all this found within a single plant! These are marvellous things to draw, and make one appreciate the incredible breadth of nature's diversity; there is so much material from which to choose.

The botanical illustrators of the last century understood these natural rhythms and, harnessing them to their own innate sense of design, produced the exquisite drawings found in the plant manuals of the time. These have never been surpassed and much can be learnt from their combination of the decorative with the accurately observed.

LILIES (DETAIL)

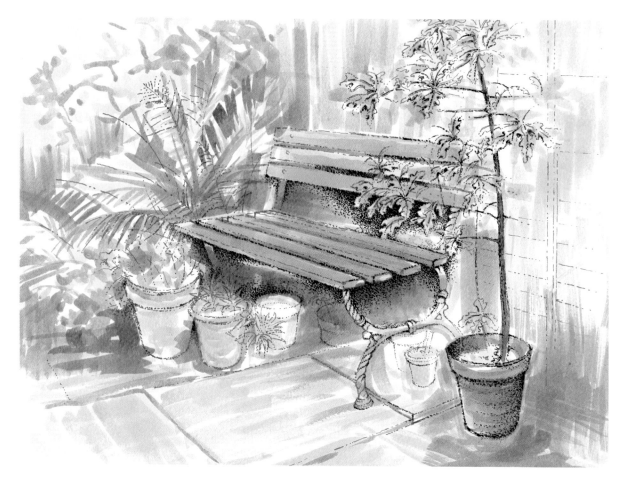

GARDEN BENCH

Gardens are full of paintable corners like this. The brightly coloured bench provides the focus, around which are grouped a few flowerpots and a miscellany of plants. The drawing has been left incompleted, partly to show my working method but also to keep it 'open-ended' and suggestible. It isn't always desirable to tie everything up – drawings need room to breathe, and leaving one area unresolved can give greater weight to a more finished part.

Coloured inks, brushes and pens were used. The broad areas of colour were brushed on with diluted ink washes, and the penwork used full-strength inks. The plants on the left show how the drawing began, and the development can be seen in the detailed work around the bench. Concentrated stippling with several colours builds up dark tones without the need for black.

Another artist whose work you may know is Albrecht Dürer. Dürer made a watercolour study of an ordinary clump of grass and transposed it into something uniquely beautiful (the original is in Vienna); it is the epitome in visual terms of William Blake's famous line 'To see a World in a Grain of Sand', and clearly underlines the value of searching out small, less obvious things that do not clamour for our attention and yet are equally deserving of our regard.

TEXTURE AND PATTERN

Textures and surfaces cross all borders of landscape, but I have decided to include them in this section because of their special relevance to intimate work. Texture and tactile sensations were mentioned in connection with the wider landscape: here they will be considered with reference to the smaller scale. For example, as we scrutinize objects close to, we are likely to touch and feel them; how many people wandering in a garden would be able to resist the temptation of touch? It is something we do almost unconsciously.

Pattern and texture are closely linked, although pattern usually refers to what is seen, while texture can refer to what is felt as well as seen. The spots on the lily's petals could be described as pattern: they break up the surface visually, but have no tactile quality; they can only be seen. Lichen on a stone, however, can be seen and felt; it both patterns and textures the stone.

These two sorts of texture play a significant role in picture-making. They help to 'explain' surfaces, and give them character and individuality.

GREENHOUSE (DETAIL)
This shows the whole range of pen techniques, both linear and tonal. The ink drawing was done once the watercolour washes had been applied.

SPLATTERWORK

Splattering can be done with inks or paints; it makes an attractive texture and is easy to do.

Dip an old toothbrush into ink or paint, then drag the handle of a paintbrush across the bristles; as they spring back into place they will splatter a fine mist of colour over the paper. There are two points to watch out for: (1) the splatter can spread further than you intend, so make sure the area around your paper is protected with newspaper; (2) the technique may take a little practice before you learn to control it – so try it out first before incorporating it in a picture.

◀ GREENHOUSE
Pattern is a strong element in this watercolour and ink painting, apparent in the diversity of leaves and the tonal contrast. Notice how the angle of the greenhouse apex is repeated in the shapes and angles of the plants. The foreground leaves form a trellis through which the rest of the picture is seen, dividing it into distinct areas of light and dark. The central tree acts as a mid-tone buffer between the two. The greenhouse appears to be held captive by the dark foliage, which rises above it predatorily, as though seeking to devour it. This is further enforced by the aggressive use of line; the jagged

STONE ARCH (DETAIL)
This gives a closer look at the texture of the splattering and the fine ink drawing on the stones, using scribbled and hatched techniques.

They also add interest, not just to finished work but during the course of the working process. Simulating various textures demands inventiveness, a manipulation of pen and brush to achieve a range of effects; it gives the opportunity to experiment and expand skills.

Textures have always been important to me. I enjoy their contrasts and the scope they give for trying out new methods. In *Garden Bench* (page 67) I wanted to bring out the opposing elements of 'hard' and 'soft', the contrast between the firm surfaces of bench, flowerpots and fence and the pliable structure of the plants. *Stone Arch* (page 71) combines different techniques – splattering and fine penwork: the random effect of the splattering suggests roughness, while the concentrated use of pen implies heaviness and mass in the stone blocks. The two pictures differ in the way I approached them, but each shows how I interpreted the various materials depicted.

Greenhouse (pages 68–9) is a study of leaf textures and the decorative patterns they make

angularity with no suggestion of softening curves.

To achieve this effect I used a well worn shoulder pen F which had become nicely flexible, and I worked standing up; this allowed the ink an unrestricted flow straight down the pen, producing thick lines and the occasional blob. I wanted that unpredictability, however, to emphasize that the large-leaved plant is a wild intruder in the garden. The other plants are gentler in nature, even protective. By contrast, the technique on the greenhouse is controlled and careful. I used a firmer nib and worked sitting down, which gave an oblique angle to the pen and, consequently, a slower, controllable ink flow.

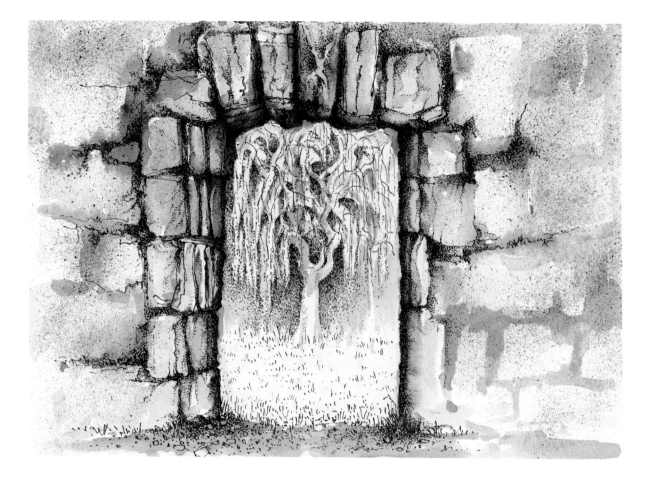

against each other. I was not so concerned with the tactile element this time, although there is a hint of it in the techniques used on the greenhouse to suggest glass and wood.

When you draw, don't think only of shape, but try to cultivate an awareness of *substance*: imagine the weight of stone, the fragility of petals, the crumbliness of earth. It is a way of getting inside what you do, to feel almost what it must be like to *be* the object, even as you paint it. This may seem fanciful, but making pictures is an involving occupation and to some extent, you are what you paint. I feel sure that you will have experienced those heightened moments when everything goes along swimmingly, when you are able to work with increased sensibility, and feel at one with yourself and with the subject.

PLAYING AROUND WITH PERSPECTIVE

Looking out from inside a house gives yet another prospect to a landscape. For one thing it may well be 'enclosed' by a door or window-frame, so that you have a contained picture: it becomes a picture within a picture, and if the glass is divided into segments, as shown in *View Through A Door*, there

STONE ARCH

I have always enjoyed the theme of looking through one shape into another, the channelling of the eye into the space beyond. In this case it was a stone arch opening onto a weeping tree. The stone was old and worn, the carving had long since crumbled away, and the large stones made a sharp contrast with the drooping shape of the tree. I wanted to convey the sense of inanimate mass set against organic form; once again it was intrinsic differences that attracted me.

The picture incorporates the splatter technique with watercolour washes and pen drawing. I began with the arch, drawing in the shapes with a round No.12 brush and a wash of yellow ochre, into which I worked a darker wash of raw umber and Payne's grey. The colours ran together where they were still wet. To suggest the rough surface of stone, I splattered on Payne's grey and yellow ochre.

Next, the whole of the central area through the arch was filled in with a wash of lemon and cadmium yellow; it was then left to dry thoroughly, before further working in pen. Then the tree was picked out with a wash of cobalt blue. This part of the picture was kept light in tone to maintain the distance between arch and tree. I used a Brause 513 nib and black indian ink for the pen drawing.

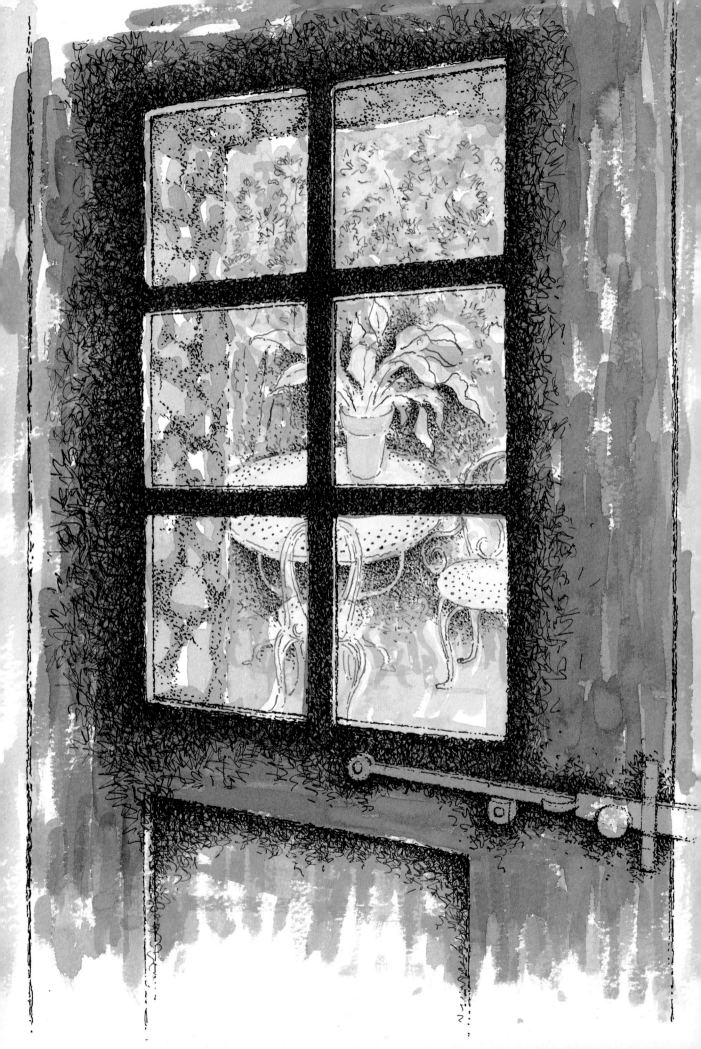

will be a series of little pictures, fitting together rather like a jigsaw.

Tonal contrasts will feature prominently, with the bright outside offset against the dark inside. This idea could be extended even further, with various objects shown in the room, rather shadowy and mysterious, against the light: landscape combined with still life. You could also reverse everything and look inside through a foreground landscape, peering through the foliage as though it were a jungle; there would be plenty of scope for texture and pattern here. Once you start thinking in this way the possibilities are infinite, and one idea always seems to generate another, leading deeper and deeper into a subject.

Drawing from an upper storey window gives a fresh view of perspectives, looking down on the top surfaces of objects close at hand – although distances will hardly be affected beyond, perhaps, a less restricted view. Try drawing a garden chair from above, or a row of plant pots – the unfamiliar

VIEW THROUGH A DOOR

Similar to the previous picture in that both images look from one area to another, the difference between them is in tonal balance. The inside of a house will always look much darker in comparison to outside, so the whole of the door appears dark against the view beyond. In Stone Arch, *only the part immediately around the opening shows this pronounced contrast. The house is in Provence where the disparity between inside and outside, sun and shadow, is very marked.*

The drawing was carried out in acrylic inks. I find these mix into washes well and are less harsh in colour than shellac-based inks. I used washes of colour first, and then drew on top with pen and undiluted inks.

shapes will certainly make you concentrate harder.

Landscapes seen from a house don't necessarily have to include a surrounding frame. *Garden Bench* was drawn looking through a patio door; because I was working close to the large area of glass there was an unrestricted view of the subject, but there is no indication in the picture of whether I was drawing inside or outside the glass. Glass can cause interesting effects sometimes; distortions in the surface, or patterned glass, produce unusual images. Paint your garden through this and you will have something very singular.

Greenhouses and sheds are other places from which to work, and as far as the greenhouse is concerned, there may well be a landscape inside in addition to the one outside. Greenhouses are fascinating subjects for the artist, especially those large Victorian municipal glasshouses, with their decorative ironwork and tropical plants. The lush, exotic growth, sometimes seen through a greenish filtered light that produces eerie subaqueous effects, can be most compelling as a subject.

IN CONCLUSION

This chapter has shown that the intimate landscape has just as much potential as the expansive landscape. Indeed, there is no need to feel that a landscape artist has to roam far and wide in search of material; there is a wealth of inspiration waiting for you much nearer home. Enjoy the wide open spaces and dramatic panoramas, but don't neglect the small view, the charm of the intimate, the details and the textures of the less obviously spectacular; your work will develop and become richer when you include all these aspects.

TOPOGRAPHIC OR IMAGINATIVE?

Anyone taking up painting for the first time is usually most concerned with making a likeness of the subject. Thus the aspiring landscapist will probably be more than content if he can put down what he sees in front of him; there is, after all, plenty to cope with in achieving a convincing approximation to the chosen view. This topographic, or objective approach will inevitably include drawing in the traditional sense.

IMPROVING DRAWING ABILITY

I am convinced that sound drawing is the basis of good expressive art of all kinds, and a key to greater creativity. I believe that through the discipline of drawing we attain artistic freedom; it enables us to visualize concepts more effectively and it increases the options, whether these involve recording a scene in a straightforward or a more subjective manner.

One of the best ways to improve drawing ability is to work directly from nature. This will accomplish several things: first, it encourages observation and trains the eye; second, it makes us aware of the world about us; and third, it gives the opportunity to practise technical skills. These are practical ends necessary to all artists, but particularly the landscapist who derives his subject matter primarily from the natural world. In addition, these objectives can provide the rudiments of a structure for the imaginative ideas I shall be considering later in this section.

Don't be daunted by the prospect of drawing. It should be fun. Try to draw something whenever you can, however simple: a leaf, a twig – it doesn't have to be a 'grand statement'. Use pen, brush, stick, whatever you like, and enjoy the discoveries you make, along with the act of drawing. Regular practice will improve both your powers of observation and your technique, although they have to develop steadily so don't be too impatient.

Learning how to *look* at things is a vital part of successful drawing, and not always sufficiently appreciated. Before fluency of hand can develop, the eye must be trained to see and understand what it is looking at. I used to train my eye by studying the stones in a wall, sitting very close so that I could see every detail. It was highly concentrated work and exhausting, but it sharpened up my perception and taught me to notice all the tiny nuances of shape and tone. You have to be exacting and make yourself really draw what is there. It was a marvellous discipline and I got to know that wall extremely well!

Before starting any kind of observational drawing from life, spend enough time looking at the subject to note special features and particularities. Make assessments: compare height with width, depth with height, darker parts with lighter parts. Look also at the *spaces* around and between objects – the negative shapes. Often it is only positive shapes that are studied, but in a picture *every* area matters and the negative shapes help to clarify the positive. Breaking the subject down into these components makes it easier to

HAZEL HEAD FARM, CUMBRIA

A direct interpretation of a scene, and I use the word 'interpretation' advisedly: although I put down what I saw, there is no attempt to imitate reality in a photographic manner; if I had wanted that effect I should have used a camera instead of paints. The picture is topographic in that it represents a particular place, but it also contains the enjoyment of what I was painting.

Watercolour was used freely, applied with round and flat brushes. I drew the initial stages with a round brush and changed to a flat brush to block in larger areas. The effect seen in the sky employed a dry brush technique, in which the brush was blotted to remove most of the moisture and then dragged across the paper. The pen was an Ajusto painting pen with a lovely bouncy action that produced bold lines to match the open brushwork.

RANNERDALE

A panoramic scene that incorporates many land-scape elements: hills, trees, buildings, water and mountains. It is another example of the topographic approach of drawing what is seen – a recording of an actual place. Since it concentrates on depth of focus rather than width (the more usual panoramic proportion) I have used an upright format.

Without the enhancement of colour, black and white drawings must rely for their effect upon the techniques of pen and interesting tonal variations. In this picture there is a broad mix of technique: stippling, scribbling, hatch-ing and cross-hatching, and different types of line. Intensively worked areas are set against barely touched areas in order to give tonal range. Compare the drawing of the trees with that of the buildings beyond, or the lake with the mountains behind.

judge how it should be drawn and where the lines should go. Once the eye is familiar with the terrain, then brush and pen can move into action.

In addition to training hand and eye, and as well as the pleasure involved, drawing is a way of gathering information: it provides a storehouse of images. This is sketchbook territory, because it is here that the information will be accumulated. Notes, sketches and studies of every sort should spill out from these books: they are some of the artist's most valuable commodities. If you don't already keep one, get one and start using it *now!* Many of the illustrations in this book were taken directly from sketchbooks, or worked up from notes; even the imaginative pictures were derived originally from sketches.

THE IMAGINATIVE APPROACH TO LANDSCAPE PAINTING

If the topographical approach records the external and objective, the imaginative approach concerns itself with the introspective and emotional. It conveys what we *feel* about something, and often expresses more about ourselves than it does about the subject that triggered it. Landscape is frequently used as the vehicle for these imaginings,

and two artists who spring to mind in this respect are Paul Nash and Graham Sutherland. Through the motivation of landscape they have depicted an intensely personal vision: thus we can recognize the origin of the forms they have used – trees, walls, fields and roads – but these have been endowed with a unique quality, realized solely through painting.

For some, the divide between the objective and the subjective is crossed without difficulty; others may find it considerably harder. This isn't likely to be an issue if you prefer to work objectively anyway, but if you would like to explore imaginative channels you may wonder how to break through the barrier. The two demonstrations entitled 'Viaduct in the Wood' were designed to help with this problem. In them, my intention was

to show how emphasizing different elements produces different outcomes: the first version concentrates on the realistic, or objective image – in other words, what the place looked like. The second is concerned with my imaginative, or subjective reaction to it – that is, what I felt about it. The descriptions of the various stages explain in detail how I set about them, and will give pointers to directions for realizing your own ideas.

Compare some of the other illustrations in the chapter as well. *Hazel Head Farm, Cumbria* (page 75) and *Rannerdale* (opposite) are straightforward depictions of actual places. On the other hand, *Yellow Tree* (page 78) owes more to imagination and atmosphere than it does to the original sketch. Similarly, *Maiden Castle – Moonlight* (below) is a

MAIDEN CASTLE – MOONLIGHT
This strangely magnetic place makes an appropriate subject for an imaginative painting. While walking over its mounds and terraces one day, I managed to make some very quick jottings (I would hardly call them sketches, they were so slight) which sufficed to trigger off this picture some time later. The idea relies heavily on romantic inspiration and the atmosphere conjured up by it. I have exaggerated the shapes of the hills and the rhythms of the lines, and capped it all with a mystical moon.

In essence it is quite a simple painting, a series of flowing bands of colour worked on with finely scribbled tones in black ink. I limited myself to three colours – cobalt blue, prussian blue and oxide of chromium (green) – to give the pale, ghostly effect of moonlight. These were brushed on freely with a flat 2cm (³/₄ in) brush and superimposed in layers. None of the colours were intermixed beforehand. On top of the washes I worked a fine network of black indian ink, using a Brause 513 nib. A fine nib can produce a very subtle modulation of tone.

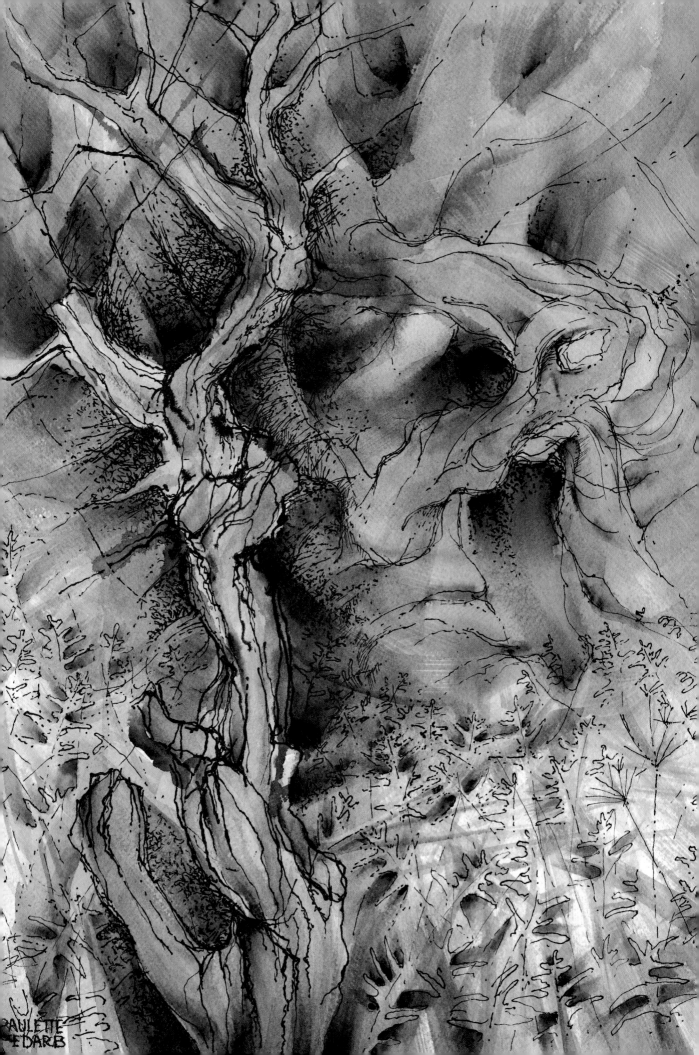

YELLOW TREE

A subjective painting that grew out of a sketch made in situ in a wood. This was an ancient copse of gnarled and stunted oak trees, several centuries old. The trees were fantastic shapes, like dancing dervishes, and the theme of movement runs through the image. The yellow tree slices through the picture, a streak of dominant colour against the cool blues and greens of the background. The dark accents of the ferns claw at the tree bases. The colour was largely imagined, in tune with the atmosphere of age, mystery and unfathomable places that I sought to convey.

I spent several days on this painting, interweaving layers of watercolour with black indian ink until it had reached the required level. Most of the tonal effects were achieved through the use of colour, although some areas, mainly those around the yellow tree, were even further strengthened with ink.

freely romantic interpretation of the scene.

It is perhaps worth noting that these last two paintings were made some time after the preliminary (objective) drawings, allowing a period of fermentation in the mind. I find this is necessary, and rarely do an imaginative picture straight from source. If I try to transpose a 'straight' drawing into a subjective image too soon, I find it difficult to break away from the literal image; the reality is still too fresh and dominant, and needs to fade before a new concept can arise. This is why I suggested earlier in chapter 3, Making Decisions, that painting what you see can restrict imaginative development. On the other hand, I seldom make up a picture entirely out of my head – I like to have some point of reference, however tenuous.

This is, of course, purely to do with my personal way of working and may not suit you. Be guided by your own instinct, and if you feel the urge to grab a brush and paint whatever comes into your head, then do it! Always find your own way whenever possible. Copying other people's pictures will teach you just that – how to be a good copyist, but it won't teach you to be a creative painter. For that you must beat out a new path, which will take time and even courage, but will be much more rewarding eventually.

A step from imagination leads to abstraction. I haven't written a lot about this as I am not naturally an abstract painter. It is a fascinating area but a difficult one; so many abstract pictures seem to be either merely decorative or rather crude and empty. I am full of admiration, tinged with envy, for those artists who do manage it successfully, amongst whom I would select Ben Nicholson, Mark Rothko, Nicholas De Stael and Viera da Silva – you might like to look out for these names to see what *you* think about their work.

IN CONCLUSION

During the course of these pages I have discussed the value of drawing and observing from nature, and have shown how this can be developed imaginatively, possibly to be followed through into more abstract regions. If until now you have kept to the traditional routes, uncertain how to venture further afield, I hope you may be sufficiently motivated, even excited, to try something a little different. Let your imagination take wing and fly, along with your brushes and pens, paints and inks, in new directions.

VIADUCT IN THE WOOD *(a)*

THIS was one of those incongruous subjects that one sometimes encounters by chance. Walking through a wood, I unexpectedly came across the massive structure of a disused viaduct. Backlit against the brilliant greens and yellows, it made a dark, menacing shape in the wood. A striking, surreal image, it caught the eye and provided a spectacular subject for a picture.

I made several black and white drawings from different positions, jotting them down in a small sketchbook using a cartridge sketching pen. This demonstration is based on the sketches, and I have treated the subject topographically. The next demonstration shows an imaginative interpretation of the same subject.

STAGE 1

Unusually for me in a colour drawing, I have decided to start with pen. This is chiefly on account of the complex nature of the structure,

which I want to explore carefully, but also because it is good to vary the approach occasionally. You can see how I 'feel' the way with the lines, altering them where necessary and not worrying about any that are superfluous. Some artists would use a pencil for this stage, removing the guide lines later, but I always prefer to plunge straight in with pen, believing that all lines, even misplaced ones, help to build the eventual 'character' of a drawing. In most cases, anyway, I find that the extra lines merge with the rest of the drawing by the time I have finished.

Notice the differences in the lines used for the viaduct and those which portray the plants: the drawing of the plants is fluid and loose compared to that of the viaduct, which is firm and structural. One piece of advice about drawing buildings and other such structures: never use a ruler to get the lines straight. If you place a ruler against the edge of a building you will immediately see why: it is far from 'straight', and the natural irregularity of a

STAGE 1

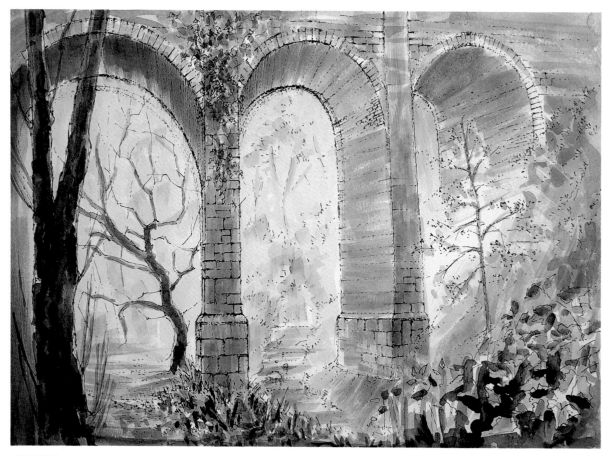

STAGE 2

free-hand line will look much more convincing.

There is some indication of surface texture but not a great deal at this stage, to allow for further development later.

STAGE 2

The first colour to be introduced is lemon yellow, applied with a flat 2cm (¾in) brush. This will be the lightest and brightest part of the picture. I paint freely to establish broad blocks of colour, deliberately going over the trees and not round them; I like to use open sweeps of colour, and meticulously painting up to the lines is restricting. I want to avoid a fussy look, which sometimes arises when there has been a lot of careful initial drawing, as in this case, so the brush should be given its head whenever possible. The next colour, olive green, is applied in the same way.

Darker, shadowy tones need to be brought in now as a contrast to the sunlit areas – for these I use indigo, blue-black and burnt umber. Touches of cadmium yellow are added to the background foliage and a little burnt sienna is applied to the brickwork inside the arches. Round brushes Nos.10 and 12 are used here, in addition to the flat 2cm (¾in) brush.

STAGE 3

Reverting to pen and ink, I want to reassert the drawing and build up and bring out the different textures – the various types of plant and the stones and brickwork. In addition to the penwork, the tonal range is sharpened up with more colour washes of burnt umber and indigo on the undersides of the arches, emphasizing the contrast between the dark arches and the bright sunlit foliage beyond. The eye should be led towards these areas, with the silhouetted tree a focal point. Notice how the 'weight' of the ink drawing is in the front of the picture.

A considerable range of pen techniques has been used in this final stage – hatching, cross-hatching, stippling and scribbling – which helps to add 'flavour' and interest. Compare them with the mainly linear technique at the beginning of the picture in Stage 1; this will point up the difference between searching, structural drawing and more descriptive methods. Two types of nib were used: a medium shoulder pen F and a fine Brause 513, with black indian ink. The paper was Cotman watercolour 300gsm (140lb).

STAGE 3 ▶

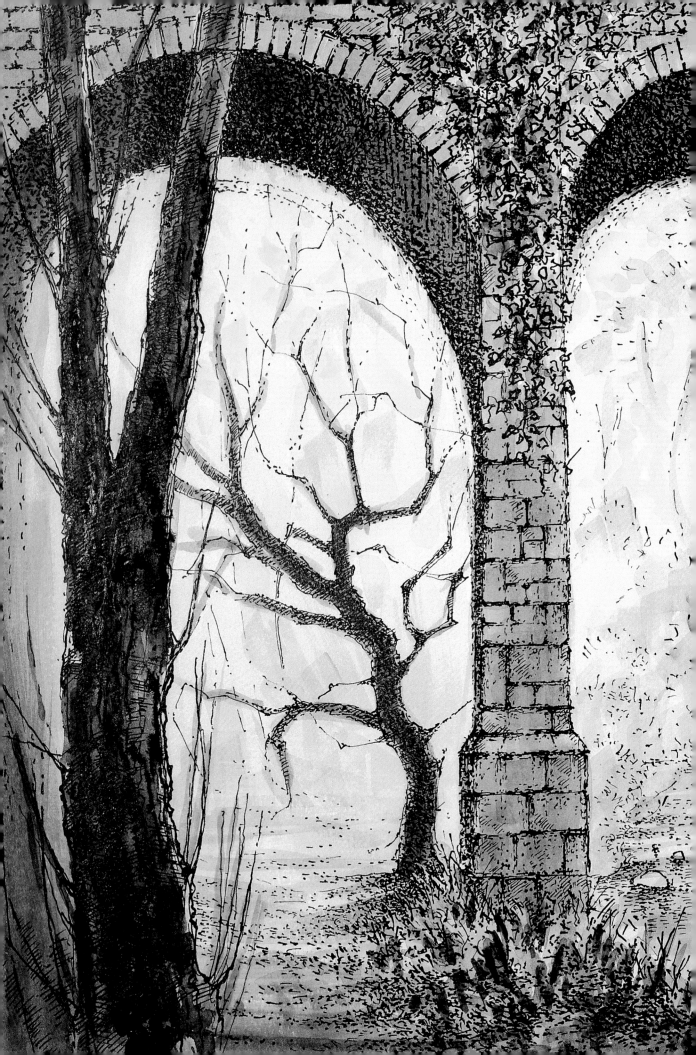

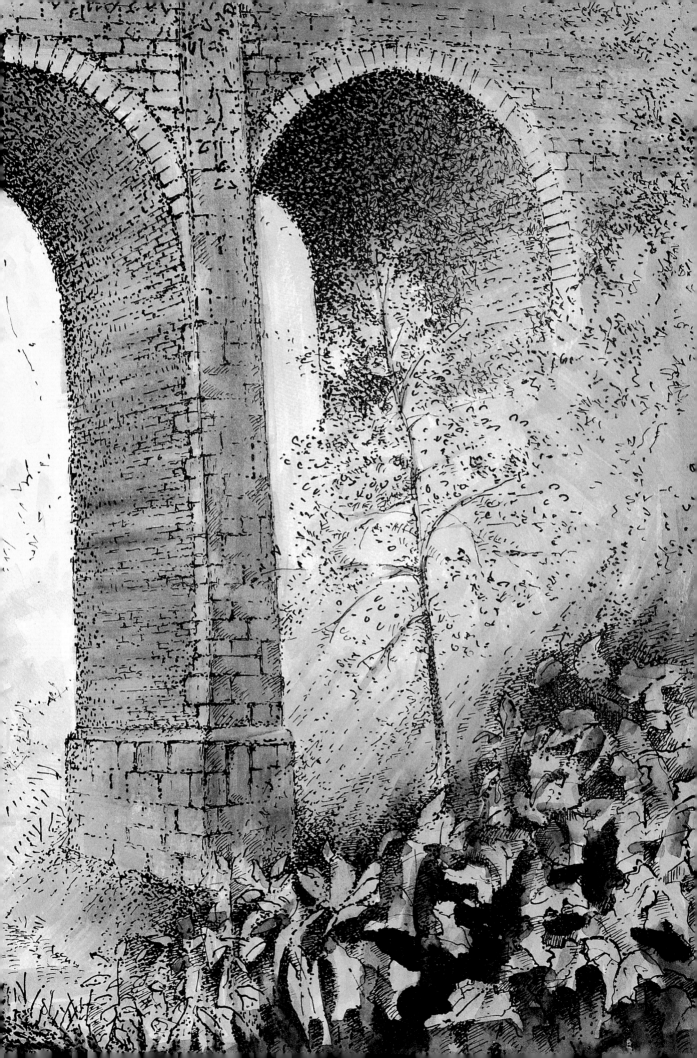

VIADUCT IN THE WOOD (*b*)

WHERE the previous depiction was topographic, this one expresses an introspective view. The success of this sort of picture will depend upon the atmosphere that is created; mood will be of greater importance than realism. In this demonstration the approach lies somewhere between direct recording and abstraction. Although it is still representational, with recognizable objects, these have been used to convey subjective feelings born of imagination; I am 'bending' the subject to suit my own purpose.

Colour, shape and texture will all play key roles, but this time they will be used more inventively. In order to break away from conventional colour I have decided to use a range of sepia inks, which bear little relation to the colour of the first demonstration. Releasing the image in this way from its usual aspect gives great freedom to the artist but also imposes restrictions of a

different kind. Most of us like to feel that our pictures have meaning for other people as well as for ourselves, and this in turn raises the question of communication.

In objective work the spectator's response is usually straightforward and immediate. Even if we are not familiar with the actual place depicted, it is easy to identify with the type of image presented and to recognize the forms. We can 'understand' the picture. In subjective work this is not always the case, and the further removed the picture is from reality and the deeper it reflects personal expression, the harder it may be to bridge the gap. The artist's intentions and the viewer's expectations do not always match. Much, of course, depends upon individual response and how readily different concepts can be accepted.

In the following demonstration my aim is to show how a subject can be treated in a creative way,

STAGE 1

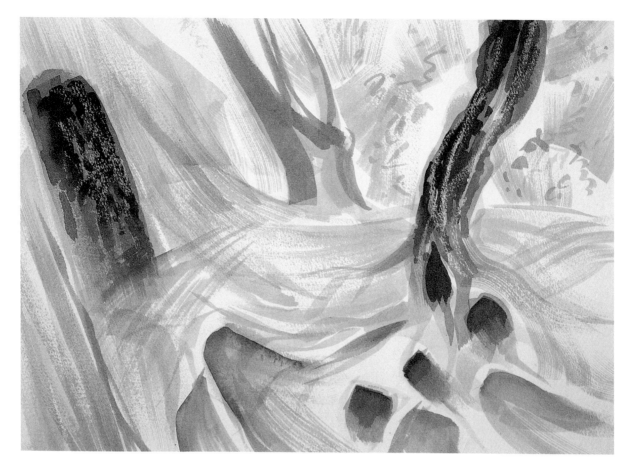

STAGE 2

and be developed without entirely losing sight of the original starting point.

STAGE 1

Using a flat 2cm (¾in) brush and a diluted sepia wash, I begin by roughing in the main composition. I want to establish the expressive rhythm of the picture early on, and I do this by distorting the lines, shown in the exaggerated lean of the viaduct and the twisted shapes of the trees. Some of the diagonals oppose, some echo each other; this introduces movement and also a suggestion of unease, and it is this underlying sense of disturbance that I hope to bring out as the drawing develops. I said earlier of the viaduct that it made a 'menacing shape in the wood'. In this picture I reverse the roles, so that the trees with their grasping roots become the elements of menace.

Just how the drawing will develop I am not yet sure; however, I am interested in the abstract possibilities and want to play on these. All pictures, whether figurative or non-figurative, have rudiments of abstraction within them. A shape is a shape, whether it represents an association with a particular object or not. Turn something familiar upside-down, and it takes on a different appearance; it becomes 'abstract'. Again, if we look at the negative spaces around objects instead of the objects themselves, we see them as pure shapes with no special connections.

It is along these lines that I hope the work will evolve, although there will be other 'unknown' factors of development to consider. These materialize as the picture progresses; they could involve colour, form, texture, tone or technique.

STAGE 2

Changing to a darker wash of french sepia and using the same brush, I work over most of the drawing, reinforcing the linear rhythms, filling in more of the fore- and backgrounds, and darkening the tree trunk on the right and the arch on the left. The 'holes' between the roots have also been emphasized; this is an area that will be given greater prominence as the picture progresses – it will provide the opportunity for abstract development, as mentioned earlier.

The textured effect on the tree and arch was made by rubbing white candlewax over them before applying the french sepia. Later I shall be

using other innovatory techniques as well. Most of these have already been introduced in chapter 2, Basic Techniques, but now you will be able to see how they can be used to invigorate a picture and give it a different textural edge. There is an excitement about working like this, and although I would not advocate it as a regular approach – it can lead to superficial 'trickiness' – it does have a refreshing effect on one's work and outlook; it is a good way of loosening up, especially if you are inclined to be tight and over-cautious. However, ultimately there is nothing to touch the traditional tools of brush and pen for sensitivity and artistic expression.

The picture has now reached the point where the bones of the composition have been blocked in and certain passages are beginning to come forward. It is starting to 'speak' and take on a life of its own.

STAGE 3

I start by mixing a wash of iron gall ink and again work over the whole drawing, with a more concentrated application on the background so as to lose and merge the shapes together. The cool,

purplish-grey colour of the ink provides a foil to the warm browns of the sepias.

It is time now to introduce some linear drawing. So far I have only used brush; however, as I don't want to overstate the drawing and make too strong a contrast against the brushwork, I decide to use a stick. Pen would give too crisp and clearly defined a line, whereas the stick gives a crumbly, intermittent line which provides the required 'bite' and yet still marries well with the rest of the picture. The ink used here is full-strength french sepia.

More sepia wash is added to build up the colour, notably in the foreground. Finally, touches of undiluted sepia are brushed over the waxed areas. Notice how the untouched white parts of the paper stand out as strongly contrasted shapes against the darker tones, accentuating the pattern. Later it may be necessary to modify these.

This stage sees a considerable development, from a representational image to one that is much freer in concept. Releasing it from the confines of the original subject means that it is no longer a replica of that image: other factors have taken over, and I am concerned now with the issues of shape, pattern and colour existing in their own

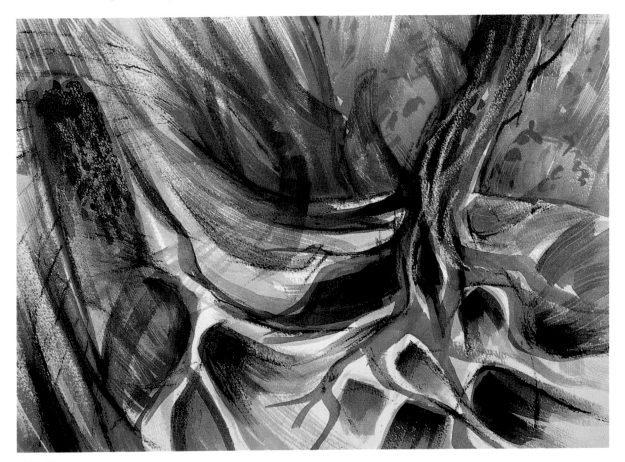

STAGE 3

STAGE 4

right, and not as descriptions of recognizable objects. The abstract elements are coming forwards and I am finding the direction I want: until this stage I have been feeling my way, searching for that direction, and it is only now that everything starts to 'gel', and painting becomes very involving. The momentum carries one along, and the process of deciding what to do becomes almost instinctive, as the picture seems to dictate its own terms. For me this is the most enjoyable part: the groundwork has been done, and the expressive side can be given full rein.

STAGE 4

During the final stage, more time is probably spent in looking and assessing than on actual drawing and I scrutinize the picture from every angle. The purpose is to judge shapes, tones and colours, detached from subject matter.

The previous stage saw the major development of the ideas. Now these must be consolidated into an integrated whole. One or two adjustments need to be done, particularly in the area of the tree roots, which look too white and must be taken down. To

break up the whiteness and provide more texture, candlewax is rubbed over first and then a light wash of sepia applied; this fuses them more successfully into the foreground.

I now realize that the overall balance of the composition is too symmetrical, with the arch and the right-hand tree matching each other too closely. Extending the near edge of the arch and darkening the background tree introduces the necessary asymetry. Lines are strengthened with neat iron gall ink, and scratching with a scalpel produces the light tones in the background.

Pen has not been used in this illustration at all; in fact it is the only picture in the book where pen-drawn lines have been omitted altogether. This was not a deliberate intention originally, but as the drawing evolved and 'took over', the broad, rather painterly quality that resulted rendered the finer graphic character of pen inappropriate.

Looking back to the first stage it is interesting to compare it with this final stage. As with any adventure into the unknown, it is difficult to know where you will end up – but half the fun of painting lies in discovering where the paths will lead!

THE EXOTIC AND THE FAMILIAR

Flying in new directions could also be taken literally, not just meta-phorically. The ease with which we can now traverse the world has opened up possibilities that were once only dreamt about; places that used to be familiar solely through pictures for

most people have since become popular holiday resorts, and painting holidays are available almost anywhere, from romantic Spanish castles to the Indian Ocean, complete with guides and tutors – a very different situation from the past.

Painters have often been intrepid travellers, recording their adventures in colourful accounts, both literary and pictorial. J.M.W. Turner undertook many journeys around Britain and Europe, and on one occasion gives an amusing and graphic account of his coach overturning in a snowstorm while crossing the mountains from Italy to France. He goes on to relate how he and his companions had to walk through deep drifts in order to seek assistance. In his case he thrived on these experiences, frequently making use of them as painting subjects.

Edward Lear was another indefatigable painter-traveller; he was all the more remarkable because he had poor health, was terrified of horses and boats, and was upset by discomfort and noise. Painting in Albania, he was bombarded with stones and had to be protected by a guard with a whip, and at Petra he was attacked by Arabs who stole everything he had in his pockets, including some hard-boiled eggs! Then at the age of sixty in spite of suffering from attacks of epilepsy, he went to India and produced more than fifteen hundred drawings, filled nine sketchbooks and kept a detailed diary. An intrepid traveller indeed and also a delightful landscape painter, a fact not always known about this sensitive, melancholic man.

My own experience at Petra was very different. An hospitable Bedouin brought me a refreshing glass of tea while I sat sketching in the lee of a rock, sheltered from the searing sun; he even improvised

a table from the stones strewn around, so that the glass would not fall over. The only 'adventure' I had that morning was to watch a runaway horse galloping at full stretch down the path, chased by shouting boys – otherwise all was peaceful and I worked undisturbed.

Another story tells how Holman Hunt, the Pre-Raphaelite, was attacked by brigands on the shore of the Dead Sea while working on the background of *The Scapegoat* (Manchester City Art Gallery). So engrossed was he that, barely looking up, he waved them away, asking not to be disturbed while he painted. Apparently they were so astonished they left him in peace! I cannot vouch for the absolute truth of this anecdote, but it illustrates the dangers and difficulties painters were prepared to put up with to achieve their goals.

CORINTHIAN TOMB – PETRA

Petra is unique. As a painter I found this ancient city more exciting than anything I have yet encountered. Shut off from the rest of the world by mountains, the entrance is through a deep natural cleft. Once inside the city, enormous tombs carved out of the rockface stand on either side of the main thoroughfare. Proportioned and embellished like temples, their colours dazzle in the intense light. Over the centuries earthquakes and climate have taken their toll, but this has made the tombs even more dramatic to paint: part cave, part structure, it is difficult to tell sometimes where nature ends and artifice begins. The Corinthian Tomb shows the ravages of time more than most, and the mixture of opulence, crumbled stone and deep holes appealed to my painter's imagination.

I used watercolour washes of burnt sienna, raw sienna, burnt umber, indigo and cadmium yellow. I also made use of the white paper to show the contrast of brilliant light against the shadows of the rock. While the watercolour was still wet I ran black ink into it, producing the effects seen in the background. I drew freely on the rock with a thick nib, letting the lines spread spontaneously. The tomb was drawn more carefully, the lines building up to suggest structure and texture. This was because I wanted to accentuate the difference between the natural and the architectural.

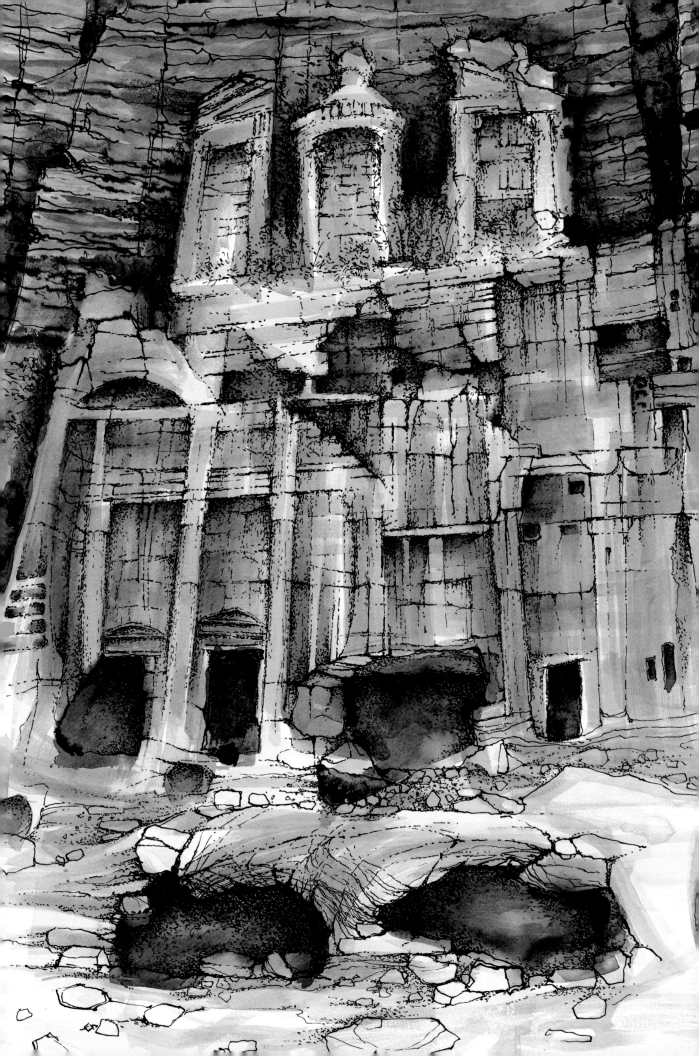

▲ MARBLE TOMB (SKETCH)
*Behind the Cathedral of Alexander Nevsky in St
Petersburg there is a cemetery. When I stumbled across it
by chance, late one evening, I found a remarkable
collection of tombs, memorials, effigies and crosses.
Materials of every kind had been used in their making,
from costly marble and stone to crudely painted
corrugated iron. Some were surrounded by elaborate
wrought-iron railings, others stood simply.*

*Surrounding these edifices and growing through them
were plants, trees and creepers of every description:
flowers, leaves, tendrils tangled with pillar, arch and post.
Half forgotten and largely untended, it was a bizarre and
unexpected sight, a rueful reminder of what once had
been. My artist's eye responded immediately to the scene
and out came my sketchbook. I drew in that strange,
compelling place for several evenings; it was peaceful,
hidden from the clamour of the city, and no one disturbed
me. The long twilight of a Russian summer enabled me to
work until nearly midnight – in itself an unusual
experience – and I was able to make a number of sketches
and notes.*

*The tombs were an eclectic mixture of styles from the
Orient and the West, reflecting how these influences had
shaped Russia's history. The tomb here was one of the
oddest of all, a forbidding, almost menacing shape that
might have come from another planet. Constructed from
marble, it represented the affluence of a former age.*

▶ MARBLE TOMB – ST PETERSBURG (DETAIL
SHOWING PENWORK)

Happily, today things are different, and we
can usually work at our pictures without fearing
for our lives.

THE QUALITY OF LIGHT

One of the most noticeable things about working
in different countries is the variation in the quality
of light; this is particularly striking in the sunnier
parts of the world. Northern Europe is typified by
a diffused, gentle light and the artist must adjust
to the strong contrasts between sun and shadow –
not always easy when time is limited if you are a
visitor and perhaps you have only a week or two
for painting. Many of us must have felt
exasperation at having to pack up and leave just
as we have got our eye 'in' and are feeling settled
in the different environment.

Another feature about intense light that you
may have encountered, is the curious 'flattening'
and draining of colour that occurs around
midday. Suddenly everything looks bleached and
without form, and this is difficult for the artist to
deal with. The wisest solution is probably to join
the rest of the populace, have a siesta and wait
until the colour returns later in the day.

The duration of light varies, too. Summer in
northern countries means long, drawn-out
evenings – in St Petersburg during June it is light
until midnight, and the black and white sketch for
Marble Tomb was done at eleven o'clock at night.
If you decided to go on a painting trip to the

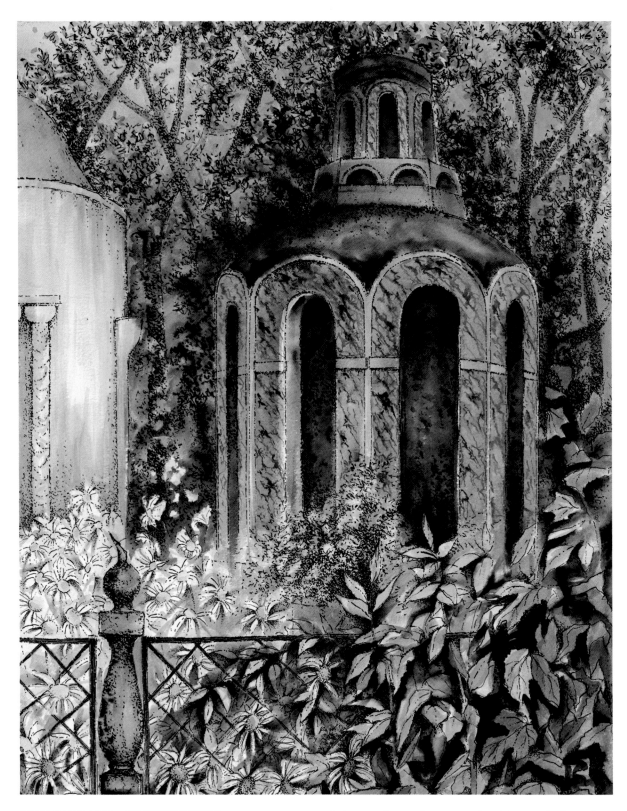

MARBLE TOMB – ST PETERSBURG

The painting that was based on the sketch shown opposite. The colours were freely interpreted. There are one or two written colour notes on the sketch, but I was really more concerned with the memory of the place and the atmosphere generated. The sky, for example, was in reality much lighter, and not orange at all, but the warmth balances the cool greys and whites, and the colour intensifies the 'closed in' feeling that suffused the subject. An advantage of making black and white sketches is the freedom it gives for developing the colour creatively.

The picture was carried out in watercolour and black indian ink on rough grain Arches 185gsm (90lb) paper.

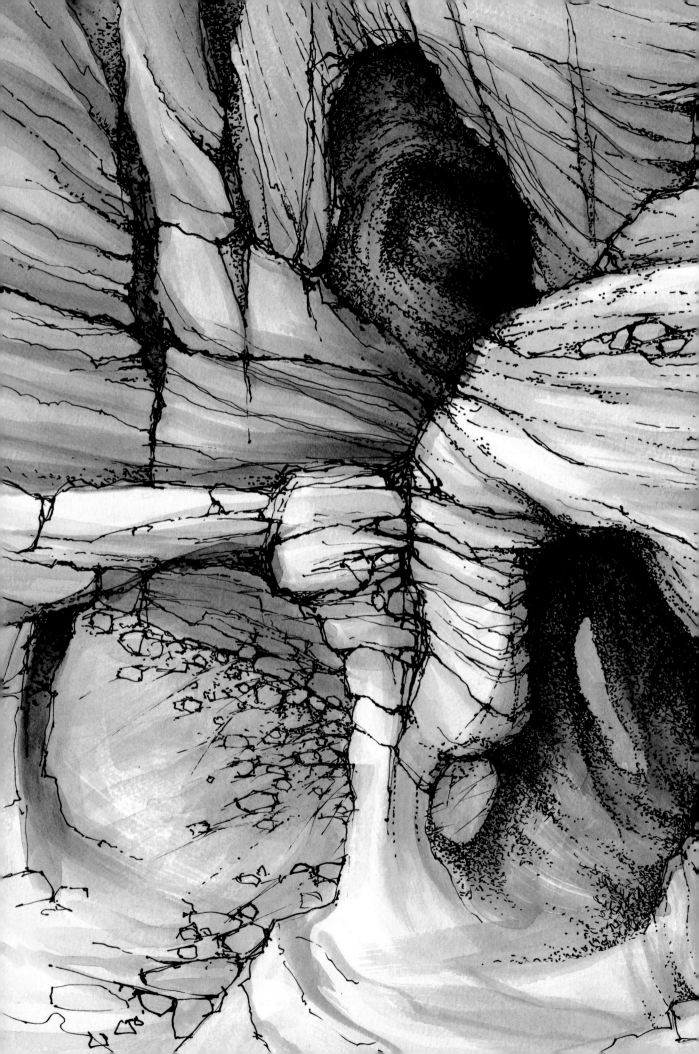

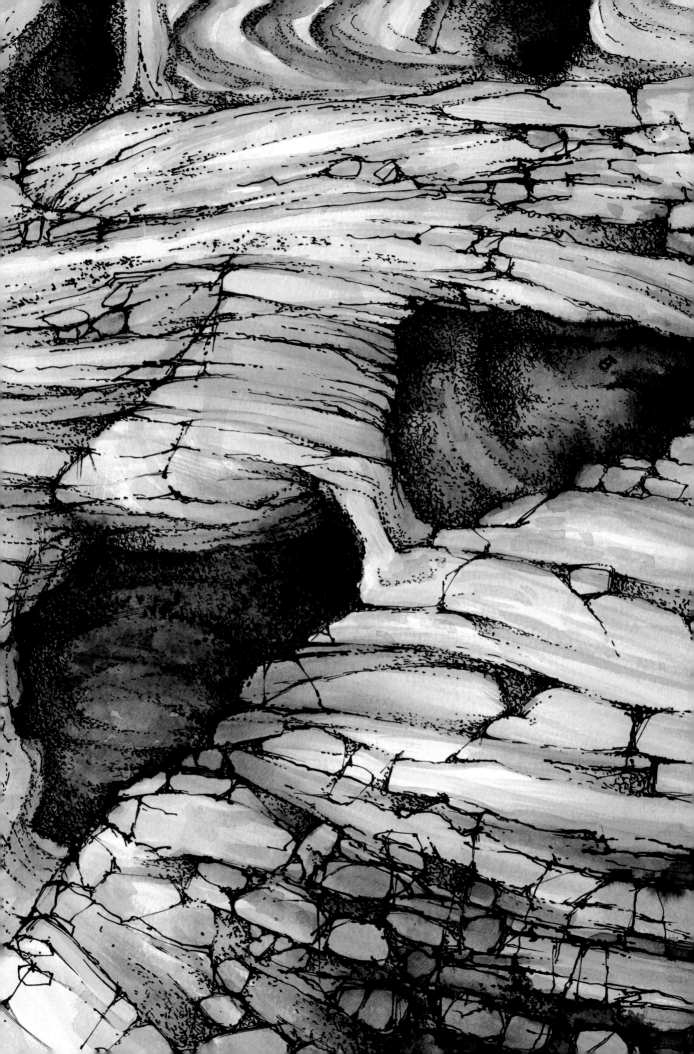

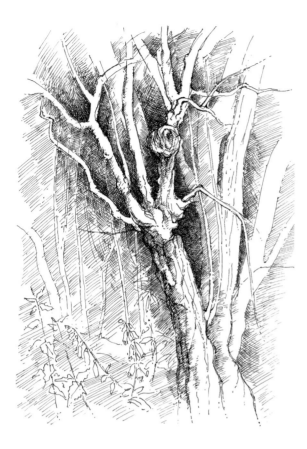

Arctic you would be able to work continuously in daylight throughout the summer months. By contrast, when I was working in southern Portugal I found the evenings were short. Twilight, suffused with an attractive violet, was brief and the change from day to night was more sudden than I was accustomed to in Britain.

Quality of light has a profound effect upon artists, and nowhere is this more apparent than in the paintings of Van Gogh. The change that overcame his work when he moved from Holland to Provence is evident in the brilliance that poured onto his canvases after the sombre, almost monochromatic colours he had been using earlier in the north.

I remember reading somewhere that artists need a change of environment and the experience of a completely different scale of light. I feel sure this is true of all those who paint, no matter at what level. The jolt that a new experience gives acts like an electric shock, polarizing thought and shaking us out of complacency. This happened to me in a desert in Jordan and is described in the demonstration, 'Wadi Rum', to be found at the end of this chapter.

THE TRAVELLING LANDSCAPE PAINTER

Take advantage of any opportunities you get for travel. Paint pictures and fill your sketchbooks with drawings and descriptions of all the places you visit. Later, when you are at home again, you will be able to relive those moments captured on paper and use the sketches for other projects to be worked on during the cold, dark months of winter. Thus you will provide yourself with a supply of original material, and will never be stuck for something to paint, or feel the need to copy from anyone else.

Pen and wash is the ideal medium to take away on holiday. It dries quickly and is convenient to carry around. If you prefer to make sketched notes rather than more finished pictures, consider getting a sketcher's pocket watercolour box; this, together with a small sketchbook, would fit into most jacket pockets. Ballpoint and cartridge pens would eliminate the ink problem, but take enough with you – they can get used up surprisingly quickly, especially if they are employed for writing postcards as well.

Brushes are likely to be the most vulnerable items of your equipment and will need protection against possible damage. An improvised brush carrier can be made from a sturdy piece of card,

TREE STUDY

A detailed drawing that explores the individual 'personality' of a particular specimen: I sat close to this tree in order to see and understand how the structure worked, with all the extra bumps and lumps that gave it character. I am sure I could not have invented anything so interesting out of my head – it would have appeared more ordinary than this. Trees are so familiar to us that it is too easy to turn them into a formula: a trunk divided into two main branches, which are divided into four smaller branches and so on until the twigs are reached. It would undoubtedly be recognizable as a tree but it would lack individuality. Studies like these enable us to discover the ingenuity of shape.

I drew on cartridge paper with a shoulder pen F and black indian ink. The technique is predominantly hatching, or cross-hatching, which gives the high degree of control necessary in this type of work.

◄ BEDOUIN CAVES – PETRA

Alongside the tombs at Petra are numerous caves where the Bedouin once lived. These are striated in such a way that the surfaces resemble veined marble or watered silk. The colours glow, and even in shadow they seem to absorb the light and give it back in smouldering hues. They present yet another fascinating subject to paint at this extraordinary site. I used colours and techniques similar to the previous Petra picture, amalgamating pen- and brushwork in layers of watercolour and ink to convey the variety of these incredible formations.

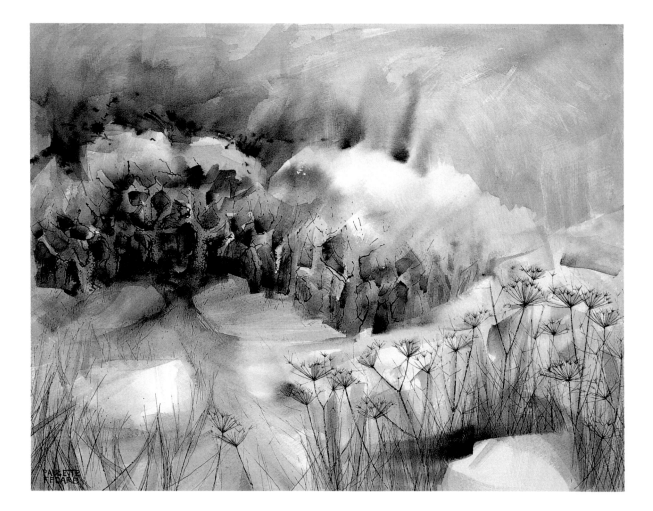

cut 3 or 4cm (1 or 1½in) longer than the brushes; attach the brushes to this with two or three rubber bands, and make sure they can't slip off. It may be necessary to have more than one card if the brushes are of assorted sizes. Dip pens could also be transported in similar fashion.

PAINTING THE FAMILIAR LANDSCAPE

I have dwelt at some length on the advantages of working abroad in unfamiliar surroundings, but this should not imply that familiar places are to be ignored. Areas that one knows well have a special significance; even if they are not particularly dramatic in themselves, they have a closeness to us which makes them meaningful. We enjoy painting them because of their very familiarity, although within that familiarity there can be unexpected surprises. Quite little things sometimes – a sharp green that suddenly attracts attention where a shaft of sunlight has caught a lichen-covered branch, or the torn wood of a tree that glows startlingly orange after rain.

'Familiar' has several connotations. It can refer

DISTANT WOOD

A subject that is familiar in the sense that I know woods and plants like these and see them every day, although the scene depicted was actually invented. It was a case of using what I knew in an imaginary setting, or at least partly imaginary, for even this had its origin in a wood I had once visited – the same ancient copse that inspired Yellow Tree *on page 78 and* Thorn Bush *on page 119. It is a different interpretation and possibly less subjective than the earlier paintings, but nonetheless contains introspective elements – the familiar used expressively.*

The technical range included free, experimental work in the area of the wood where ink has been dropped on and allowed to spread, and precise line drawing, shown in the foreground plants. The watercolour washes were applied with single sweeps of a flat 2cm (³⁄₄ in) brush, seen most clearly in the painting of the ground behind the plants. The colours were modulated by additional single strokes, without disturbing the wash underneath. This technique requires that you do it and leave it – it will not tolerate 'worrying', which loses the effect. The white areas are the paper left between the strokes of the brush.

to the immediate environment in which we live, or it could refer to unknown territory that has certain recognizable properties in common with our own: this might include for example weather, land structure and vegetation.

It so happens that the drawings I have chosen to illustrate the 'familiar' theme were not drawn in my own neighbourhood at all, and yet I regard them as places I know, or at least that have characteristics I recognize – and in that sense they *are* familiar. The term can be interpreted broadly.

PAINTING HOLIDAYS

I would like to add a few more words about painting holidays, which are widely advertised early in the year in practical art magazines. They have become

THE ROAD TO SLONCOMBE FARM

The narrow road shown in this picture is typical of many roads in Devon, where the farm was situated. I made the sketch one wet afternoon, drawing from a window. The light was flat and there was not much tonal variation, except in the deepest recesses of the trees; painting conditions with which many of you may be acquainted. The colours were soft, blending together harmoniously, with the exception of the sharp green next to the stone bollards; a note which adds piquancy to the otherwise quiet mood of the scene.

I used pale watercolour washes of olive green, yellow ochre, burnt umber, indigo, blue-black and a touch of winsor yellow. The pen drawing was done with a shoulder pen F and black indian ink. I made use of different techniques to bring out the characteristics of foliage, stone, grass and so on.

increasingly popular and cater for many kinds of painting activities all over the world. Some are run on a permanent basis, with their own studios and a selection of courses throughout the year; others are of a more roving nature, and visit various countries. If you feel you would like to go away to paint but are not sure, or not confident enough to do this on your own, they might be worth your consideration. However, do ascertain beforehand that you know what to expect; some courses are highly structured and organized, others are more relaxed. Find out, too, how large the group will be: some people thrive on jolly get-togethers after a hard day's painting, while others prefer a quieter approach. Numbers could also indicate how much undivided time you might expect from the tutor. Personal recommendation is obviously helpful in making a choice, and occasionally art magazines compile a comprehensive review on what is offered. Generally you would be expected to provide your own materials.

IN CONCLUSION

Whether you consider yourself a compulsive, dedicated artist, or just an occasional dabbler, the potential for painting the landscape in its many forms is huge. The world lies at your feet: jungle exotica, palm-fringed shores, Himalayan ranges and parched desert on the one hand; on the other, pastoral fields and shady woods, villages and country roads. Subjects to lure both the adventurous spirit and the contemplative mood are waiting to be set down on paper.

WADI RUM

WADI Rum is a desert in the south of Jordan, lying behind the mountains that overlook Aqaba and the Red Sea. It has a strange and desolate attraction. Huge, sheer mountains, or jebels, rise abruptly from the sandy floor. Towering walls of stone, they stand on each side of the valley looking as if they had once melted and dripped like candlewax, or been smeared across their surface with a giant palette knife. Fretted, pierced, hollowed, striated with vertical bands of black, and riven by deep shadowed chasms, these formations are awesome and dramatic.

Some writers have likened this scene to a lunar landscape, but unlike the moon which is cold and dead, Wadi Rum is alive with colour: reds, russets, golds, ochres, greys and pinks flood the terrain, the hues intensifying in the evening light. It has solitude, grandeur and beauty. It was here that T.E. Lawrence found solace, a respite from the exhaustion of desert fighting during World War I,

and his memorable description of it in *The Seven Pillars of Wisdom* captures perfectly its timeless, majestic atmosphere.

There are no roads here, only a tangle of tracks and footprints that criss-cross in all directions through the undulating sand; bouncing and jolting, vehicles must pick their way around the clumps of grey bushes and across the shifting ground. Vistas of rock, sky and sand open up; colours, shapes and tones alter in the changing light. The sun lessens its hold as afternoon gives way to evening, and eventually to the deep indigo-black of an Arabian night, brilliant with stars. The stillness is palpable and the peace indescribable.

It was a potent experience. I made no attempt to draw. It was too vast, too overwhelming; unreal, like a dream. All I could do was look, absorb and store the sensations in my mind. It needed a period of distillation before I was able to translate it into terms of painting.

STAGE 1

STAGE 2

The demonstration that follows takes a different format from the others in the book. Instead of showing the progressive stages of one picture, it shows the development of an *idea* into a painting, with accompanying work-out sketches.

STAGE 1

The first stage involved organizing the idea into a coherent shape. I had a strong sense of the general feel of the place that I wanted to get across, but needed to find a way of translating this response onto paper. I could have chosen an abstract option and restricted it to colour and fluid shapes, but settled instead on a more representational image.

I decided to make the initial drawing in sepia and black ink, the sepia introducing a note of warmth that suited the subject. This is a rudimentary sketch mainly to work out the composition. The sketch divides into three areas: sky, mountains and sand, and it was important to get the right relationship between the elements of mass and space. I made one or two alternative drawings but finally settled for the version seen here. I blocked in the sepia wash with brush to give

an indication of tonal structure, and then worked on top with pen and black indian ink.

As this was an exploratory stage, I didn't want to work out the drawing too precisely; there would be opportunity for that later. Working sketches need to be just that – sketchy and incomplete – otherwise there is a danger that the final picture will be merely a tired repetition of the first work-out, with little added during the development.

STAGE 2

I had a lot of fun with this stage, as I wanted to try out some experiments with the colour. One of the impressions left by the desert had been the visual impact of black rocks seen against the evening sky, with blinding stabs of sunlight flooding through the gaps. Since it was impossible to capture this brilliance with sufficient intensity in watercolour, I decided to compromise and to make the sun lower in the sky with a more diffused effect of colour.

I began with the sky, brushing in a pale wash of cadmium yellow. While this was still wet, I loaded a brush with vermilion and let a single drop fall onto the yellow. It spread exactly as I had intended.

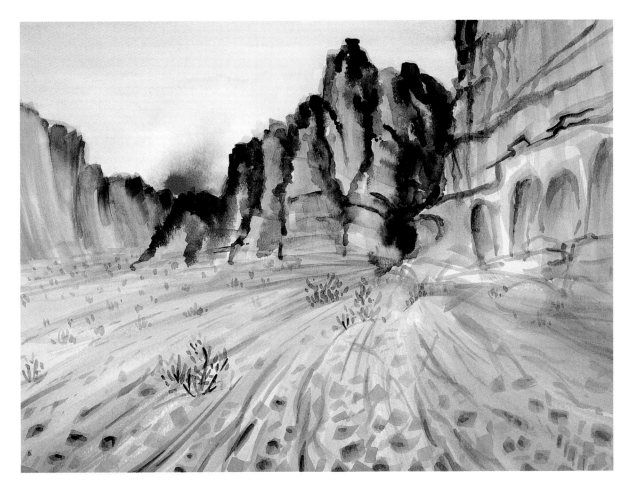

STAGE 3

Alas, though, impatience got the better of me and I rushed on with the rocks without waiting for the sky to dry sufficiently first. The indigo ran into the vermilion and the effect was all but lost – the disastrous result seen in the sketch! However, although the sky had been sacrificed, the rocks, on the other hand, had worked well, with the mingling of the indigo and raw umber. In fact I prefer the spontaneity achieved here to the more controlled version shown in the next stage.

The experiences I had in the course of this stage illustrate the exciting unpredictability of watercolour, and it is this quality that, for me, makes it so attractive. The ratio of water to paint; the dampness or dryness of the paper; the timing of the action, are all governing factors in the outcome of a picture. It is a medium that sails close to the wind, inviting experimentation and the pushing of its boundaries as far as you dare.

STAGE 3

Now that I had resolved the main format and colour, I could start on the final version of the picture. The obvious alteration to the previous stage is the greater area of foreground sand; this increases the feeling of depth and spaciousness that I wanted to convey, which is such an integral part of the subject. It also gives more opportunity to bring out the warm pink as a contrast against the dark brooding mountain – and this time I *have* managed to get the strong accent of vermilion for the sun. The mountains were brushed in, first with raw umber and then with indigo, the colours running together in places where they were both still wet.

There are so many aspects of a single subject that no one picture will contain them all, which is why artists return again and again to the same theme: there is always something more to say. In this case I have chosen to bring out the theme of light against dark; of hard, unyielding rock against soft undulating sand, with the colours underpinning this: friendly pinks and yellows set against cooler blues and harder browns.

The colours used were cadmium yellow, vermilion, burnt sienna, indigo and raw umber; and the brushes were flat 2cm (¾in) and round No.12.

STAGE 4

The picture was ready now for the pen to add texture and clarify the form. I began with the central rock: as it is both the dominant shape and the dominant tone, I wanted to enrich it with detail. The pen is a beguiling implement and rock structures are lovely to draw, with their rhythms and intricate patterns, so I had to be careful not to let it run away with me and make it all look too fussy. Effectively there should be enough drawing to suggest the character of the structure, without overwhelming the broader sweeps of colour underneath.

For this type of drawing I like to let the pen 'wander', which means holding it loosely about halfway up the handle, allowing the lines to unravel almost of their own accord. This gives an erratic effect, with lines of varying thicknesses. Here, I concentrated on the middle of the central rock and the inner side of the right-hand rock. These two areas counter-balance each other: one dark, one light; one warm, one cool. Opposing factions create visual tensions and add interest to a picture.

Another opposing element is the textured surface countered by the plain. Pictures need restful interludes and pauses in a similar way to music; a picture that shouts everywhere confuses the eye. It is for this reason that I have deliberately underplayed the right- and left-hand sides: not only does this provide a breathing space but it also directs the eye towards the centre and the main area of 'action' in the picture.

The foreground sand proved to be more of a problem than I had at first anticipated. I wanted to bring out the patterns formed by the dents and ridges in order to balance the dark shapes beyond, but the texturing became a little too pronounced and caused some of the hollows to look like holes! I could have remedied this by scratching out with a knife but decided to leave well alone.

All new subjects require exploring, and if they don't work out first time it is essential to carry on and have another go. Sometimes the most successful pictures are the result of many previous abortive attempts and battles. The important thing is not to give up.

I used two shoulder pen F nibs: a new one for the finest lines and a worn one for the thicker lines. The ink was black indian, and the paper Cotman watercolour 300gsm (140lb).

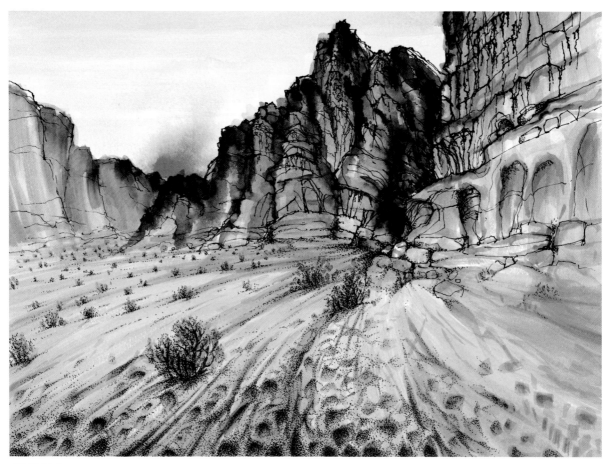

STAGE 4

LANDSCAPE AND THE SEASONS

MY chapter begins with spring, a season that starts almost imperceptibly, with a glimpse of yellow here and a smudge of pink there. February is always the month when I realize that winter is at last on its way out. A day comes unexpectedly when biting winds drop, rain stops slashing at the face and there is a different feel to the air; the sun's warmth can be felt, birds are singing and buds are swelling. Yellow is the first colour to appear among the wild flowers, usually the celandines, those cheerful stars brightening up the grass. Everything is full of expectancy and there is a compulsion to seize pens and brushes and hurry outside. Sometimes the mood is premature and winter tightens its hold again, but usually not for long.

It is a good time to check all your gear. Paints and inks may have dried out if you haven't painted much during the winter months, or tube tops may have become jammed and impossible to move. A remedy for this is to immerse the top end in hot water for a few minutes and then try removing them, with pliers if need be, but gently to avoid distorting the tubes. Brushes and nibs should be examined to make sure they are in serviceable order. It is frustrating to arrange a day's sketching only to discover, too late, that your equipment is unusable and needs replacing.

PAINTING THE SPRING

As spring establishes itself, it is the freshness of the greens that impresses; the landscape sparkles and everything is new. It is a lovely season to paint, either side of the window, in the garden or the open countryside. The drawing opposite was done early in May when trees and plants were coming into blossom, and I kept it light in treatment to convey the essence of the time of year.

This picture was drawn from my studio window; it can be compared with another spring picture, *Stream* on page 16, also made in early May, but out of doors. In the latter it was those brilliant yellow-greens I sought to catch, contrasted against the dark indigo-greens of the stream. Looking at the image I can immediately recall the sensation of the spring sunshine on my back, the sound of the water and the light breeze that ruffled my paper; a perfect example of the picture evoking more than the scene depicts.

Even with the sun shining, you can feel cold if you sit out for long so early in the year. Drawing requires concentration, which burns energy, and that, together with sitting still, seems to suck the warmth out of you – so it is essential to wear thick clothing. Sketching when you are cold is a miserable occupation, and inevitably deflects attention from your work. It may seem an obvious point, but sometimes people don't realize just how chilly you can get on these occasions.

An interesting spin-off from such excursions is the wildlife you may encounter, especially birds. They soon get accustomed to your near-motionless figure and after a while ignore you – you might even get an extra sketch or two. I have 'shared' my patch with some strange companions in the past: once a praying mantis, that strange robotic-looking creature, settled on my paintbox, and another time a

SPRING GARDEN
In order to convey the freshness of spring, I have kept the drawing 'open' and made much use of the white paper – there are almost as many unpainted areas as there are painted ones. Many watercolourists do this, and it helps to bring a liveliness to the picture.

I drew in the composition with a round No.12 brush, and continued to fill out the colour in the same way, using short strokes and dabs with the tip of the brush. For the sky, I pressed the brush down slightly to flatten it and wiggled it across the damp paper. The wash spread in the dampness and gave the soft cloud effects. This is another 'one-off' watercolour technique that may need some initial practice. A sketching pen was used for the ink drawing. Echoing the brush method, I then added hatched and cross-hatched strokes – more in the foreground, and fewer in the background.

AUGUST EVENING

Golden stubblefields, when the corn has been cut and the straw stacked in bales, are the epitome of the late summer landscape. The evenings are still long and light, and at the end of a warm day it is possible to continue drawing outside until it is nearly dark, which is what happened on this occasion. I had a small sketchbook with me, and made several black and white pen sketches from different positions in the field. I was interested in the lines of

stubble converging on the brow of the hill, and the way they contrasted with the round shapes of the bales.

I started the painting soon after making the sketches, as I wanted to do a representational picture before the memory of the scene faded; this time the topographic took precedence over the imaginative! It shows a different approach to the previous picture. There is no white paper showing, and it has a density of texture more in keeping with the heavier mood of late summer. I interwove the

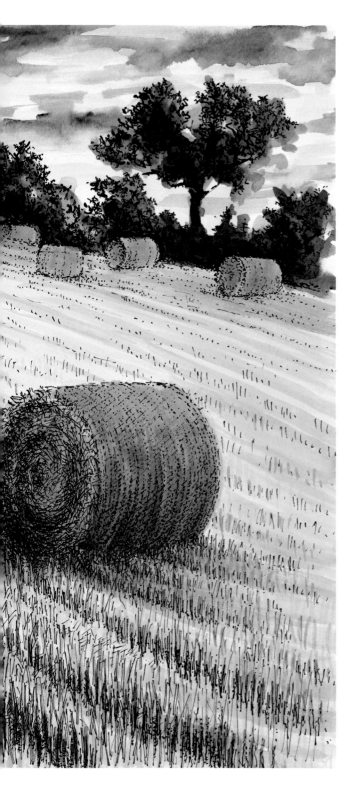

brush - and penwork until I had achieved the desired effect.
The watercolours used were yellow ochre, cadmium
yellow, burnt sienna, winsor blue and Payne's grey with
black indian ink. The paper was Saunders Waterford (HP)
300gsm (140lb).

small black scorpion scuttled round my feet. It was very small but I kept a wary eye on it all the same!

GARDENS AND FAMILIAR LANDSCAPES

We are most aware of the passing seasons in our own gardens and in the landscapes with which we are most familiar. And if you are a gardener as well as an artist, you will be particularly conscious of these changes.

Gardening and painting have a natural affinity: both involve form, colour and texture and are occupations that require physical and intellectual exertion. It is more than mere coincidence that artists are frequently gardeners too. The Impressionist painter Monet was a famous example with his garden at Giverny, an inspired place full of light and colour, which he painted obsessively. Gertrude Jekyll, one of the best known gardeners of all, was a watercolour artist originally but was forced to give it up owing to poor eyesight, and so turned instead to gardening; hence her enjoyment of colour, which became one of her hallmarks.

Working in the garden gives a direct contact with the landscape and provides ample opportunities for studying plants at close quarters. Even weeding can have its compensations! Be on the lookout, and when you notice something interesting try to make a note or sketch of it.

Familiar landscapes provide similar opportunities for noticing changes, but at a remove from the close contact of a garden; our eyes will do the work instead, observing as the scenery alters month by month. Walking is a good way to absorb what is happening; there is time to look around and stop for closer inspection. Get into the habit of carrying a pocket sketchbook, always at the ready for a quick 'thumbnail' drawing; an enormous amount of information can be collected in this way. Even if you are with companions, a brief scribble will only take a moment and it shouldn't hold up proceedings too much – and besides, it might encourage them to do the same.

SUMMER LANDSCAPES

Spring gives way to summer, the best time for working out of doors in comfort; daylight hours are at their maximum and, with a bit of luck, should generally be warm. I find the evenings and early mornings have the most appeal, especially late evening when the countryside is flooded with golden light. This is the sort of scene I have depicted in *August Evening*, where the trees are

silhouetted against the sky-line, the circular bales stationed across the stubble like monoliths. These late evening skies, with wisps of dark cloud in sharp contrast to the pale oranges, yellows and egg-shell greens, are exciting to paint, offering scope for colour and brushwork.

Holidays are often taken in the summer, and if this involves travel it could mean experiencing a different scale of light, as discussed in chapter 7 (page 90). Moreover new locations and strange atmospheres can refresh you, so that you see anew your own familiar surroundings when you return.

Summer is the time when foliage is full and rich. Greens are massed together in tier upon tier of voluptuous shape, providing a wonderful opportunity to exploit the variations and subtleties of this colour. Thus as a change from making a complete picture, try noting down all the different greens you can see. This will involve much mixing of colour and keen observation – make your paintbox really work for you. If you have a great many colours at your disposal it is easy to be tempted to use them straight from the tube or pan, without bothering to mix them. However, limit yourself to only two or three, and find out how many you can make from these. Since green is a secondary colour – in other words it can be made by mixing blue and yellow – it is not absolutely necessary to have any ready-made greens at all. Try mixing black or raw umber with yellow; raw sienna with cobalt blue; indigo with raw umber, for example, in addition to the more obvious blue and yellow range.

Exploring colour will enable you to increase the potential of materials and perhaps make do with less than you thought possible. This course should be followed with other colours too, not only green. However, a word of warning – it is possible to overmix colours and produce a nasty muddy effect, mainly because too many colours are used at once. Again, experience will teach you how far you can go before this occurs.

GLORIOUS AUTUMN

Although summer is a beautiful season, enjoyed for many reasons, I think autumn is even better from a painting point of view. At the end of summer there is a dusty heaviness in the landscape, the greenness can become oppressive and it is a relief when the spectrum of warm autumnal colour appears. No other time of year can boast such a collection of glorious hues: reds, golds, yellows and umbers tumble across the landscape – golden larches, rowans and maples

SELECTING COLOURS

Without becoming too involved in colour theory, the following guidance may help those selecting colours for the first time.

The three primary colours are red, blue and yellow. These colours cannot be mixed from any other colours, and they will form the basis of all the colours you have, with the exception of black and white. Pairs of primary colours will give the three secondary colours: thus red and blue make purple; blue and yellow make green; red and yellow make orange. Each primary has an opposite, or complementary colour: thus green is the complementary of red; orange is the complementary of blue; and purple is the complementary of yellow. Many artists use opposing colours in their paintings, so look out for this – maybe you already do it yourself. Mixing all the primaries together will make brown.

In theory, therefore, it should be possible to manage with only the three primaries, in addition to black and white. The issue would be simple enough if there were only one version of each primary – but this is not so. Take the colour red as an example. Reds will range from purplish (crimson) to orangy (cadmium red), so in order to produce a clear purple, a crimson would be required to mix with blue. If cadmium red were used instead it would give a muddy brownish-purple. However, cadmium red mixed with yellow would produce a brighter orange than would crimson. The conclusion we must draw is that both crimson *and* cadmium red are needed – in other words, two reds.

The same applies to blue and yellow. Choose a deep blue (french ultramarine) and a softer blue (cobalt); a golden yellow (cadmium yellow or chrome) and a greenish-yellow (lemon). This would provide a basic palette of six colours from which many more could be mixed, giving a wide range at your disposal.

Later the earth colours could be added: raw and burnt umber; raw and burnt sienna; yellow ochre. Further additions would be a matter of personal preference; we all have 'favourite' colours which mark our pictures.

ULVERSCROFT IN AUTUMN

I painted this sketch in situ on a breezy October day, when the light changed continually from bright and sunny to overcast and subdued. This can be a nuisance to the outdoor painter, and generally a compromise is called for in which you must decide which light to choose. I settled for the more subdued version. I also had to contend with a herd of cows, obstinately curious and which completely blocked my view at one stage!

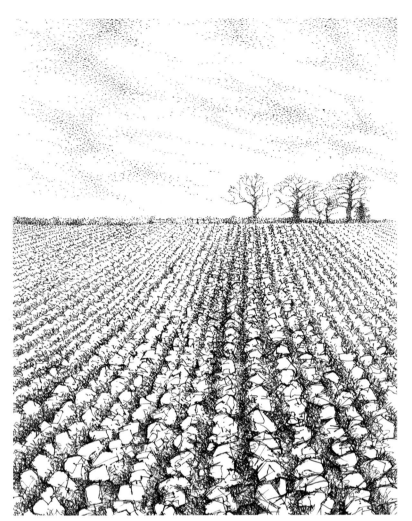

WINTER FIELD

This drawing is about the space and openness of winter, the dialogue between earth and sky without the intervention of foliage. There is much appeal in this 'boney' kind of landscape, which in many ways I find more interesting than the obvious lusciousness of summer. The starkness of the subject is repeated in the austerity of medium – no colour here to add a touch of warmth.

The drawing was carried out in pen and black indian ink on cartridge paper. I used a Bank nib which gave a firm medium line, slightly harder than the shoulder pen F that I often use. The furrows were done with linear and scribbled strokes, while small dashes and dots were used for the trees. Although these are silhouetted against the sky, I was careful not to make them too dark or they would have risked competing with the dark tones of the foreground and destroying the sense of distance.

Stippling was used for the sky. This was kept light to suggest the slight variations perceptible in a typical grey sky. The diagonal drift indicates air movement and it also counters the strong verticals presented by the furrows.

alight with reds, the singing yellows of horse chestnut and oak. Against this strident splendour are set the quieter browns and the remaining fading greens of summer.

An extra bonus at this time are the berries seen in hedgerows and the fungi found in woodland and grass verges. Echoing the oranges and reds of the leaves, they can be gathered and studies made from them at home if you don't want to draw them *in situ*. The picture *Autumn Fungi* in the following chapter (page 115) could just as well have been included in this one.

While you are collecting these bounties of autumn, pick up some of the leaves, too, and examine them closely. The markings of the brilliant colours astonish with their beauty and are frequently missed as we carelessly pass them by. The vignette of the bramble (opposite) illustrates a tiny part of the variety of colour and form that is there for the taking; the original drawing was a life-size study, and you can see how I made use of dark tones to focus attention on the delicate, feathery leaves.

WINTER AUSTERITY

Finally we come to winter, the skeletal season, the time when the structure of the land can be seen clearly and things that have lain hidden under the lush growth of summer are revealed. Corn and hay have been cut, and fields ploughed to expose the earth; decaying leaves festoon the ground. It is a season of browns and greys and pale ochres, relieved here and there by a spark of colour – a circlet of bright berries hanging in the hedge like a necklace, or the vivid yellow of a lone leaf still clinging to a twig.

Winter has an austere beauty. These are the months of angularity and sharpness seen against a background of rolling contour. Lines of plough, or thin lines of winter green, pick out the undulations in the land, perspectives drawn across the country; there is a sense of space and openness, with the countryside untrammelled by foliage. Later, with frost and snow, other changes occur: etched with a rim of ice, each plant stands out and the landscape is transformed into a world of shimmering glass; under snow the land is smoothed into piercing

whiteness. In all of these a host of topics calls to pen and brush.

Trees are one of the dominant features of winter landscape: only in winter is it possible to see the complex structure of trunk and limb, and large trees can be positively overwhelming, reaching up to great heights like cathedrals, their branches dark against the sky. Now is the time to understand what happens under the canopy of leaves, to notice the difference between one type of framework and another, and to make drawings whenever possible. Braving the elements you need to work swiftly to jot down observations, although sometimes there are mild days when it is feasible to work longer and perhaps do a painting or two. It is essential to take any opportunities that present themselves during these severe months.

CONVEYING MOOD AND ATMOSPHERE

Threaded through seasonal change is the weather, determining mood and atmosphere on a day-to-day basis. Atmosphere is an integral part of the landscapist's work and adds to the 'flavour' of a picture: soft, hazy blues in the distance suggest summer; make them grey and a colder day is implied. Autumn mists are whiter and more vaporous than the ochre fogs of winter, which flatten and swallow up shapes. Look at trees in a fog and see how the flat tones progressively weaken, until they vanish altogether in the murk. Think carefully about the mood you wish to convey; it can be an important ingredient.

Linked to atmosphere is the time of day – or night. If you have never attempted one, try doing a night picture where strongly contrasted tones can be balanced against ghostly half-lights and shadows. Choose a place that is readily accessible as you will probably have to memorize much of it, unless you use a torch and manage to draw under these conditions. The picture I show in the demonstration, 'Garden at Night', was carried out in watercolour and black indian ink. An alternative could be done in coloured inks, or black and white for dramatic effect.

IN CONCLUSION

Landscape is inextricably linked to the seasonal cycle, and herein lies much of its attraction. Through the passing months we watch the changing colours, forms and weather patterns: greens alter to reds and golds, and then to browns and greys; the fatness of summer changing inexorably to the spareness of winter. Each season has a special beauty and quality, producing a continual procession of images, and whether we work from the sanctuary of a window or outside *in situ*, we should try to make the most of them.

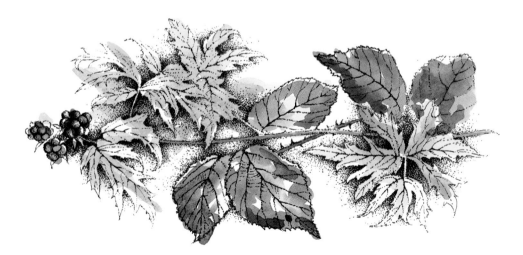

GARDEN AT NIGHT

Not only do the seasons offer variety, but the changing light also provides countless opportunities for landscape painters. I have always been intrigued by my garden at night, whatever the time of year, and the way light falls on it from the house. Near the windows in summer, plants make dark patterns against the lit rectangles; leaves and petals appear to be translucent, and white flowers seem to float disembodied, their stems drowned in shadow. In winter the lines make a sharp fretwork against the glass.

In the demonstration that follows I have tried to capture the essence of the scene, with strong tones contrasted against more subtle features. It is a picture that depends upon the imagination as well as observation.

STAGE 1

Autumn is the setting, when trees have started to shed their leaves and the twigs begin to show.

Using a very pale wash of burnt sienna and a flat 2cm (¾in) brush, I start by painting a large rectangle for the window. Adding a little more colour to darken the wash, I continue with the surrounding area until the paper is covered. Deepening the wash still further and changing to a round No.12 brush, I draw in the main shapes of the composition.

At the end of this stage the picture consists of three graduated washes of burnt sienna. As I required a lot of wash, I mixed a sizeable pool in a plastic dish before I began. I was also careful to use a separate brush for mixing it to ensure I didn't get blobs of unwanted pigment on the painting brush; this shouldn't happen if the wash is mixed carefully, but sometimes enthusiasm gets the better of patience! It is surprising how quickly a wash disappears when large brushes are used, so mix more than you think you will need so that you will be quite sure of having enough.

STAGE 1

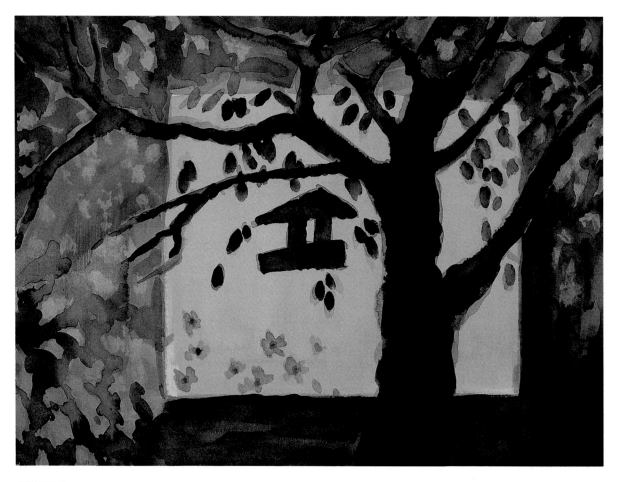

STAGE 2

STAGE 2

This is the stage when the picture starts to come together and develops atmosphere. I begin by painting a wash of indigo on the area surrounding the window; while this is still wet I 'lift' the leaves by blotting with the corner of a tissue so that the underlying wash shows through.

The silhouetted shapes against the window are put in with full-strength indigo, although because these areas have been dampened with water first, there is some modulation of intensity. I don't want to bring in the full force of the darkest tones until I see what is needed in the final step.

The petals of the flowers along the lower edge of the window should look transparent, so only the centres have been darkened. Lastly, I work a little more dark tone around the edges of the picture; this directs the eye towards the light central area.

STAGE 3

Standing back to take stock, I detect a certain clumsiness: the pen is needed to hone the shapes into greater refinement. Using a fine nib, I work over the background with a scribbled network of lines; this thrusts some of the leaves forwards,

while merging others into shadow. The same technique is continued into the foreground around the flowers.

The indigo on the tree now looks too dense, so before working on it with pen, I 'lift' some of the colour. This is done by adding brushfuls of clear water, waiting a moment or two for the paint to loosen, then blotting it with tissue. This results in a variegated texture, giving a softer effect. So although in real life the tree *was* very dark, in pictorial terms it appeared too heavy. This underlines the importance of making adjustments according to what is needed, rather than to what is actually seen. Finally, I add some texture to the window area to reduce the contrast slightly.

Drawings like this provide a refreshing change from 'daylight' work. I suggest you try one if you have not done so before. I used Brause 512 and shoulder pen F nibs, with black indian ink on Saunders Waterford (Not) paper 300gsm (140lb).

► *STAGE 3*

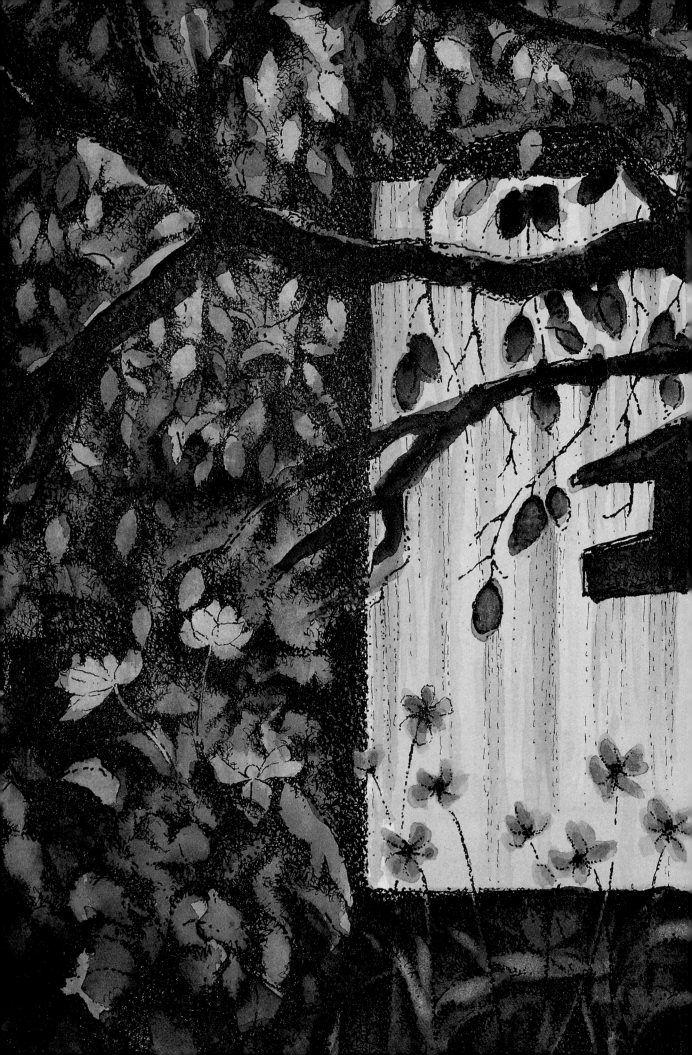

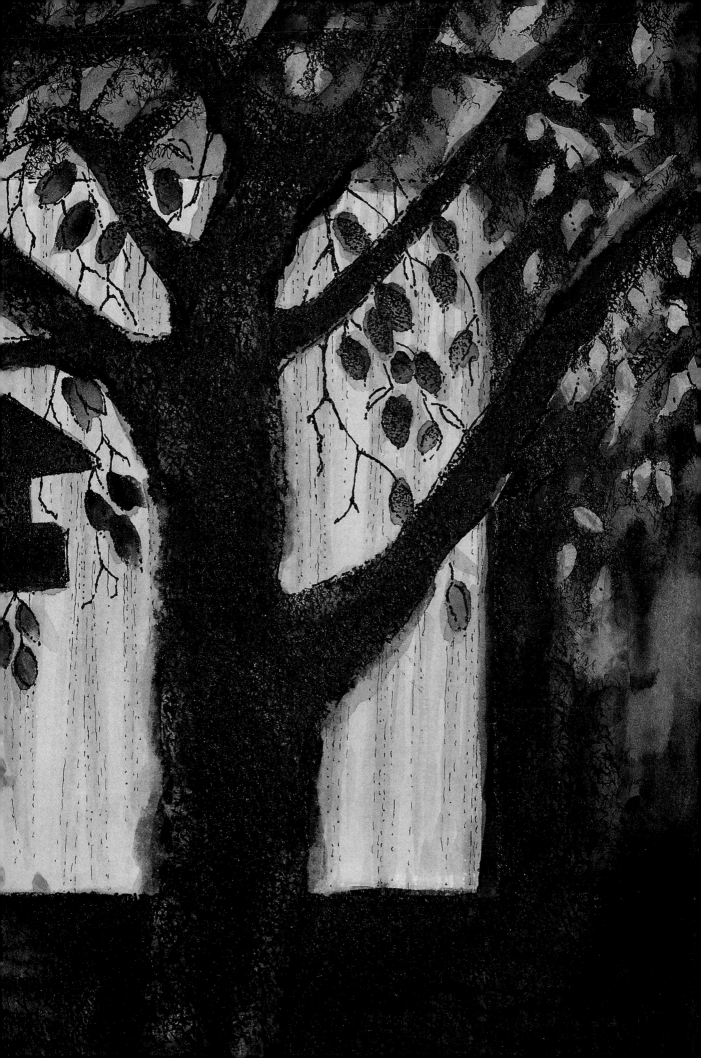

THE 'FURNITURE' OF THE LANDSCAPE

HILLS and valleys provide the 'bones' of the landscape, while the details, which I have called the furniture, fill it out and give increased interest. These fall into two main groups: those that are natural and those that are man-made. The natural objects are trees, plants, rocks and stones; the man-made ones include constructions imposed on the land such as buildings, walls, gates, bridges and telegraph poles. As they weather, many of these in fact come to look part of the natural landscape: the moss-covered wall and the ivy-clad building, far from detracting, often enhance the beauty of a place, and a distant church spire or the glimpse of a turret above a forest interest and intrigue us – they 'season' the countryside.

It is well to remember that the landscape has been shaped not only by climatic patterns but by farmers, landowners, road builders and town planners. Moreover, this process goes on continuously, sometimes obviously as in the case of new motorways, sometimes less so. Gardens, too, reflect this reshaping when we make alterations. We are manipulating our own landscapes, albeit on a small scale.

Much of what we regard today as natural countryside owes its present appearance to people in the past. Woodlands were planted, pathways trodden, fields enclosed, rivers dammed and diverted – even the wild plants are not all indigenous. The stately Himalayan balsam that grows in such profusion along river banks was an 'escapee' from the garden, introduced from the Far East by plant hunters of an earlier century. Yet how attractive it looks with its pink and white flowers, fitting in happily to the surroundings – a perfect subject for the painter of stream and woodland.

BUILDINGS IN THE LANDSCAPE

Buildings in the context of the country have inspired painters for generations. Apart from their use as focal points, they complement the landscape: the warm, mellow colours of brick contrast with the greens of foliage (the colour 'opposites' mentioned in the previous chapter, page 106); the greys of stone stand out against the browns of the earth; angles of walls and rooftops counter the curves of woods and hedges. Sometimes the shapes echo each other, as in the arch of a bridge that repeats the roundness of a clump of trees.

Occasionally a dissonance occurs: a sharp splash of colour on a door, or a line of washing in a garden. These accents can add excitement to paintings, although they need to be handled carefully as they could wreck the overall effect. If you are uncertain about dealing with small areas of sudden colour in an otherwise harmonious landscape, then play them down and subdue them, however bright they may appear in real life. Contrasted colours, even when they are considerably subdued, can still provide an effective note. It is a question of degree which you will learn through experience, as I have frequently remarked.

Another colour – or tone, as it is not strictly speaking a true colour – that may cause difficulties is white. White buildings feature extensively in the landscape, but too often they are made over-prominent and 'jump out'. The problem is the difference between what is actually seen and how to portray it; it concerns interpretation rather than imitation. White paint is not normally used with transparent colours and washes, the white paper serving instead, but whatever the medium, the same principle of relating colours applies. This is demonstrated in *Hazel Head Farm, Cumbria* on page 75. Here I have left white paper showing, not only on the white front wall of the house, but also on the roofs, the side, the surrounding stone walls, the foreground and in the sky. Thus white is woven throughout the painting, and is not left as an isolated area; it relates to the entire image.

Colour relationships are vital in helping to make a picture come together, which gives them a special relevance to this section. The 'furniture'

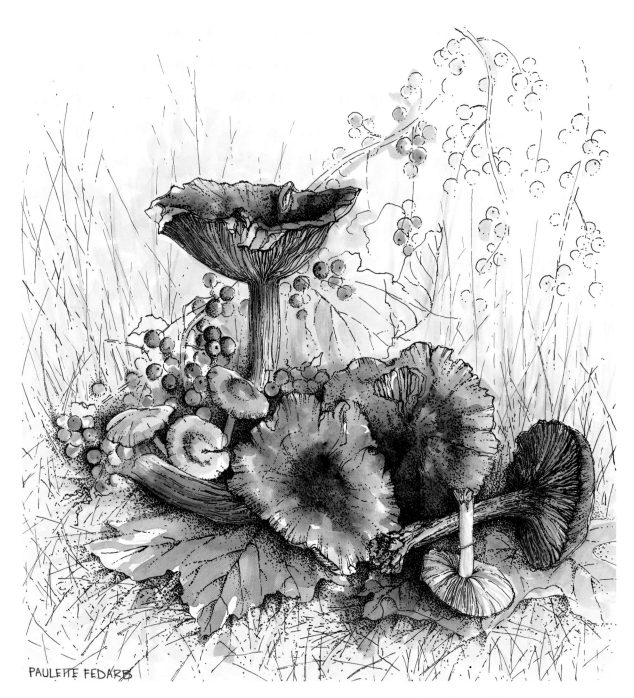

PAULETTE FEDARB

AUTUMN FUNGI

The fruits of autumn are lovely to draw. Fascinating in shape, colour and texture, they provide plenty to occupy both brush and pen. This was a study in which I wanted to bring out the subtleties and contrasts of the richly coloured fungi.

Washes of burnt sienna, raw sienna and indigo mingled to give the colours of the fungi bodies, and raw umber was added to these for the gills and stems. Alizarin crimson was brought in for the leaves, and the berries

were a mixture of vermilion and burnt sienna.

The background was a light wash of cadmium yellow, to suggest bleached grasses and also the sunlight of an autumnal day. Lines of cobalt blue were brushed over this to indicate texture and tone, but they were kept understated in order not to detract from the main group.

The ink drawing followed the brush, concentrating on the fungi and leaves, and lightly stating the background. Stippling in the shadowed parts pushes the shapes forwards and gives an indication of the space around them.

PACKHORSE BRIDGE – CUMBRIA

Bridges might almost have been invented with the painter in mind! Varied in form, diverse of material, providing a focal point and a lead into a picture, there must be few of us who have not included a bridge at some time in our compositions. They nearly always make an attractive feature in the countryside – and in pictures, too.

I began the painting with loose, open washes of watercolour: cobalt blue for the initial drawing, then raw umber, raw sienna and Payne's grey, to which were added burnt umber, oxide of chromium (green), indigo and cadmium yellow. These were applied with a round No.12 brush (for drawing) and a flat 2cm (³⁄₄in) (for blocking in).

Two nibs were used for the ink drawing: a shoulder pen F for the finer lines, and a worn Waverley nib for the thicker, stronger lines, seen mainly on the larger stones of the bridge. The scratchy strokes on the right-hand foliage were made by working the pen vigorously up and down, and from side to side; needless to say this needs a robust pen in order to avoid splutter and catching on the paper. The paper was Cotman Watercolour 300gsm (140lb), and the ink was black indian.

should appear to be an integrated part of the landscape, and not stuck on like a postage stamp. In the painting *Packhorse Bridge – Cumbria* (pages 116–17), in which the structure of the bridge and the surrounding country are intrinsically different, colours have been used as a linking element; colour has not been 'localized' – grey for the bridge, green for the foliage, yellow for the field and so on – but followed through in a similar way to the white farmhouse. Thus the dark indigo blue appears under the bridge, on the wall and in the trees; the yellows and browns also repeat throughout the picture. Once more I have co-ordinated the colours. Aim to avoid painting only local colour, which tends to cut up a picture and make it look 'bitty'. This happens when you think of each object separately, and paint it separately, without considering it in relation to everything else. Be conscious of the whole even as you concentrate on the part.

REARRANGING NATURE'S FURNITURE

The embellishments of the scenery may be considered on a smaller scale, too; they don't always have to be connected with the broader view – the drawing *Autumn Fungi* (page 115) is an example. I made the collection of fungi and berries while out for a walk one day, took them home and then arranged them in a group. The arrangement looks more contrived than it would have done had I drawn the group *in situ* where they were growing in the grass in a straggly line, but I wanted a more compact shape so I orchestrated them to fit my idea. 'Found' objects can be used for making individual studies or for partially invented pictures, as I have done here.

Keep on the look-out for bits and pieces: wood, leaves, pebbles, feathers, bones and shells. Many of them are exquisitely shaped and patterned, some are odd and unusual, but they all make beautiful subjects – another instance of the small world at our feet.

Thorn Bush, too, is an 'orchestrated' picture, based partly on life and partly on imagination. The bush was originally drawn from one in my garden, then transposed to an invented setting, although even this was founded on an ancient wood discovered on Dartmoor. So much of what we paint is a fusion of things seen, remembered and imagined. Other examples of this can be seen in *Yellow Tree* (page 78) and *Distant Wood* (page 95).

THE IMPORTANCE OF TREES

Trees are the most notable natural 'furniture' of the countryside. They punctuate and break up the contours, and contribute texture and colour. They are possibly the most universally loved pastoral feature of all, and most landscape pictures will contain a tree of some description. Their fascination to artists is unwavering and must be attributed to the enormous wealth of variety in the species – every size, shape, and colour. They have been drawn, painted, etched, sculpted, carved and welded in as many different media.

No two trees are ever exactly alike, even within the same genus. Whenever you draw one it will be different from the one you drew before; each will present a singular image of structure, markings and textures. Try drawing the same tree at different times of year and notice how it alters in colour and shape as each season rings the changes. Compare the two versions of the plum tree on page 35 in chapter 2, Basic Techniques.

Interesting and beautiful as they are, deciduous trees in winter can be quite difficult to draw three-dimensionally. In chapter 5, Intimate Landscape, I gave suggestions for depicting massed foliage (page 65), but as this did not include trees without leaves, the following advice may help. In order to make the nearest branches appear to come towards you, make the drawing stronger, the lines a little

THORN BUSH
A subjective picture resulting from an objective drawing, and with a large measure of imagination added. The painting was done on tinted paper – Canson Mi-Teintes, gris ciel – with washes of watercolour. Because of its transparency, watercolour will be affected by any underlying colour: in this case the colours are muted and given a unity, which adds to the atmosphere of the picture. The effect would have been different on white paper.

I worked in broad strokes with a flat 2cm brush. There was no preliminary drawing, I simply plunged in with colour to establish mood. The ink drawing was interwoven with the colour washes: colour first, then ink, and so on until I judged it to be enough.

I used two nibs and a stick to apply the ink, which was black indian. The finest lines, shown in the background and on some of the grass, were made with a shoulder pen F. The thicker pen lines on the bush were made with an extremely old Waverley nib which has broadened and become eccentric with age – it is unpredictable, produces many surprises and I am deeply attached to it. The stick, a discarded paintbrush sharpened into a point at the handle end, produced the very thick, intermittent lines in the foreground and on the lower part of the bush.

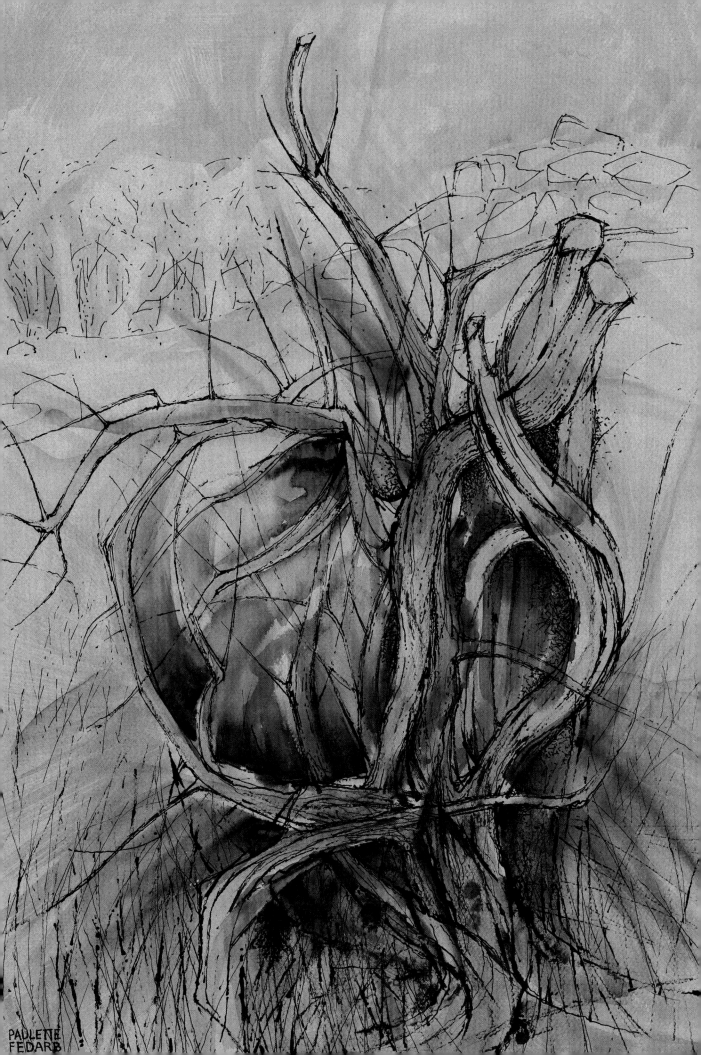

PAULETTE
FEDARB

thicker. This will make them stand out from the page. Conversely, keep the furthest branches lighter and the lines thinner, to send them back. If you make all your drawn lines of equal weight it will flatten the branches and reduce depth. Gradation of tone also plays a part, with darker tones at the front and lighter tones at the back. This pinpoints the difference between reality and drawing, and the need to think constructively about what you do to make it look convincing.

Strong, upright trees with sturdy limbs have obvious appeal, and yet the broken tree has another kind of attraction, the decayed trunk, holed and splintered, hung with creepers and grass, having a curious beauty of its own. Artists in fact seem to have a peculiar predilection for decay and ruin. Maybe it is the incongruity of the appearance, or could it be that imagination can roam more freely with the disintegrated image? Certainly some of the finest and most powerful pictures produced in Britain this century were those done during the two World Wars, a devastated world that proceeded to flower in paint – a strange phenomenon.

Near to where I live there are some ancient willows. Battered by gales, one or two have succumbed and lie on the ground; fallen giants in the embrace of ivy tendrils. These are marvellous to draw and I often do so; the possibilities seem to be inexhaustible. Their 'mood' changes with the seasons; in summer when the leaves are out, they are full of secret places and deep shadows, half-hidden and mysterious; in winter it is the weight and form that predominate, and they become like great beasts of mythology, wound about with snakes. I find them much more interesting to draw than their vertical neighbours.

Throughout this book trees have appeared again and again in the pictures. Some are imaginative, evoking a personal, inner world; others are straightforward recordings. Some are 'portraits' of particular specimens, or careful observational studies; others are quick notes and jottings. Wild or cultivated, clipped or exuberant, summer foliaged or winter stripped, the tree makes its presence and its fascination strongly felt.

THE INDUSTRIAL LANDSCAPE

A completely different type of furniture occurs in the industrial landscape. This is often harsh and grim, redolent of deprivation and hard toil, but

▲ TWISTED TREE AND FENCE

A sketch made on the spot in the fullness of summer. Branches, foliage and fence posts combine in an interesting pattern: horizontal shapes are offset by diagonals and verticals; texture of wood is contrasted with that of foliage.

Working like this is immensely enjoyable. Colours can be flooded on freely as you interpret what you see, and then the pen comes in to exert a little discipline, sharpening up form and tone. But don't be too rigid with it, let the pen enjoy itself as well as the brush. It is a sketch, which implies a certain openness of spirit.

◄ FARM GATES

The textures in this drawing give scope for a variety of pen techniques. I used two nibs, an Ajusto pen painting nib and a shoulder pen F, with black indian ink on cartridge paper. The heavy lines on the large gate and the left-hand stones were done with the flexible pen painting nib. The finer strokes, including the stippling in the sky, were made with the shoulder pen.

If you compare the drawing on the large gate with that of the foreground stones, you will notice how the fractured thick and thin lines suggest wood, and the firm, regular strokes indicate stone. I was aware of the hardness of the one and the relative softness of the other. The sky introduces a different technique, the stippling giving a nebulous effect appropriate to this element.

► CHIMNEYS – NORTHUMBERLAND

A painting that relies heavily upon atmosphere, generated by the subject and the foggy conditions. I began with the background, painting a wash of raw sienna right across the paper. Into this I brushed raw umber to position the chimneys, working from their bases upwards so that the wash faded towards the top, giving the impression of disappearing into the fog. Next, I worked from the chimneys towards the foreground, introducing olive green into the umbers and increasing colour strength as I progressed down the paper. Pale washes of blue-black and indigo were added to the lower part of the chimneys, and a hint of prussian blue on the grass in front of them.

With the tonal scale of the top half of the painting established, the tones of the lower half could now be intensified. Colours were deepened and contrasts increased to distinguish between the surface of the ground and the flue hollow. Dark tones of prussian blue and indigo were worked in and around the edges of the holes; lighter tones of olive green, raw sienna and blue-black were laid on the grass.

The pen drawing was put in with a shoulder pen F and an elderly Waverley. The charcoaly effect between the stones and in the foreground was made with a reed pen. The paper used was Bockingford 300gsm (140lb).

▲ CHIMNEYS – NORTHUMBERLAND (SKETCH)

It was a raw December day when I came upon these lead chimneys, and it was one of the few occasions when I had not heeded my own advice, always to carry a sketchbook. I had no drawing materials with me, not even an odd scrap of paper: instead I had to rely entirely upon my ability to absorb the image and the atmosphere. On return home, I made a number of exploratory sketches first, of which this is one. I needed to sort out what I wanted in the painting: there were several possibilities jumbled together in an amorphous collection in my head.

The sketch shows an idea for the flue and the collapsed ground around it. In reality, the three elements of the picture – the chimney, the flue and the hole behind it – were more widely spread out, but in order to make a composition they had to be condensed. I used three colours and black indian ink.

For a picture that hasn't quite jelled, it is a good idea to work it through first in a series of rough preliminaries, though make sure they are rough. Overworking at this stage could mean using up all the inspiration before you really get going.

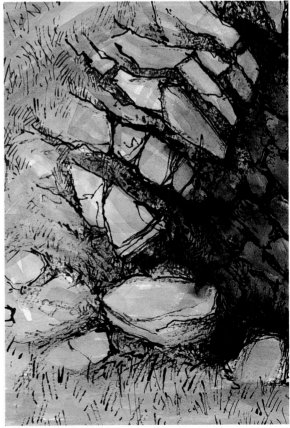

► CHIMNEYS – NORTHUMBERLAND (DETAIL)

This shows the reed pen technique around the stones.

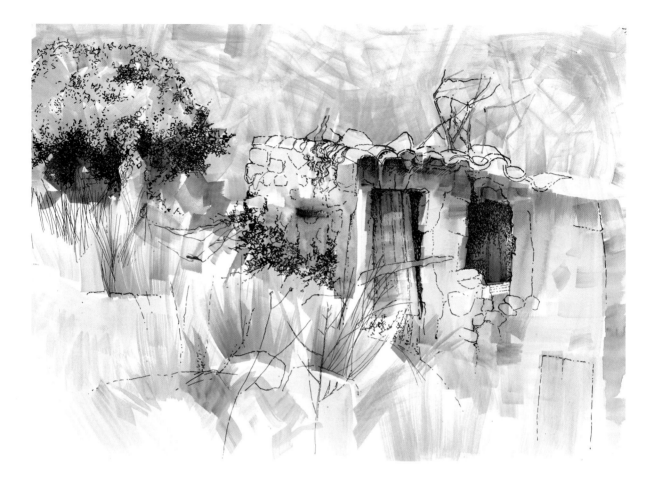

again it catches at the artist's imagination. The sight of a tall chimney rising out of desolate moorland; huge cooling towers, awesome in their size; pylons and telegraph poles scattered across fields; defunct coalmines – many of these have been the inspiration behind a picture.

Chimneys – Northumberland (page 122) was a painting based largely on memory. The area had originally been mined for lead and there were several ruined chimneys dotted about the moor. Fanning out from the ruins were brick flues, the roofs of which had collapsed in places. The day I saw them, fog shrouded the moor and the only sounds were the harsh calls of birds, occasionally flying low over the ground. It was damp and eerie. After following the track of the flue for some while, a shape could be discerned ahead – the broken outline of a chimney. Sinister and silent it rose out of the mist, the arched openings resembling the eye-pieces of a knight's helmet. The subject was one of chilling atmosphere and I felt that ghosts could well have lingered there: this was what I wanted to convey in the painting. It represents the darker, introspective side of landscape.

Not all industrial landscapes are necessarily forbidding, however, and had I encountered this

LITTLE HUT – LE BARROUX

Again I am attracted by the fusion of the constructed with the natural. The small cabine depicted here captivated me the moment I saw it. There was something almost cheeky about the way in which it sat among the boulders, observing the world through its one-eyed window, crowned with a topknot of twigs. Behind, the semi-circular tree made a contrast with the rectangles.

I applied the watercolours with a flat 2cm (3/4 in) brush, using it to bring out the inherent shape of the stroke, especially evident in the treatment of the sky. I used a shoulder pen F with black indian ink, working up the drawing to a degree of finish in places, but leaving it understated elsewhere.

one on a hot summer's day I would probably have felt quite differently and another picture would have resulted. Landscape is an extraordinarily versatile subject: we can match its moods and it can match ours, and it is malleable into many forms. It is not only the surface attraction of a pretty scene which captivates us, but the magnetism of deeper forces beneath that surface, the roots that disappear into a primeval past. The land is tied to history, some that is known about but much that isn't, and perhaps something of this creeps into every drawing and painting that it inspires.

Consider this the next time you embark upon a landscape: it might evoke a different response.

MAN-MADE ADDITIONS TO THE LANDSCAPE

Gates and stiles are generally considered acceptable pieces of landscape 'furniture', whereas pylons and telegraph poles often are not. Admittedly they have a more intrusive effect on the countryside, but I must confess to a certain affection for them, although it does depend where they are situated. Nevertheless I respond to the contrast their tall lines and angles make with the fields and foliage, and even the wires produce rhythms across the land. Pylons too have a 'presence' as they stride majestically over the fields, and their complex structure of girders and wires has a sculptural value. The sight of a ripe cornfield swaying at the foot of one of these massive structures, with the interplay between pliable corn and rigid ironwork, has considerable pictorial possibilities. It is often the case that personal vision lies in the less obvious.

Gates and fences nearly always fit sympathetically into the pastoral scene. If they are of wood, the natural affinity of the material blends with the surroundings and soon acquires a weathered patina. The construction of gates is interesting, with their cross-bars and uprights, and invariably they can be used to strengthen a picture, or to provide a focal point; in the drawing *Farm Gates* (page 120), for example, they form the central pivot. The watercolour sketch *Twisted Tree and Fence* (page 121) also shows how natural and man-made objects can knit together into a balanced unit, the one complementing the other.

Not only are the furnishings of the countryside interesting subjects in their own right, but they can provide convenient hooks on which to hang our compositions.

RECORDING THE DELAPIDATED

If you come across an intriguing feature in the landscape that you would like to draw or paint, don't delay too long before you do so, or you may find it gone! I have been caught out in this way.

Some years ago there was an old stone building in one of the fields near where I live. It was tumbled down and I had often walked past it thinking that I would like to make a drawing, but somehow never got round to it. Then one day it had vanished; somebody had decided to remove it and tidy up the field and all that was left were a few

STUDIES AND SKETCHES

I have quite often referred to studies and sketches in this book and I would like to clarify the terms more specifically.

A **study** is a drawing that requires close and meticulous observation. It is an excellent way of training the eye and disciplining the hand – try to make yourself draw *exactly* what you see, instead of more or less what you see. Studies are usually made in connection with a single object, or a detail – a plant, or part of a building, for example. It is factual drawing that enables you to scrutinize an object thoroughly.

A **sketch** is broader in definition and generally more creative. It can be used to observe and record, but it also includes the free working-out of ideas. There is a spontaneity in a sketch which is absent from a study. It may take only a few minutes, as in a 'thumbnail', or it might take considerably longer if it is more ambitious. A sketch will look open-ended in comparison with a study, which has a more finished appearance.

Studies and sketches should both have a place in your drawing repertoire as they each have a role to play in the advancement of skills.

stones – and my potential drawing was no more. This is more likely to happen on 'home' territory, where there is less pressure to get on with something than there is when you are away, when you know time is limited. It taught me a lesson: not to wait if there is something you really want to do.

I did, however, manage to even up the score on another occasion, the result of which can be seen in the drawing *Little Hut – Le Barroux*. The hut was in a badly delapidated state, but it had such character that I couldn't resist making a sketch. There was a defiance about its stance as though it were daring nature to tear it apart. Behind it was a tree, umbrella-like in shape, which stood guard; the relationship between the two was a potent factor in the attraction of the subject. This time I didn't wait: I made my drawing.

A year or so later it was pulled down and replaced with an ugly concrete block. How glad I was that I had managed to do my drawing before it was too late – and in addition I have a topographical record of something that no longer exists. For the present it remains in my storehouse of ideas, and I haven't as yet been moved to develop it further; but one day something may click into place and spur me to make a series of paintings based on the theme. It is impossible to

tell when or why an idea may surface, it can happen at any time. Always be prepared, and never regard sketches as useless, however long ago they were done.

IN CONCLUSION

My journey through landscape has taken many directions and now comes to an end. Some of my thoughts and experiences may well reflect your own, or at least strike a chord of recognition. If they have made you reassess ideas, or consider new ones, then I hope you will continue to expand these still further. Painting is a continuous stream of development; it may flow faster at some times than at others, but it should never stop completely or dry up.

I would urge you always to keep your eyes and imagination open, and draw and paint whenever and whatever you can. The more you practise, the better you will become and the greater your range of expression – but don't ignore my earlier warnings about technical prowess. Its purpose should always be that of the tool, and not the end.

Landscape is a marvellous subject, well matched by the versatility of the pen and wash medium; I hope these concepts come across in my book. The intention has been to exploit both subject and medium, and to provide a stimulus for your own work. If I have succeeded in adding to your inspiration, then my endeavours in these pages have been worthwhile.

Enjoy painting, enjoy the countryside and may both give you years of pleasure wherever you choose to take paper, pen and brush.

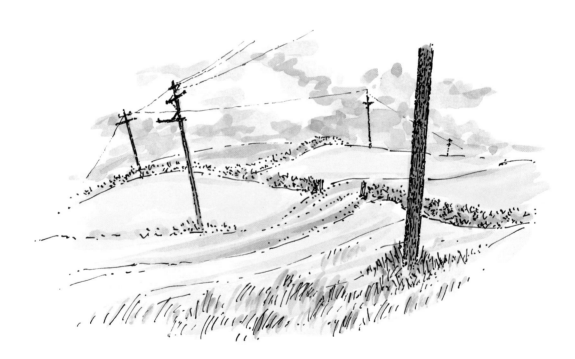

INDEX

(illustrations are in italics)

040 - 685 - 1